Straight
BOURBON

Foreword by Bill Samuels, Jr.

Introduction by Carolyn Brooks

INDIANA UNIVERSITY PRESS

Straight
BOURBON

DISTILLING THE INDUSTRY'S HERITAGE

CAROL PEACHEE

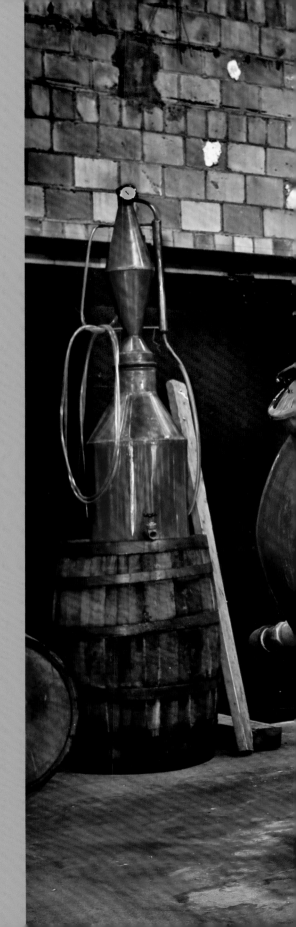

This book is a publication of

INDIANA UNIVERSITY PRESS
Office of Scholarly Publishing
Herman B Wells Library 350
1320 East 10th Street
Bloomington, Indiana 47405 USA

iupress.indiana.edu

This book is printed on acid-free paper.

Manufactured in China

Names: Peachee, Carol, author.
Title: Straight bourbon : distilling the industry's
 heritage / Carol Peachee ; foreword by
 Bill Samuels and Carolyn Brooks.
Description: Bloomington, Indiana, USA :
 Indiana University Press, [2017] |
Includes bibliographical references and index.
Identifiers: LCCN 2017011249 (print) | LCCN
 2017004952 (ebook) | ISBN 9780253029478
 (cl) | ISBN 9780253031242 (eb)
Subjects: LCSH: Bourbon whiskey—History—Sources. |
 Distilleries—Kentucky—History—Sources. | Abandoned
 buildings—Kentucky—Pictorial works. | Photography,
 Industrial. | Industrial archaeology—Kentucky.
Classification: LCC TP605 .P45 2017 (ebook) |
 LCC TP605 (print) | DDC 663/.52—dc23
LC record available at https://lccn.loc.gov/2017011249

1 2 3 4 5 22 21 20 19 18 17

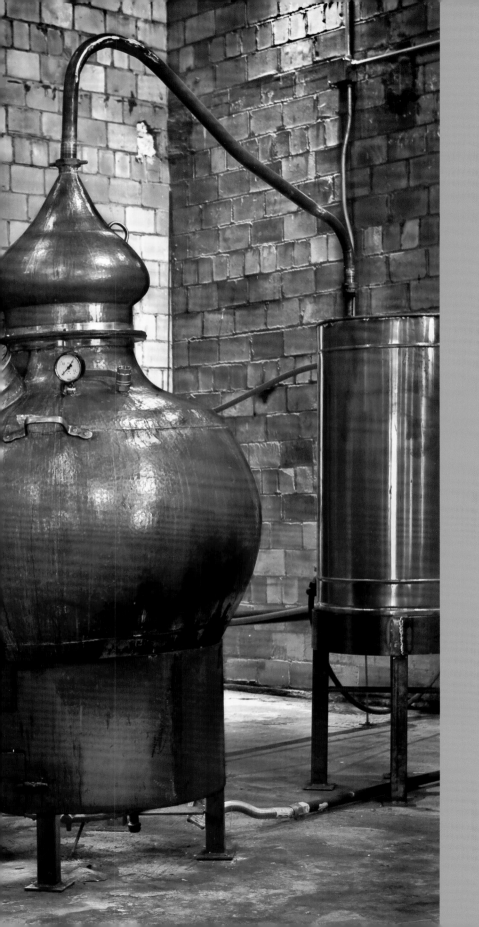

For Monica

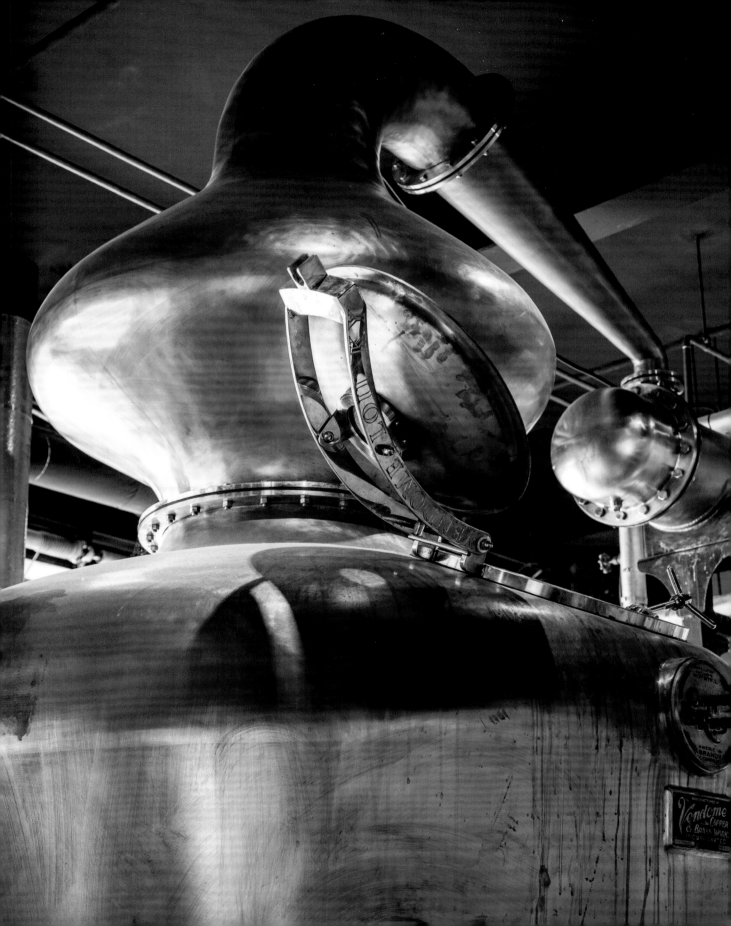

Contents

Acknowledgments

This book grew out of my curiosity about the cultural and industrial heritage of distilling bourbon. That curiosity grew from my first book, which focused on the industrial archaeology of the distillery plant itself. Yet the cultural heritage of distilling also lays in the human culture: the people who learned the crafts of milling, copper welding and design, barrel making, and warehouse construction and then passed them on through the generations down to today's workers and owners.

I owe a great debt to those members of the current generation who have been so open and willing to share their work spaces and craft skills for this book. Thank you to the Buzick family of Buzick Construction, the Robinson family at Robinson Stave Company and East Bernstadt Cooperage, Wade and Julie Daniels of Wade-Lyn Ranch Distilling, A. J. and Peg Jones at Casey Jones Distillery, Mac and Phil Weisenberger of Weisenberger Mills, and Barb and the whole family at Vendome Copper and Brass Works. I also owe a great debt to the preservationists who welcomed me and were willing to make suggestions and give me access to areas usually off limits. Thank you to Harry Enoch and Charles Hockensmith of Kentucky Old Mill Association for sharing their historical knowledge of mills in the area and for taking the time to guide me to significant areas. And I would be remiss if I didn't thank all of the tour guides who showed me around distilleries and cooperages, tolerating my frequent and lengthy stops to photograph, as well as all the small craft distillers who gave me access to their distilleries and were patient with my many requests. Thank you to all of you for making this work possible.

Finally, I must thank my editor, Ashley Runyon, for her amazing tolerance and support of this project. Her belief in my vision has kept me steady and focused and is truly the reason this book is in front of you now. And thank you, of course, to Chrissie Turner, a friend extraordinaire. Last, but most important, thank you to Monica, who just makes everything possible.

Foreword

When my dad had created the whisky that came to be known as Maker's Mark and was finally ready to bottle it after waiting six hot summers, his instinct was to name it after himself. As a sixth-generation distiller he had a pretty healthy ego, and besides, that's just the way things were done as a matter of course.

It took my mother's wisdom and insight to disabuse him of that notion. Instead, she offered him a name for his whisky that truly celebrated the care and craft and pride that went into it—not just on dad's part but on the part of a legion of men and women who work behind the scenes at every distillery.

So, if you only know your favorite whisky by the boldfaced names on the label, you're missing a lot. Because—to mangle the words of the poet John Donne— no distiller is an island. That is to say, it takes a heck of a lot of extremely dedicated people and a series of surprisingly complex processes behind the scenes to turn water, grains, and wood into the beautifully simple liquid in your bourbon glass.

Whether it's farming the corn, wheat, and barley that go into the mash or building the beautifully intricate copper stills where it gets cooked, there's vast knowledge and dedication that usually goes undiscovered—until now.

I think Carol Peachee has done a magnificent job of capturing the places and processes that most whisky lovers never see but need to understand in order to have a true appreciation for the labor of love that goes into every drop of bourbon.

I hope you'll enjoy this privileged look into how bourbon really gets made, beyond the myth and marketing spin.

Bill Samuels, Jr.

Chairman Emeritus | Maker's Mark Distillery, Inc. | Loretto, Kentucky

Introduction

Carol Peachee's remarkable distillery photographs can be appreciated on many levels—as documentation of the enduring repetition of centuries-old processes; as a glimpse of industrial equipment seen as eccentric contemporary sculptures; or as moving tales of abandonment and renewal. They are unique aesthetic statements as well as documents that inform about the inner workings of the distilling industry in Kentucky. As a group, they provide much detailed information about the ingredients, equipment, processes, and buildings involved in whiskey production. Not coincidentally, the adjectives that one might use to describe the photos—rich, warm, intense, and saturated in the colors copper, amber, and gold—are among the adjectives often used to describe the very best straight bourbon whiskey for which Kentucky is so famous.

The photographs remind us of the complex web of support industries, products, and people that have been necessary to make the distilling industry tick over time. From the early days of relatively simple whiskey making in Kentucky, farmers, millers, coppersmiths, coopers, and builders have all played a critical role in provided the raw ingredients, the equipment, and the buildings necessary for whiskey production. As the industry matured in the second half of the nineteenth century and the years leading up to Prohibition in 1920, this list grew enormously. Bottling became an important part of the industry beginning in the late 1880s and a requirement after the repeal. Supplies for bottling and shipping ran the gamut from the bottles themselves to corks, caps, labels, paste, and the wooden boxes and later many varieties of cardboard containers used for shipping. Architects and engineers specializing in distillery design and construction; tank makers who fashioned enormous cypress fermenting vats; expert still makers capable of making voluminous pot stills as well as column stills many stories high; pump, filter, boiler, and slop dryer manufacturers; and stencil and burning brand makers were just some of the many specialists supplying the distilleries.

The 1890 Louisville city directory lists more than 125 Louisville businesses serving the industry. A year later, on January 1, 1891, the *Louisville Courier-Journal* published a

long article titled "Kentucky Whiskies: A Product in Which This State Is Conceded to Lead All Others." An additional subtitle reads "A Great Employer of Labor, It Also Provides a Market for Many Products." The article singles out corn, rye, malt, coal, staves, hoop iron, cattle, hay, straw, labor, and railways as those products particularly benefiting from the industry. The cattle, hay, and straw have to do with the extensive livestock operations run by most distilleries before the common use of drying equipment as a way to deal with the nutrient-rich by-product of distillation commonly referred to as "slop." Yeast and barrels, two unmentioned products in the article, were frequently made by the individual distilleries at this date.

The photographs in the book for the most part coalesce around three stages in the production process—the preparation of the raw materials from which the bourbon is created; distillation itself, during which these raw ingredients, by this point in the form of a "mash," are transformed into alcohol; and the aging process, which starts with filling barrels with newly distilled whiskey and then placing those barrels in various types of warehouses to age into fine bourbon. The photographs show historical as well as contemporary processes and products from each of the stages. Of all the photographs, it is the images of the stills, both old and brand-new, that tie the book together. The still is the heart of a distillery through which everything circulates. And it is the copper works and workshops, large or artisan, that make the stills possible. The stills made by Vendome Copper and Brass Works of Louisville, Kentucky, are pictured in a number of images. Remarkably, Vendome has been in the business of manufacturing and maintaining stills and other distillery equipment for more than one hundred years and is perhaps the only pre-Prohibition still maker remaining in the business. All the new craft distilleries represented in this book take tremendous pride in displaying their stills, the signature piece of their equipment, to great advantage.

Peachee's photographs invite us to see through the eyes of many observers—industrial archaeologist, chemist, engineer, distillery worker, artist, photographer, lover of tradition, tourist, and bourbon aficionado. The visual pleasure these images provide will enhance the enjoyment of all who savor the beverage they celebrate.

Carolyn Brooks
December 2016

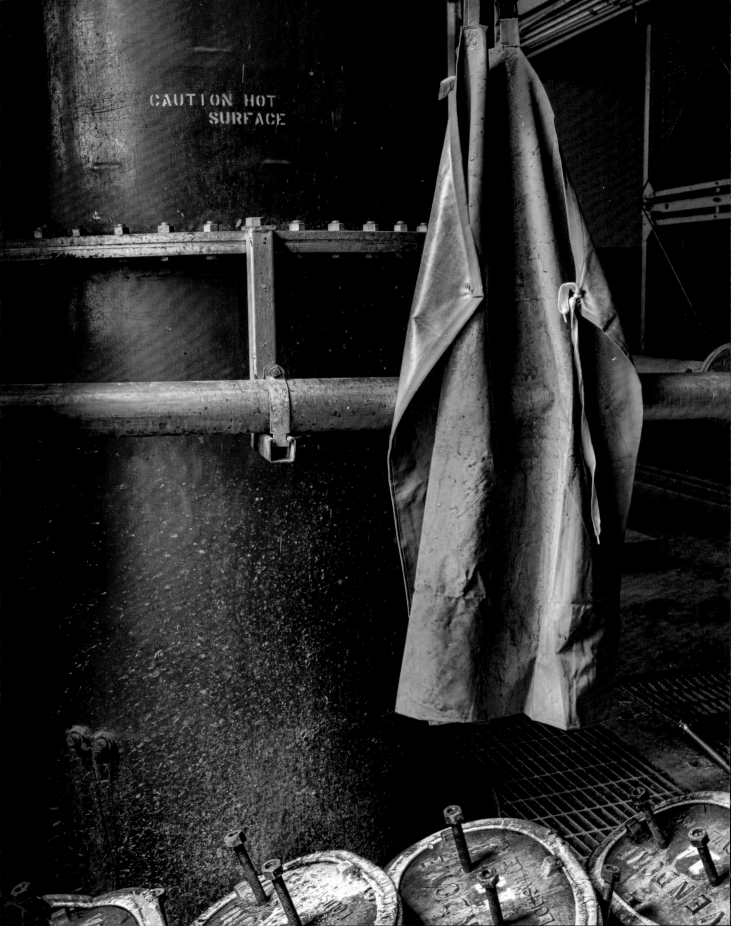

Artist Statement

DISTILLING THE BOURBON INDUSTRY'S HERITAGE

Mills, copper works, cooperages, grains, stills, tail boxes, barrels, warehouses . . . these are a few of the industries and their products that make it possible for bourbon to be bourbon. Bourbon is not just made of liquid. It is made of wood, grains, copper, stainless steel, and human ingenuity and labor. It is made of tradition and cultural and industrial heritages, and it is made of the evolution of those heritages.

I like to approach my photography as a way to both uncover and expose my subject, a sort of visual archaeology. At the same time, I'm motivated by a strong preservationist ideology, so I also photograph with the hope that my images will motivate a desire in the viewer to preserve and cherish my subject. In the case of my last book, *The Birth of Bourbon: A Photographic Tour of Early Distilleries*, I was engaged in uncovering and understanding the industrial archaeology of the bourbon distillery. The process of creating the images in that book allowed me to explore the ebb-and-flow history of bourbon distilling in Kentucky, especially the post-Prohibition distillery operations that flourished until the 1980s, when the bourbon industry crashed. My hope was to generate a desire to preserve Kentucky's industrial heritage in the distillery plant. Happily, my timing was good, and bourbon is making a comeback. In fact, there is a sort of renaissance for artisan and craft bourbon, resulting in a proliferation of craft distilleries throughout Kentucky. Three of the four abandoned distilleries I photographed are in the process of being repurposed and restored into craft distilleries.

In this book my purpose was to go beyond the industrial heritage of the bourbon distillery and into the cultural and industrial heritage of those industries that made the distillery possible. My experiences exploring abandoned distilleries and National Historic Landmark areas of currently operating distilleries had shown me that the industries that supported the distillery had a rich and historic heritage of their own. I wanted to explore and visually expose these industries as I had the

distillery itself. So I chose the iconic industries, those of the grains, the stills, and the barrels—that is to say, mills, copper works, cooperages, and the warehouse.

The agricultural heritage of distilling as found in grain production, milling, and storage goes back before this country was even founded and continued as an integral part of the development of the American frontier. The mill was a staple industry for every community, and as such it was the beginning of distilling as an industry beyond the personal distillery. Millers often ran distilleries as an adjunct business since extra grain was abundant. Today, granaries and mills continue to support the distilling industry in a major way, since without grains there would be no alcohol. I photographed mills that were both currently operating and abandoned to gain an understanding of the cultural history of this industry. Weisenberger Mill, founded in 1865, continues to operate today, run by sixth-generation family millers and using many of the same processes that would have been found in the earliest mill but with machinery that has evolved. Grimes Mill, founded in 1805, operated as both a mill and a distillery, making Old Grimes Whiskey. The original waterwheel still remains under the building, which is used as a hunt club now. Whiskey made at this mill would have been barreled and stored in a warehouse beside the Kentucky River in Boonesborough, awaiting the trip by boat down to ports such as New Orleans. Guyn's Mill had not only a grain mill but a sawmill as well. Operating full tilt in the 1840s, the sawmill would have production methods similar to those used for cutting barrel staves. Following a more contemporary way of doing things but still true to an older way, the Robinson Stave Company runs a stave mill adjacent to its cooperage, with the stave mill machine that started the business in the 1940s still on site. Another historic mill that operated as a distillery in the nineteenth century was the Bush Mill, also near Boonesborough. Although the mill is primarily in stone ruins at this point, it once was three stories high with a massive waterwheel. So many of the early distilleries and mills are now in ruins, but since these are in fairly good shape, I included the images. I was lucky enough to be able to photograph a lost and abandoned grain mill in Madison County, Kentucky, that dated back to the 1870s with equipment left intact from the 1930s. The equipment and wheels from this steam-powered mill show how a mill that would have been operating just past Prohibition would have looked. In contrast, I also photographed the modern granary at Peterson Farms, the primary supplier of corn for Maker's Mark Distillery in Loretto. Run by a local farmer with up-to-date farm operations, this industry has also been in the family for generations.

The industries that contribute the most iconic symbols of distilling, the still and the barrel, are also rich in practices that have been passed on for generations in communities

throughout Kentucky and neighboring states. I began by visiting the largest copper works in Kentucky, Vendome Copper and Brass Works. Vendome is one of the oldest copper works still operating and is completely family-run. On the porch outside the historic home that serves as the office sits a pre-Prohibition still made by Vendome and recovered from Mexico, where the still and its distillers had probably fled during Prohibition. At Vendome I not only observed stills and fermenting and mash tubs being made but also photographed the artisans at Vendome creating some of the most amazing tail boxes. The tail box, also known as a spirit box or a try box, is where the alcohol, having left the still, is monitored for proof or its equivalent. Historically the tail box was a square box, but these days it has become the piece of equipment, along with the still, that defines and delineates each distillery, with increasingly elaborate designs as a way for each distillery to stand out.

Because I am interested in the bourbon industry and its supporting industries as part of our cultural heritage, I also looked at small Kentucky-owned copper works that utilize methods close to the historic processes. That took me to two still makers in Western Kentucky: Rocky Point Stills and Hillbilly Stills. Rocky Point meets the growing demand for artisan stills by making them in much the same way that stills were made a hundred years ago. Metal is bent by hand and soldered, and each part is hand-created. Hillbilly Stills is an example of a small contemporary copper works; one could say it is small-batch intensive. Additionally, while I was researching still makers in Kentucky, I found two distilleries that made their own stills. The still at Casey Jones Distillery was made based on the designs of A. J. Jones's grandfather Casey Jones, who had been the most prolific still maker in Land Between the Lakes' notorious Golden Pond moonshine country during Prohibition. The other distiller, Wade Daniels of Wade-Lyn Ranch Distilling, remembers helping his father, aunt, and grandparents with distilling. He also made his own still, as is his family's tradition.

After exploring the heritage of making stills, mash, and fermenting tanks, I toured all of the craft distilleries operating today in Kentucky and photographed their stills—and in some cases, tail boxes. The craft bourbon industry is booming at this moment, so by the time you read this, a whole new group of craft distilleries will have joined those shown here. The variety is impressive but is still based on time-honored methods and processes that make distilling both new and ancient at the same time.

The aspects of the barrel-related industries that expose the heritage of barrel making are multifaceted. Barrel making begins in the woods, with logging, and continues

on to the wood mill and stave mill before it ever gets to the cooperage that puts those staves together. Although the logging industry is itself historic and certainly a cornerstone for the advancement of all industries, I chose to stick closer to the stave and cooperage industries. Independent Stave Co. has operations in two places, with the cooperage, Kentucky Cooperage, in Lebanon, Kentucky, and the stave mill outside of Morehead. Kentucky Cooperage, the largest cooperage in the state, was designed by its engineer owners and is cautious about showing proprietary machinery and production processes, so I photographed only selected areas of the cooperage. Nonetheless, the basic process for making and charring barrels is unchanged, if updated. The other cooperage I photographed, Robinson Stave Company and East Bernstadt Cooperage, operates in much the same fashion as the earliest cooperages, milling and assembling on the same site. I was able to photograph in depth both parts of the barrel-making process there, along with the historic stave mill engine that started the business back in the 1940s. In this cooperage, each barrel is touched by human hands over and over in a process that looks much the same as it would have decades ago.

After barrels are put together they are transported, by truck these days, to the distillery to be filled. I photographed the cistern room at Barton 1792 Distillery, where the barrels are filled, to exemplify this part of the process. After aging, the barrel will return to the distillery to be dumped and bottled. I photographed the dumping process at Buffalo Trace Distillery for this. But it is the time in between, the time the barrel spends in the warehouse, that is the difference between whiskey and bourbon. The warehouse is the central place for the all-important aging process. Aging is a science and an art, and the perfecting of the warehouse consumes most distilleries. Airflow temperature and location are variables that influence the taste and maturation of bourbon. Experiments in barrel aging have increased over the decades. Various ways of stacking the barrels and different warehouse materials such as stone, concrete, or tile block have been tried. In addition to standard warehouse ricks, or wooden rows of barrels, I show one of the newer approaches to aging, the use of stack pallets in open warehouses. I also show craft distillers' answer to aging in small spaces next to the larger distilleries' warehouse interiors. I photographed many warehouse exteriors and offer a sample of the variety, including a shot of what once was considered to be the longest rick barrelhouse in the world. It is the wooden rick warehouse that is most historic, an emblem of the industry. One of the few rick warehouse builders still around is in Kentucky, Buzick Construction. This industry is unique. Warehouse construction has been in the Buzick family since 1937, just at the end of Prohibition. I was lucky enough to

photograph them at the end phase of a brick warehouse build, while the wood could still be seen before the metal skin was put on. Methods for building the rick warehouse have changed little, although Buzick has developed methods to increase safety and efficiency. As a comparison, I include a photograph of the Dowling Distillery warehouse being torn down; this warehouse was built just after Prohibition. The differences are imperceptible.

These industries are just a small fraction of the many industries and suppliers that go into making the bourbon that ends up in the bottles and glasses of bourbon lovers. I hope you will enjoy my photographic tour behind the scenes of these industries and my distillation of the heritages into something we can drink to. Cheers!

Straight
BOURBON

COPPER

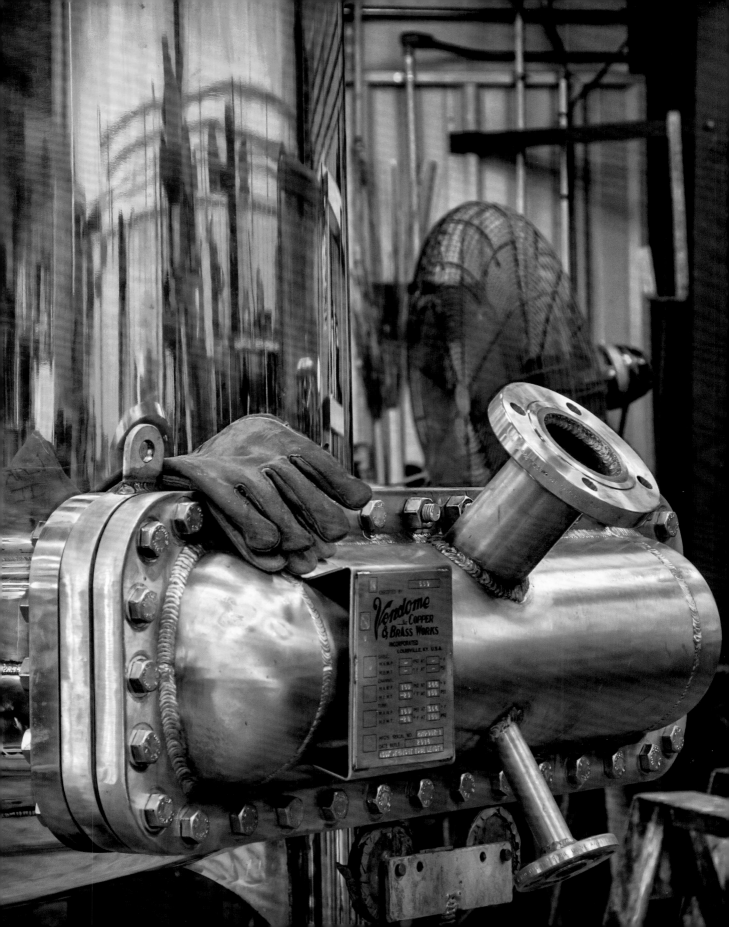

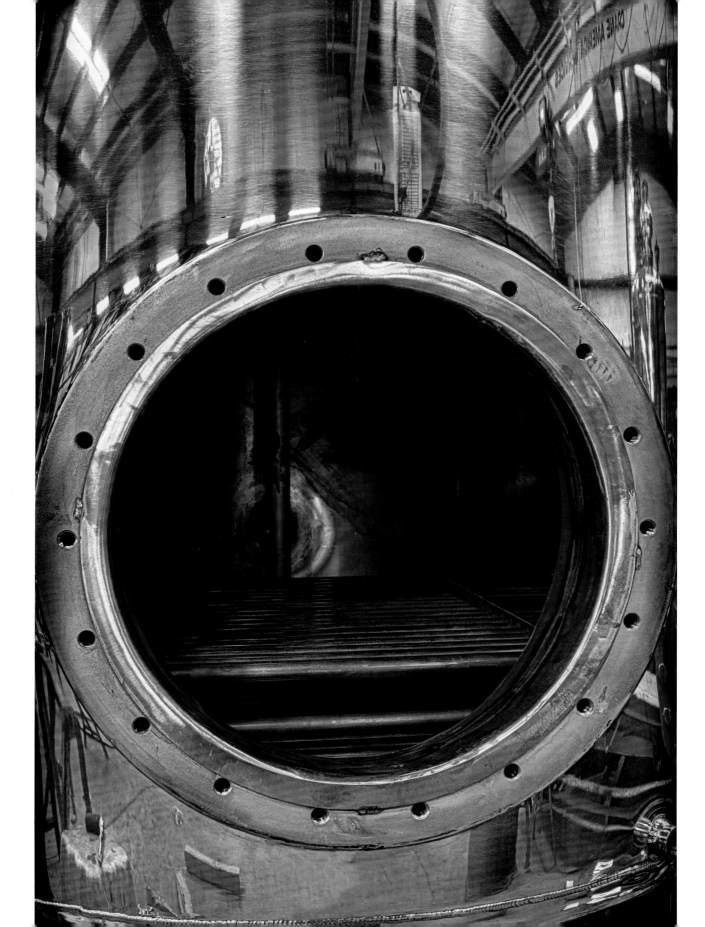

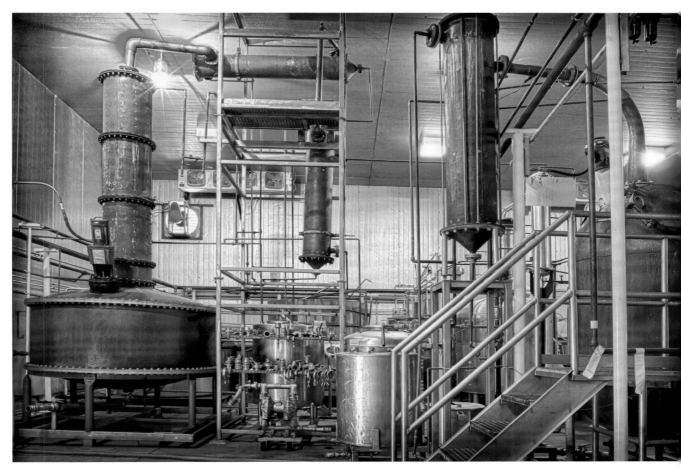

STILL HOUSE

Kentucky Artisan Distillery, Crestwood, KY. This distillery boasts four stills, including two historic stills: the 375-gallon copper pot still seen in the right foreground and the 1,175-gallon copper pot still with column, both of which produce artisan bourbons.

FACING

STILL OPENING

Vendome Copper and Brass Works, Louisville, KY. A look inside the opening of a newly built column still shows lining for the distilling process.

PREVIOUS

COPPER COLUMN AND GLOVES

Vendome Copper and Brass Works, Louisville, KY. Regardless of how many machines are used to bend and drill the copper, any still is finally created by hand through welding, shining, stacking, grinding, and bolting.

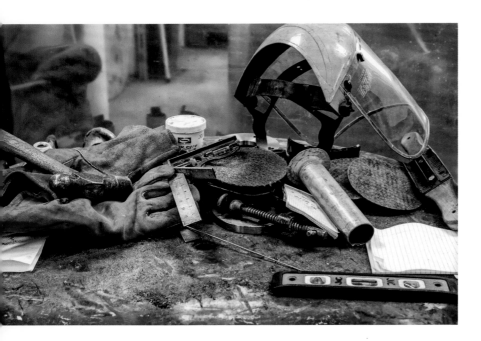

Welder's accessories

Vendome Copper and Brass Works, Louisville, KY. A welder's mask, gloves, and various measuring tools can be found in any copper worker's workstation, regardless of the size of the factory.

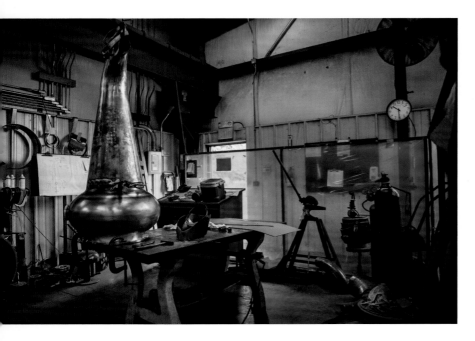

Pot still top studio

Vendome Copper and Brass Works, Louisville, KY. The tools and blueprint design for making this pot still line the workstation for the project.

FACING

Pot still and workhorse

Vendome Copper and Brass Works, Louisville, KY. The pot still operates on a batch-by-batch basis and is usually completely made of copper.

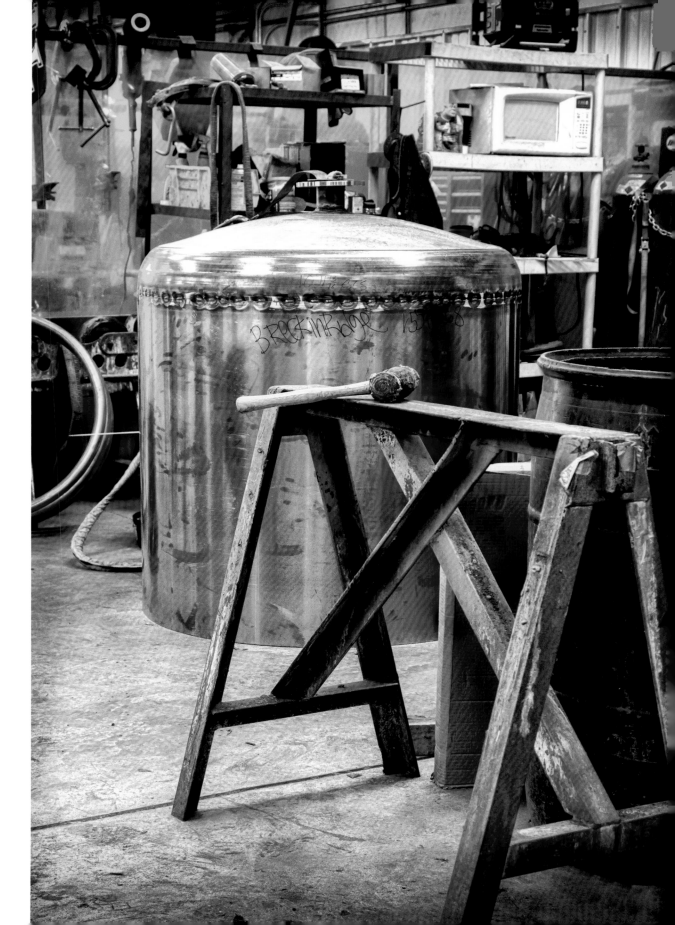

Miniature Made by Casey Jones

Casey Jones Distillery, Hopkinsville, KY. After Casey Jones got out of prison for making and selling moonshine stills, he made miniatures of his still designs. At one point he was told by the government to stop because it was ascertained that they actually worked! Later, when it was legal, he made them again.

FACING

Pot Stills with Copper Tail

Town Branch Distillery, Lexington, KY. With distilleries in several countries, including Ireland, the pot stills used in the Lexington distillery were made in Scotland.

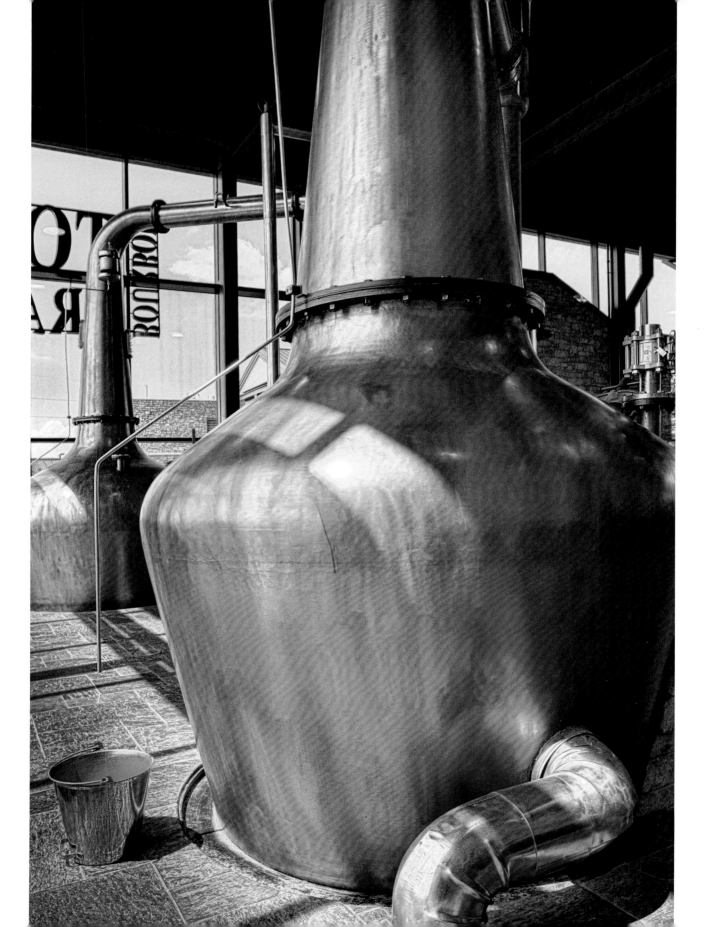

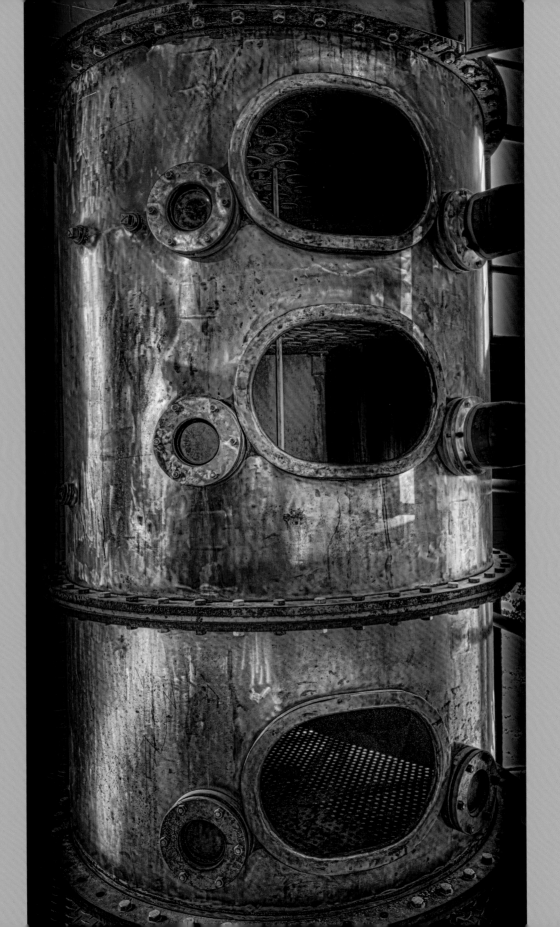

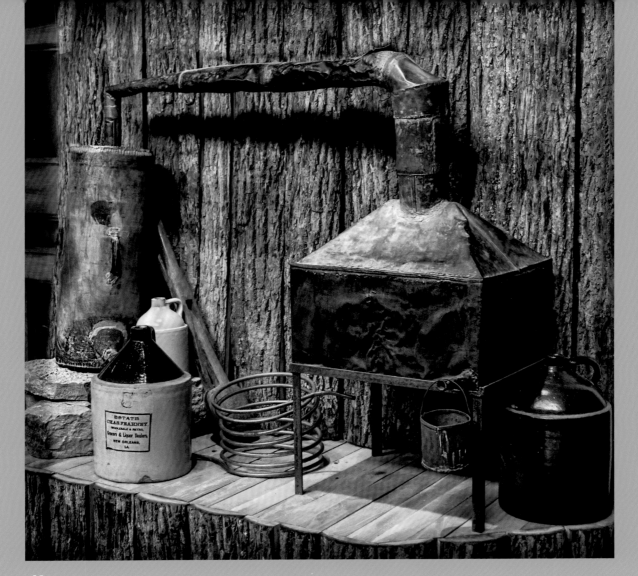

Old moonshine still

Bulleit Distillery, Louisville, KY. On display at Bulleit Distillery is a historic still setup, complete with still, cooling coils, condenser, and jug.

FACING

Historic column still

Four Roses Distillery, Lawrenceburg, KY. This early example of a column still sits in the same room as the newer pot still and adjacent to a modern column still several stories high.

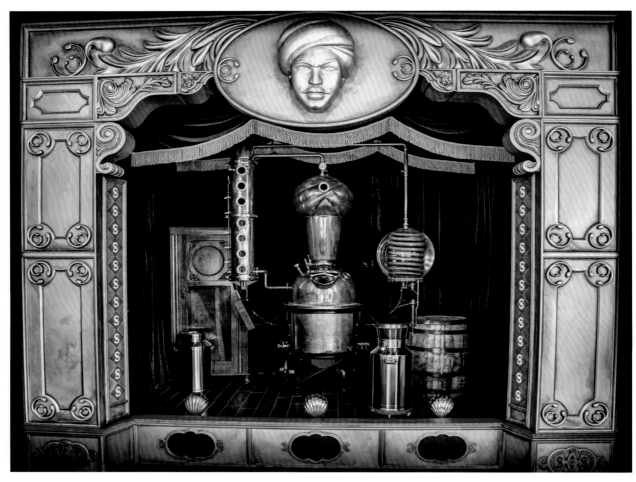

Distillation Stage

Second Sight Spirits, Ludlow, KY. The still room of this distillery allows a complete and compact view of the distilling process, from pot still to column still, through the crystal ball condenser (where the cooling coils are clearly visible), down into the parrot, and out into large stainless collection jug, with a barrel waiting in the background.

FACING

Copper Columns

Hillbilly Stills, Barlow, KY. These columns will be used as distillation columns or still heads. In the background is a completed rectifying column piece.

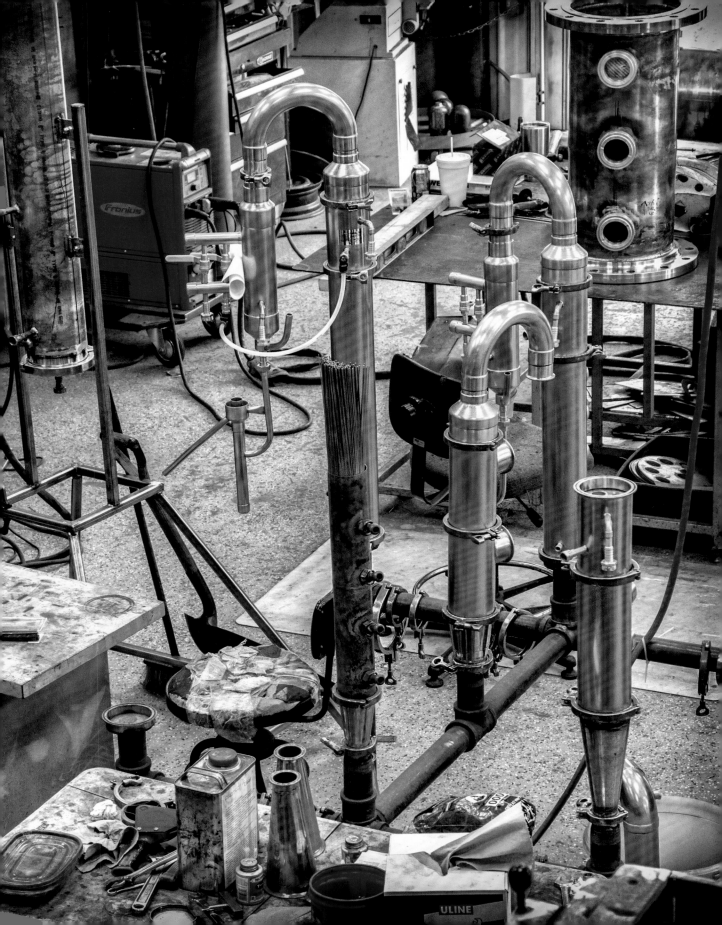

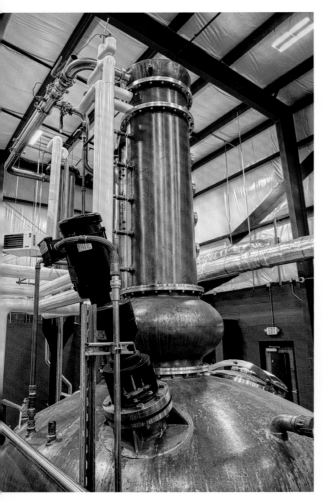

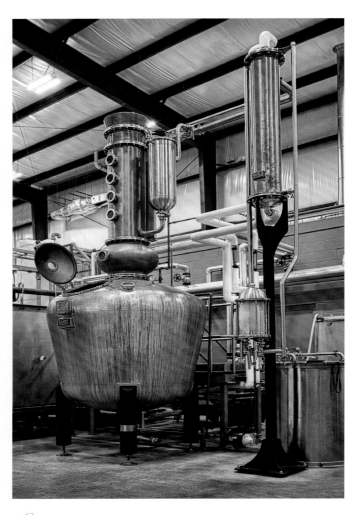

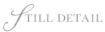 STILL DETAIL

Boone County Distilling Co., Boone County, KY. Modern technology is added to old-fashioned distilling practices in today's craft distilleries.

HYBRID STILL

Boone County Distilling Co., Boone County, KY. This pot and column combination is accompanied by a copper condenser and a stainless steel and glass tail box.

FACING

STILL AND CONDENSER

Bluegrass Distillers, Lexington, KY. This view of the Portuguese-made pot still includes the condenser, which sits on a barrel.

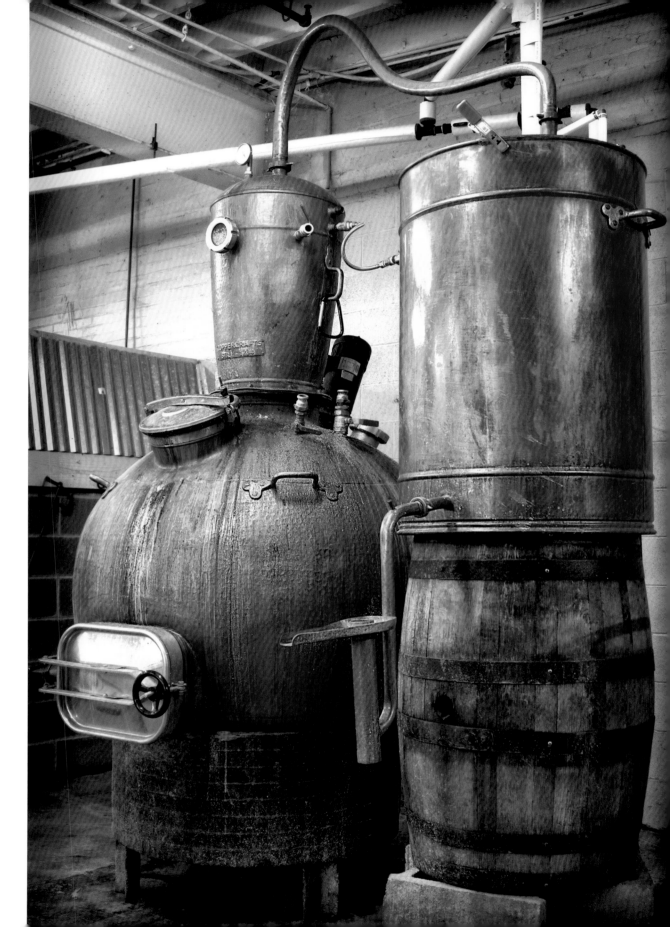

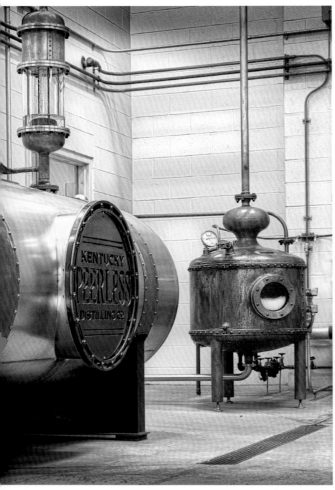

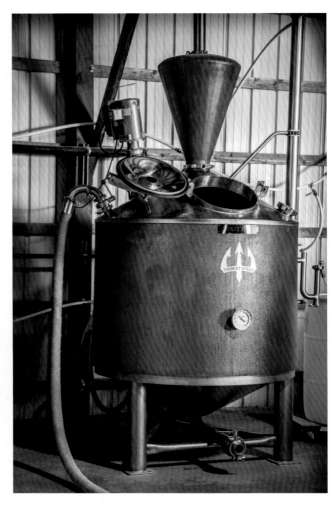

SMALL POT STILL

Kentucky Peerless Distilling, Louisville, KY. The distilling set-up at Peerless includes a tall column still, this small pot still, and a tank with two tail boxes on top.

POT STILL

MB Roland Distillery, Pembroke, KY. One of a pair of pot stills used at the distillery, this one is in the process of adding mash.

FACING

STILL NO. 2

Kentucky Artisan Distilling, Crestwood, KY. This is a 1,175-gallon copper pot still built in 1947 by the Liberty Copper Works, refurbished to a capability of producing two barrels of bourbon in one run. It is equipped with a copper bubbled tray column, a reflux condenser, and steam coils. his one is in the process of adding mash.

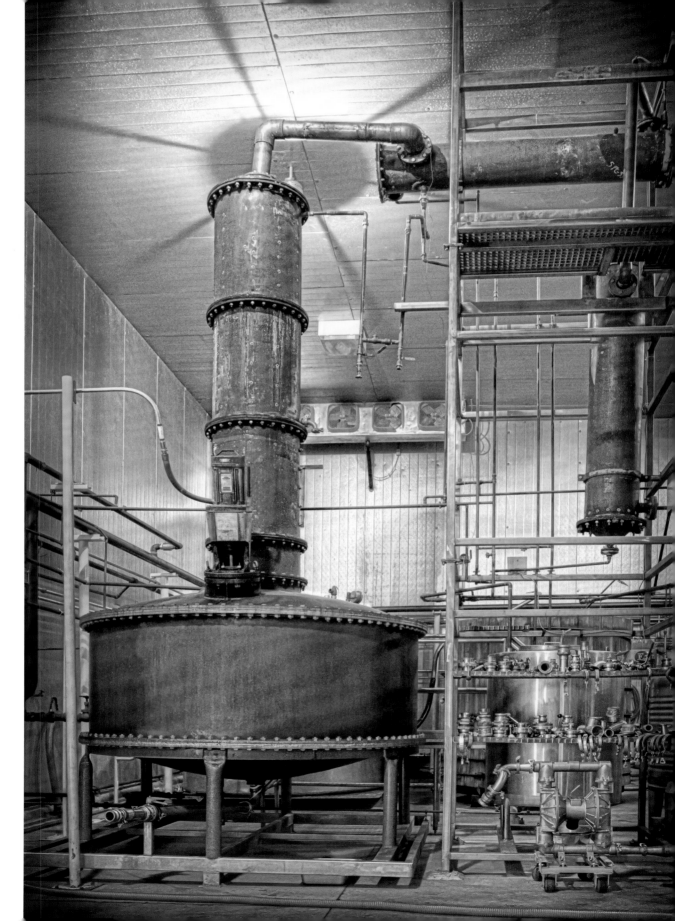

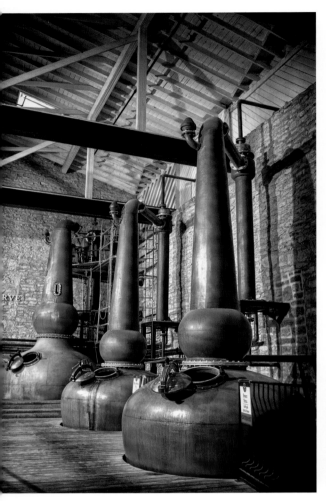

THREE POT STILLS

Woodford Reserve Distillery, Versailles, KY.
This distillery has an Irish-style distilling set-up, using three pot stills for triple-distilled bourbon that is later combined with column-distilled bourbon before entering the barrels.

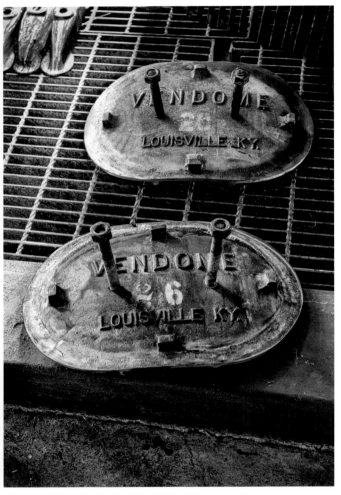

CAP NO. 26

Barton 1792 Distillery, Bardstown, KY. Cap No. 26 indicates that there are at least twenty-six openings, and therefore cooling plates, in the Barton column still. These two caps will be refastened after being cleaned.

FACING

POT STILL

Woodford Reserve Distillery, Versailles, KY. This view allows a close-up of one of three identical pot stills used for triple distillation.

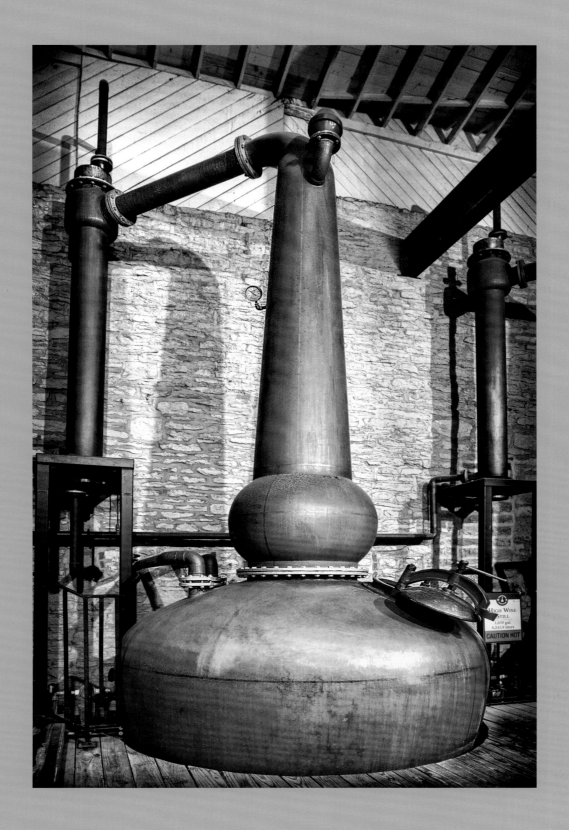

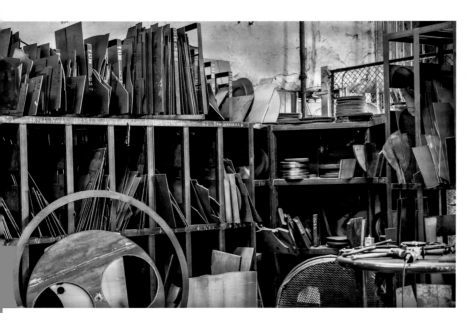

Copper Pieces

Vendome Copper and Brass Works, Louisville, KY. Throughout any copper works studio are sheets of copper and other metals that pieces have been cut from. They are saved for possible use later so that very little is wasted.

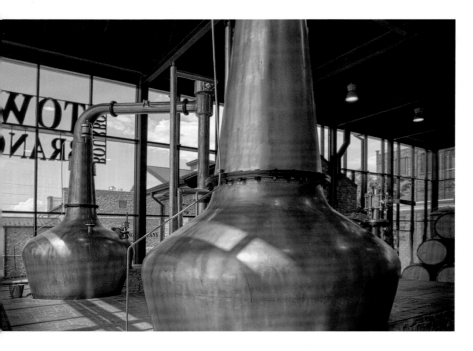

Pot Stills and Barrels

Town Branch Distillery, Lexington, KY. The pot stills at Town Branch are considered the distillery's trademark.

FACING

Pot Still Head

Bluegrass Distillers, Lexington, KY. Made in Portugal, the hand-hammered copper pot still has a unique head design.

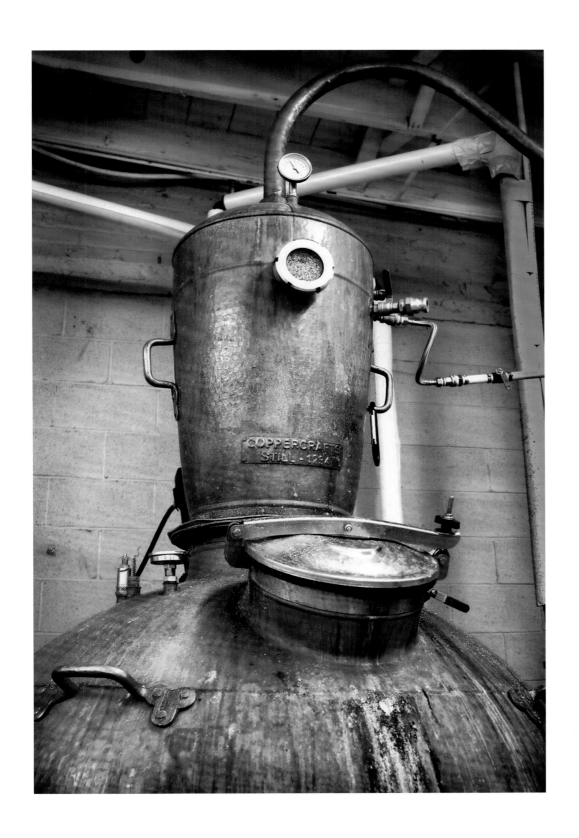

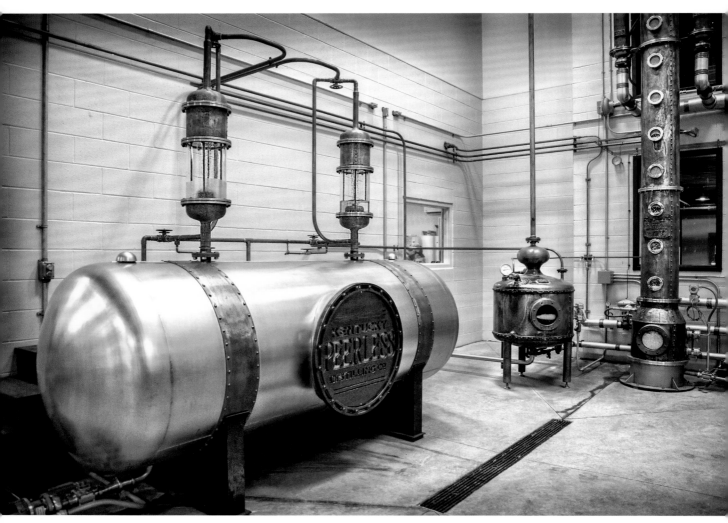

STILL ROOM

Kentucky Peerless Distilling, Louisville, KY. All three distilling elements are visible in this image: the tall column still, the small pot still, and the tank with tail boxes.

FACING

STILL NO. 2

Kentucky Artisan Distillery, Crestwood, KY. Still No. 2 is a historic still, built in 1947 by Liberty Copper Works, and has been refurbished to run today. The 375-gallon copper pot still features an external steam jacket for heating and a gooseneck that leads to a copper condenser.

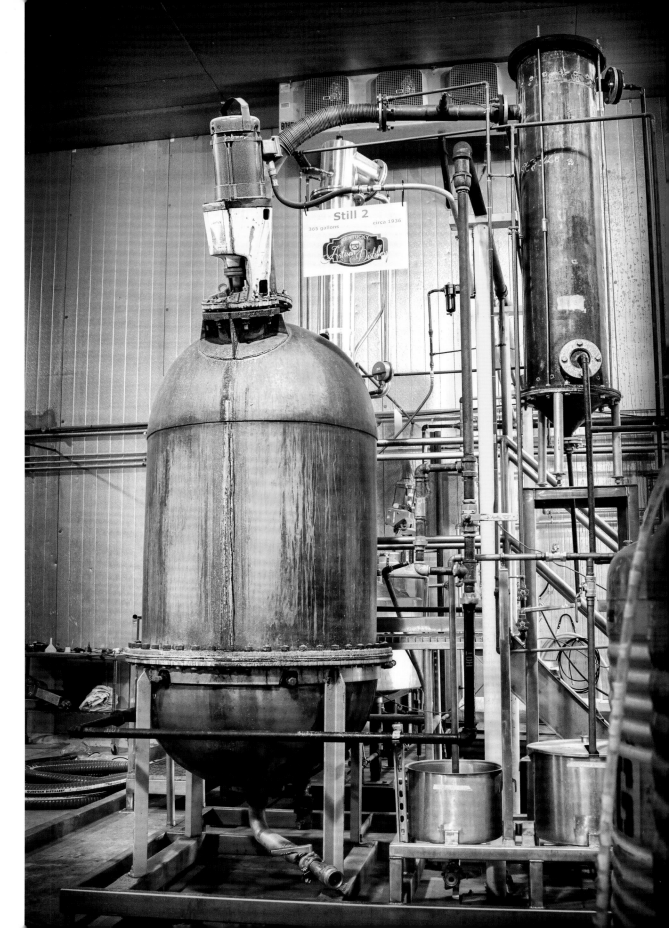

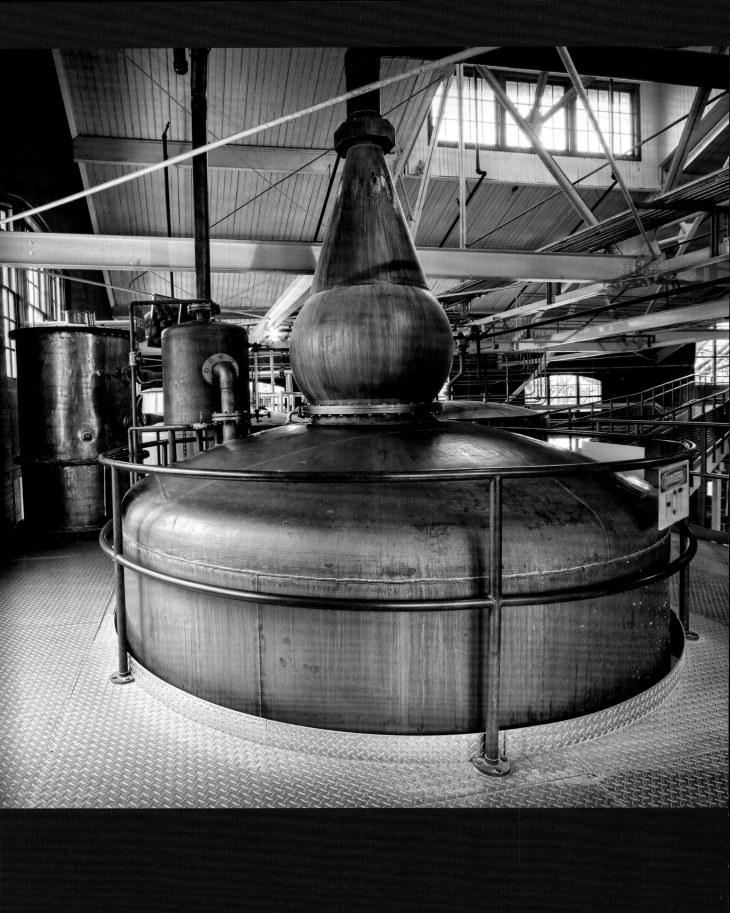

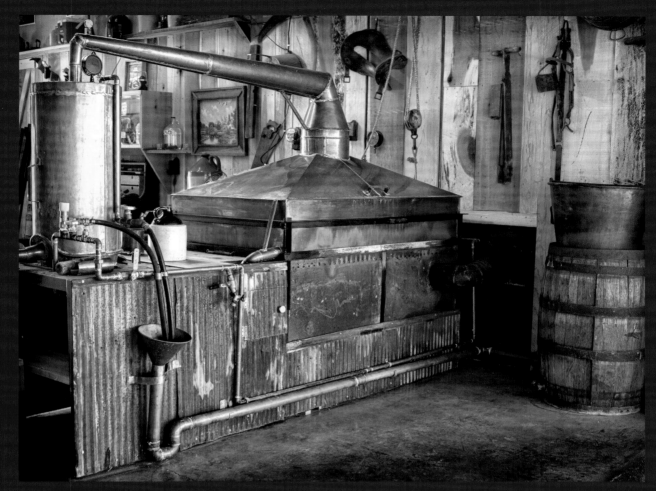

BACK SIDE OF STILL

Casey Jones Distillery, Hopkinsville, KY. On the back side of this homemade
still, the condenser and other copper elements are clearly visible

FACING

POT STILL

Four Roses Distillery, Lawrenceburg, KY. This large pot still can be
found in the still room, along with a tall, thick column still.

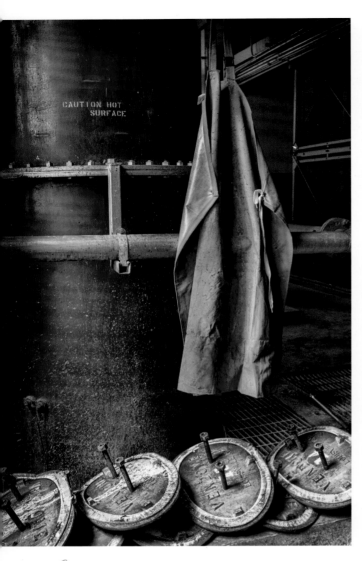

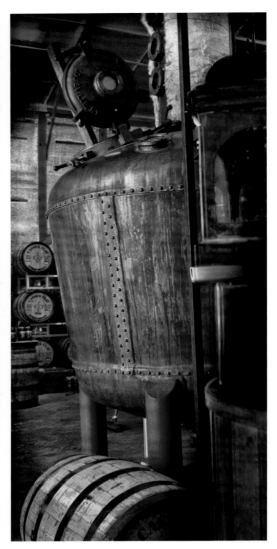

*A*PRON AND STILL CAPS

Barton 1792 Distillery, Bardstown, KY. I photographed the still room during the summer months, when the stills were inactive and in the process of being cleaned. During a worker's break, his apron and the still caps waited for his return.

*S*TILL DETAIL

Three Boys Farm Distillery, Graefenburg, KY. This view of the bottom or pot still section of the hybrid still also affords a look at the opening for pouring in the fermented liquid.

FACING

*S*TILL DETAIL

Town Branch Distillery, Lexington, KY. This up-close view shows the Scotland mark of the still makers.

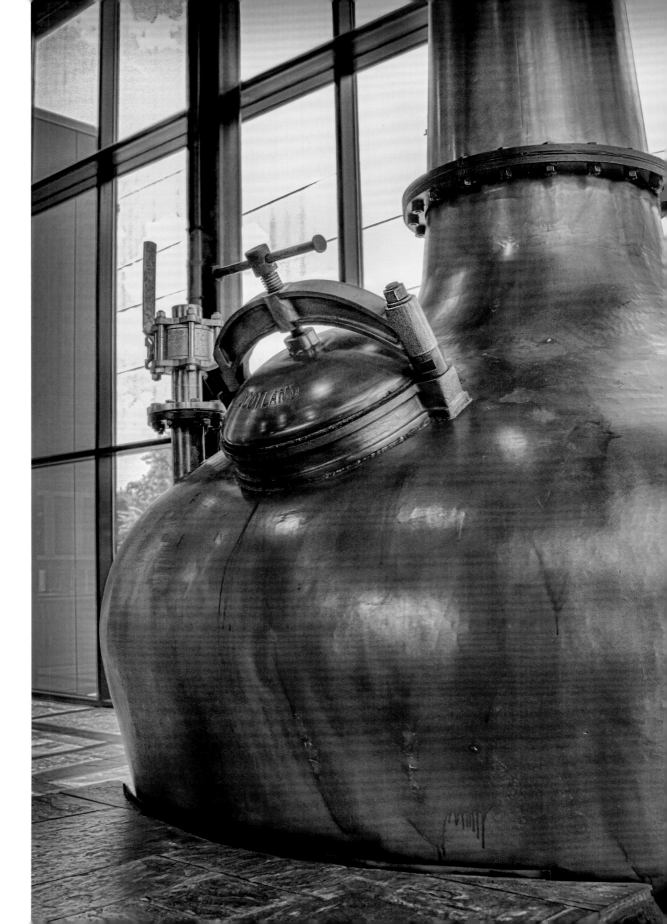

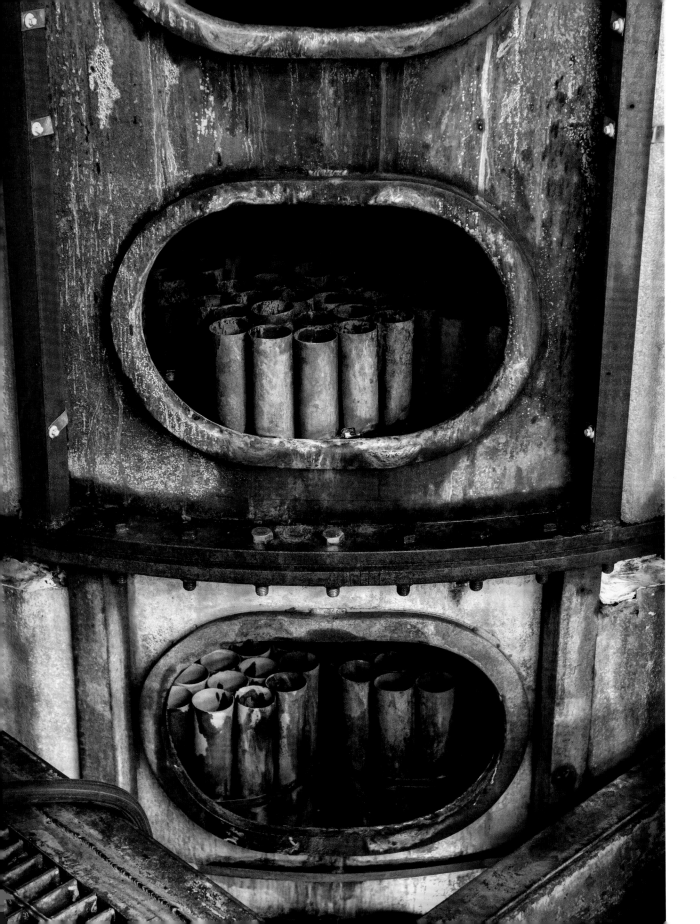

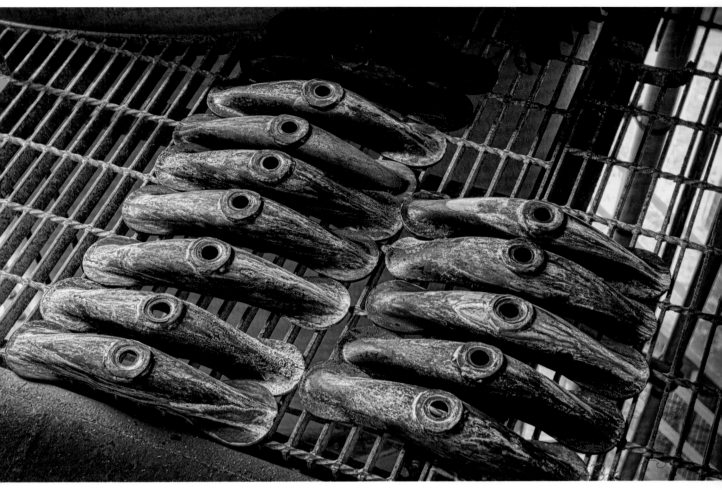

Colorful Still Cap Fasteners

Barton 1792 Distillery, Bardstown, KY. As a result of the heat and the various elements in the distilling process, these fasteners have begun to take on hues and colors.

FACING

Column Still Interior

Barton 1792 Distillery, Bardstown, KY. With the caps removed from the column still, one is afforded a view of the interior tubes that allow the vapors and steam to travel up and down in the column, creating continuous distilling.

FOLLOWING

Still Cap Fasteners

Barton 1792 Distillery, Bardstown, KY. Not only do the inside of the stills need cleaning, but all of the parts are washed and treated as well. These fasteners lock the still caps over the openings in the column still.

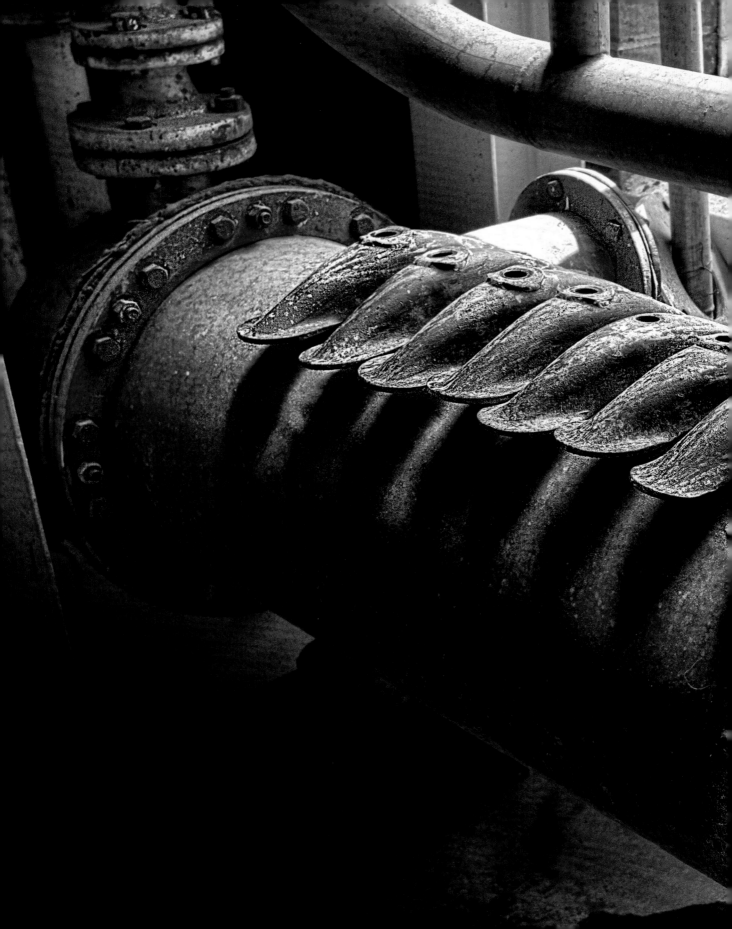

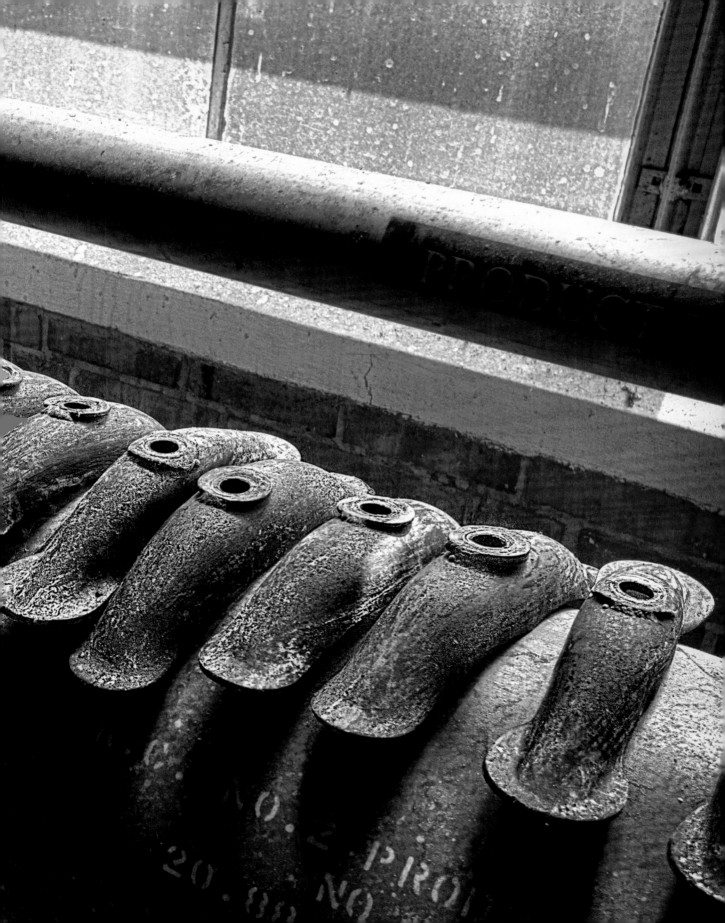

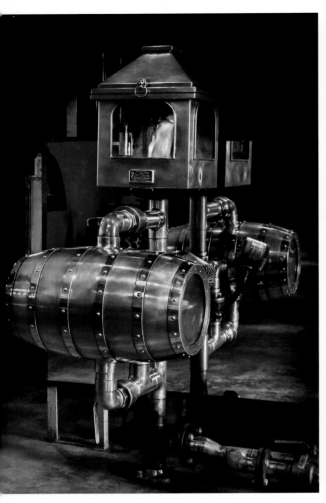

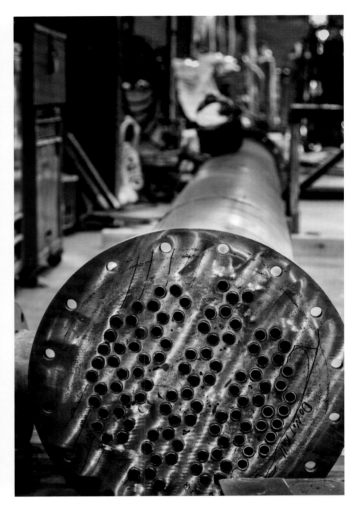

DOUBLE-BARRELED TAIL BOX

Barton 1792 Distillery, Bardstown, KY. This beautiful spirit safe is located on one of the upper levels of the still house, next to the control room where distillers can adjust cuts.

STEEL COLUMN WITH TRAY

Vendome Copper and Brass Works, Louisville, KY. This column exposes one of the trays typical in the still column.

FACING

TWO SPIRIT SAFES

Buffalo Trace Distillery, Frankfort, KY. First introduced in 1823 in Scotland following the excise tax, the spirit safe is also known as a try box or a tail box. The spirit safe is the point at which the whiskey exits the still; it contains the copper parrot's beak and the hydrometer that assess proof, or alcohol by volume (ABV).

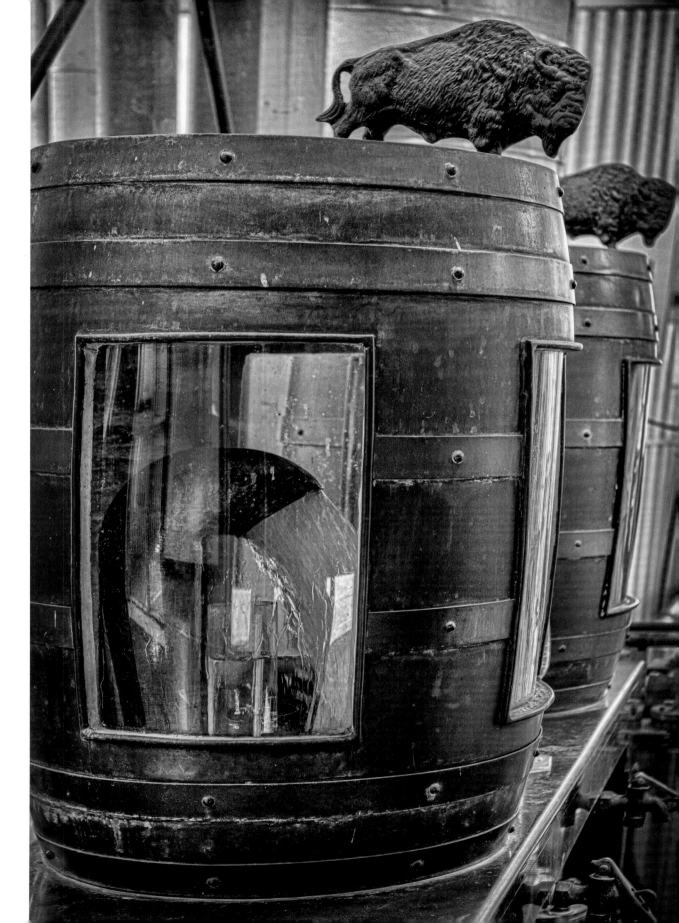

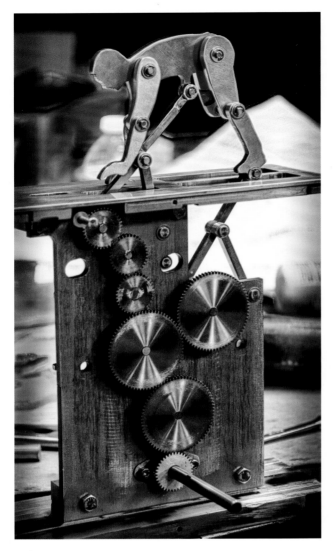

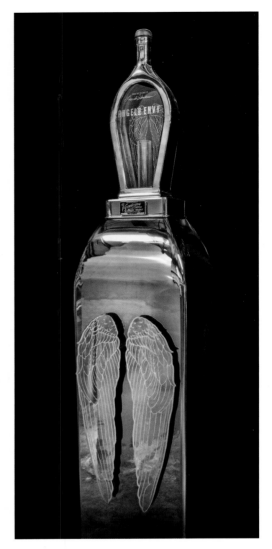

INNER WORKINGS OF KINETIC SAFE

Wilderness Trail Distillery, Danville, KY. This image is of the inner workings of the first kinetic spirit safe, built in 2016 by Vendome Copper and Brass Works. The spirit safe works like a mill, with wheels that are turned by high and low wines, or the various distillations from the stills. This in turn, using gears visible here, moves the character on top, who in the finished version appears to be pushing a barrel.

TAIL BOX

Angel's Envy Distillery, Louisville, KY. This tail box is designed to reflect the shape of the bottle that holds the distillery's finished product.

FACING

PARROT ABSTRACT

Casey Jones Distillery, Hopkinsville, KY. Not all distilleries have tail boxes. Without the safe box, the distiller will rely on the hydrometer, taste, and smell to make adjustments to the spirits.

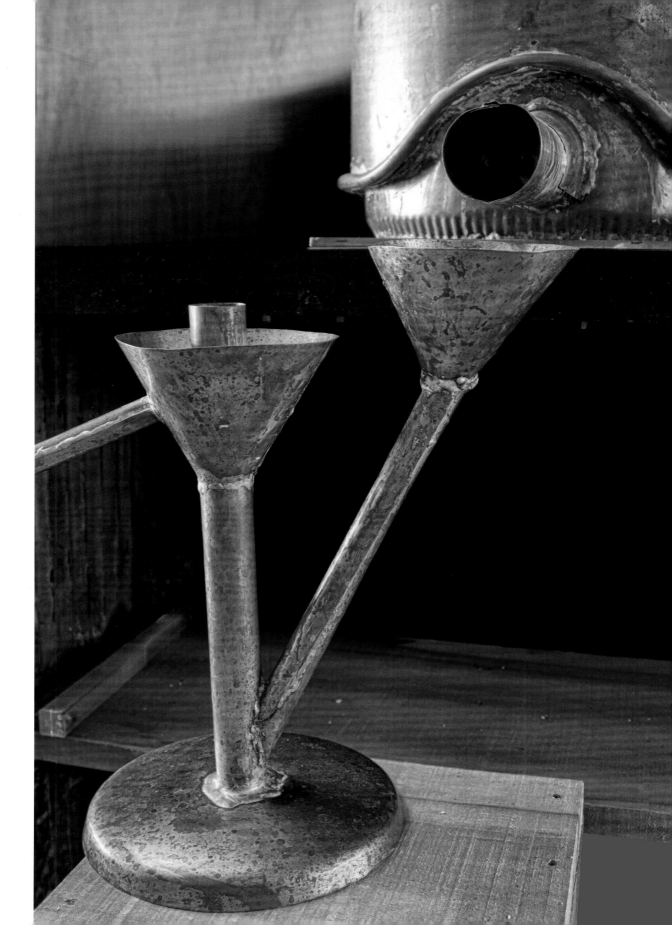

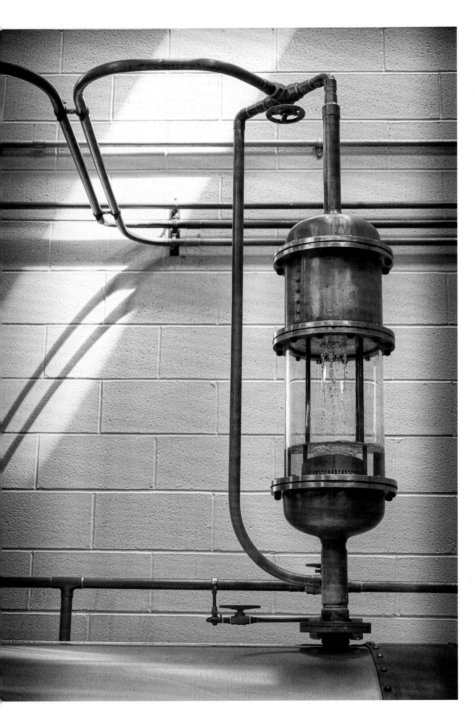

Kentucky Peerless Distilling, Louisville, KY. This craft distillery has two different tail boxes for high and low wine.

FACING

Tail Box

Bardstown Bourbon Company, Bardstown, KY. Not only do the stills operate as the focal point and pride of distilleries; many distilling companies are designing intricate tail boxes to distinguish their distilleries as well.

FOLLOWING

Building Tail Boxes

Vendome Copper and Brass Works, Louisville, KY. Two spirit safes are shown in the welding stage of construction. These two are built in the traditional shape of a box, which can be locked.

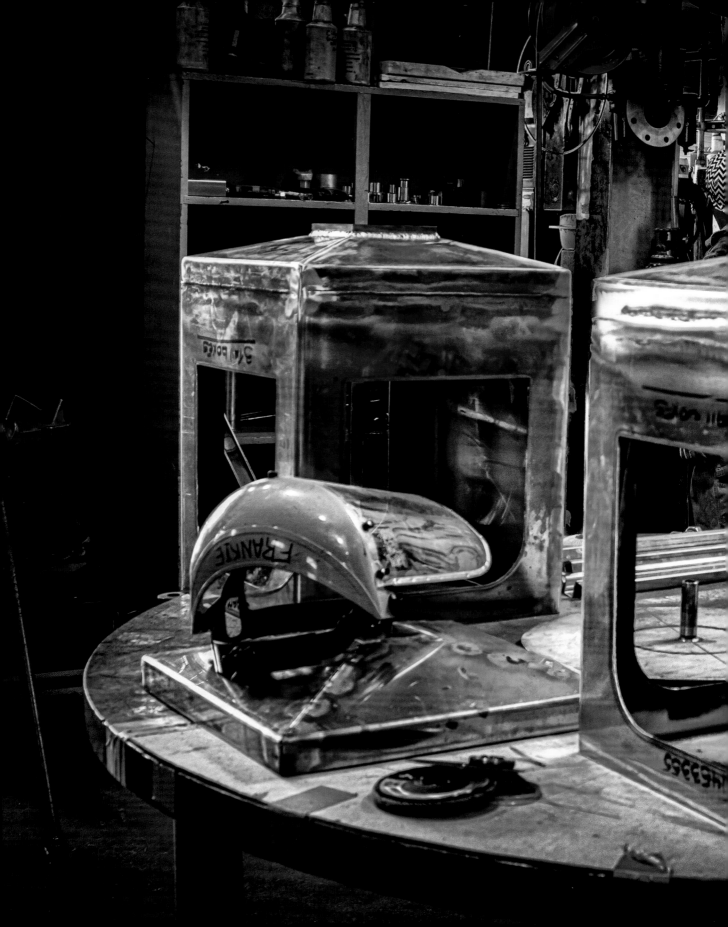

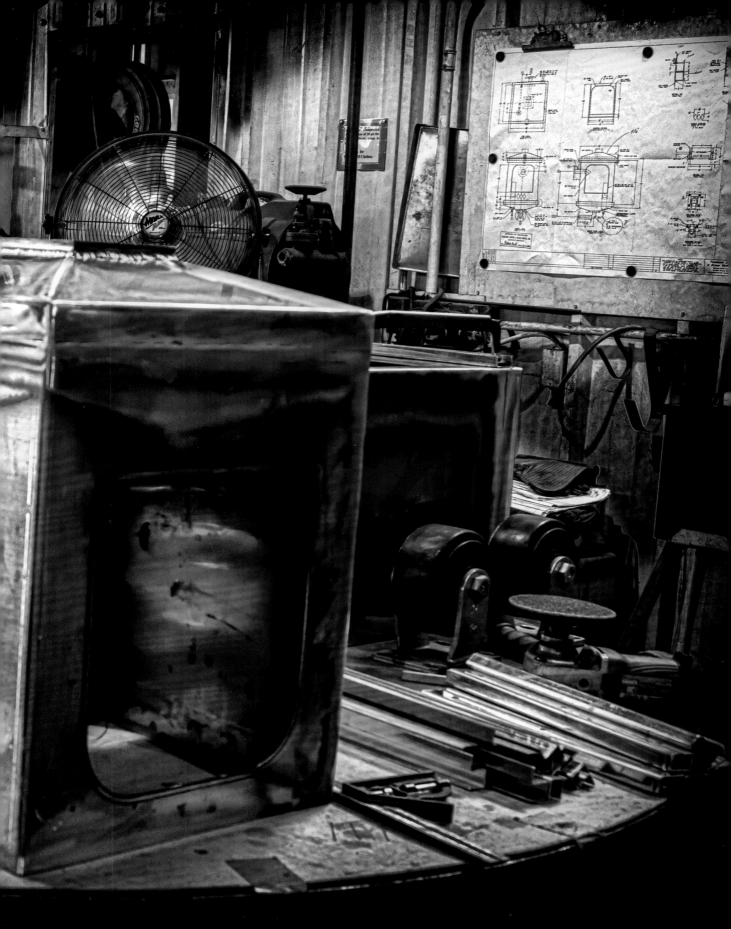

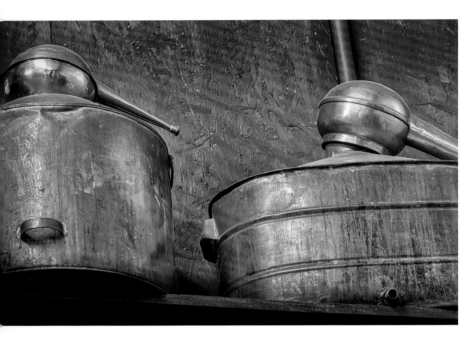

Two Historic Stills

Kentucky Artisan Distillery, Crestwood, KY. These two historic and hand-made stills were used for personal rather than commercial use and show the ingenuity that hometown distillers used to create their stills.

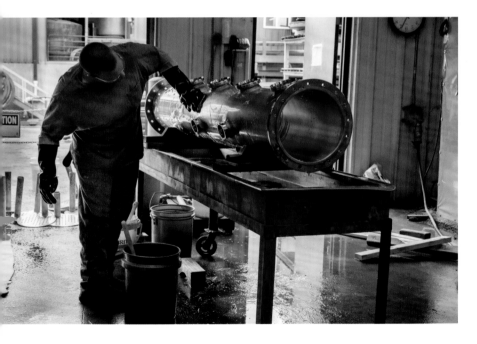

Washing the Column

Vendome Copper and Brass Works, Louisville, KY. After welding and sanding, the copper section is washed and cleaned before the next process.

FACING

Parrot

Second Sight Spirits, Ludlow, KY. The unusual condenser at Second Sight Spirits empties the spirits into a copper parrot, with no tail box, and then collects the whiskey in a container below.

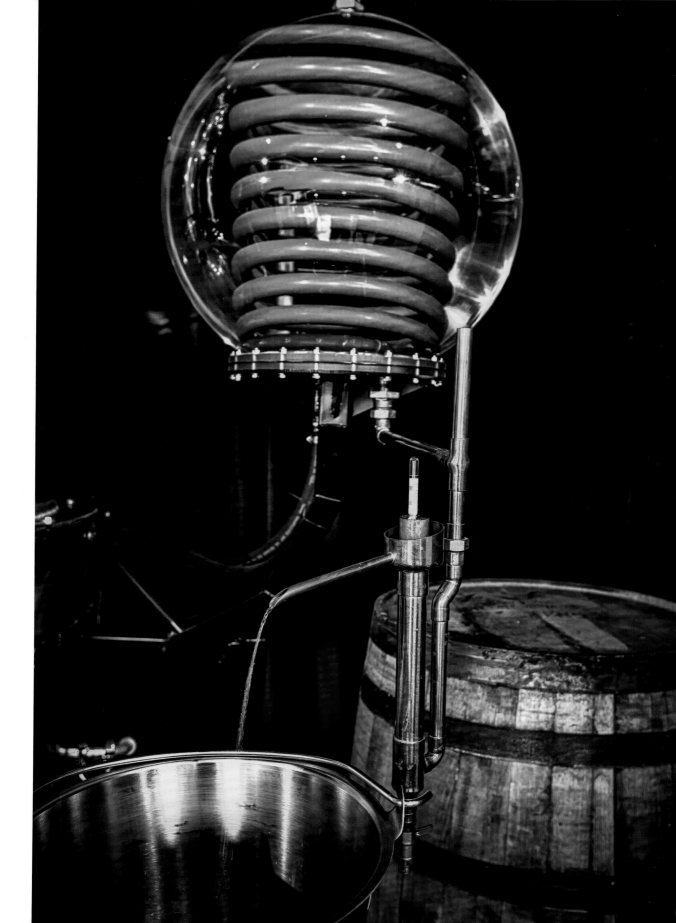

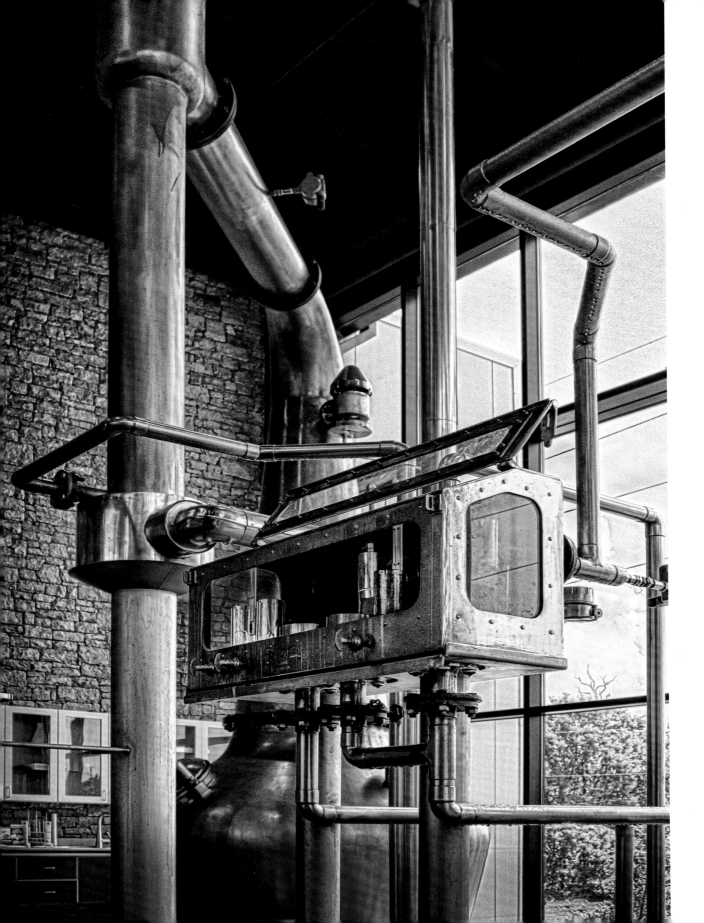

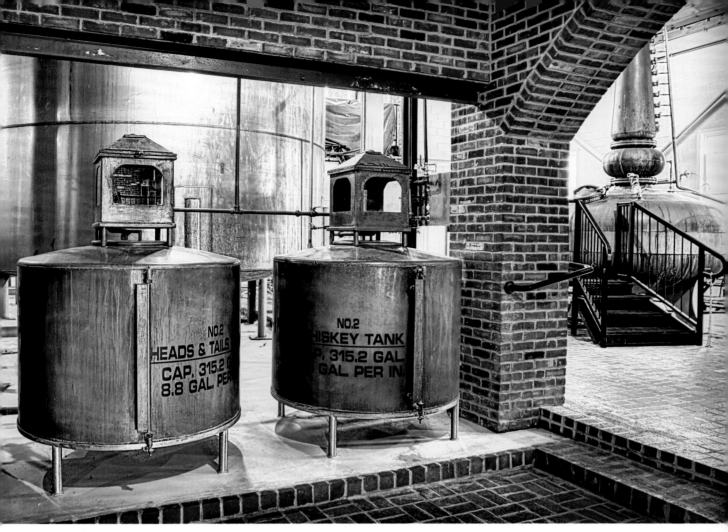

Two Tanks with Spirit Safes

Willett Distillery, Bardstown, KY. These two tanks hold raw whiskey and have a tail box for each.

FACING

Triple-Chambered Tail Box

Town Branch Distillery, Lexington, KY. This tail box resembles one also used at Woodford Reserve Distillery and is historic in design.

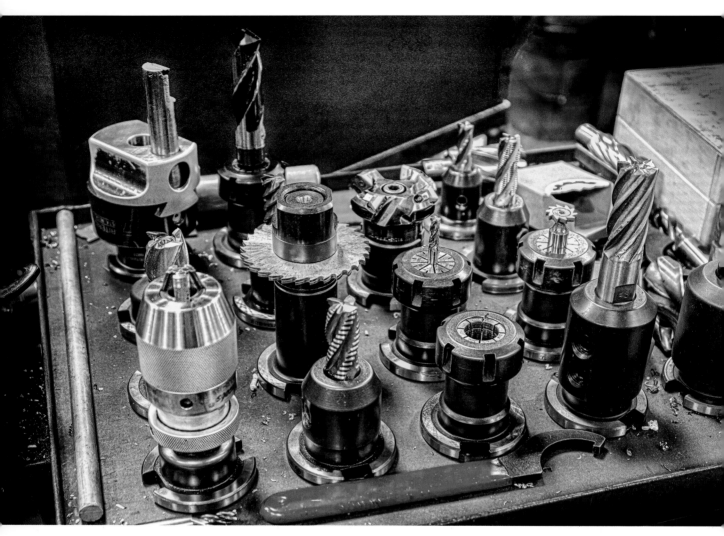

Drilling and Grinding Tools

Vendome Copper and Brass Works, Louisville, KY. Various tool bits are used to make intricate products such as custom tail boxes, also known as spirit safes.

FACING

Contemporary Tail Box and Dials

Vendome Copper and Brass Works, Louisville, KY. This recently completed tail box shows contemporary design, accompanied by dials that allow for precise measurements and thus precise control distilling at this point in the process.

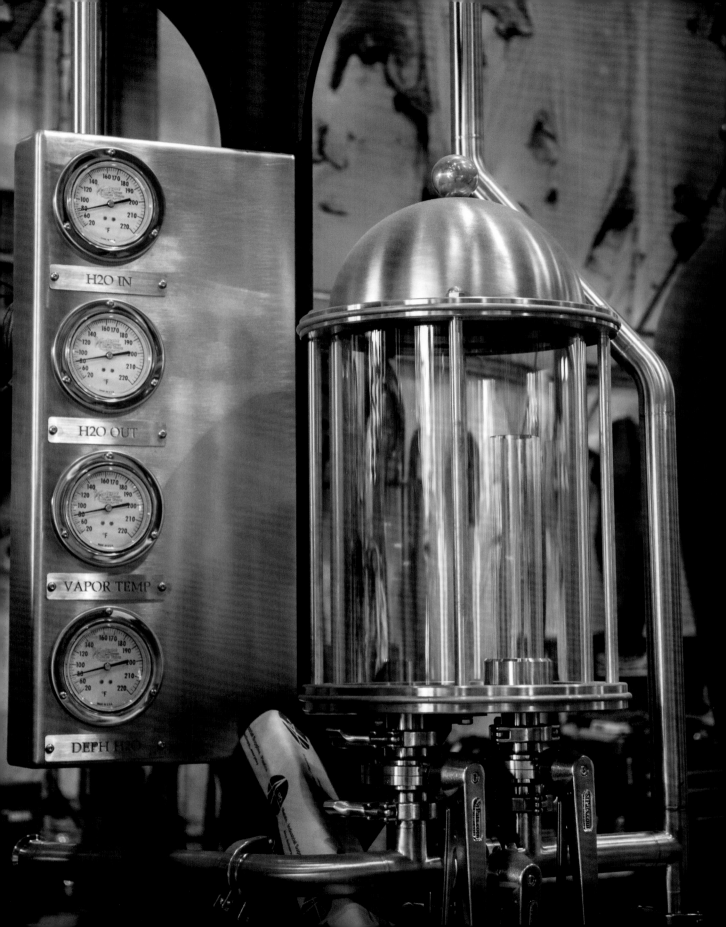

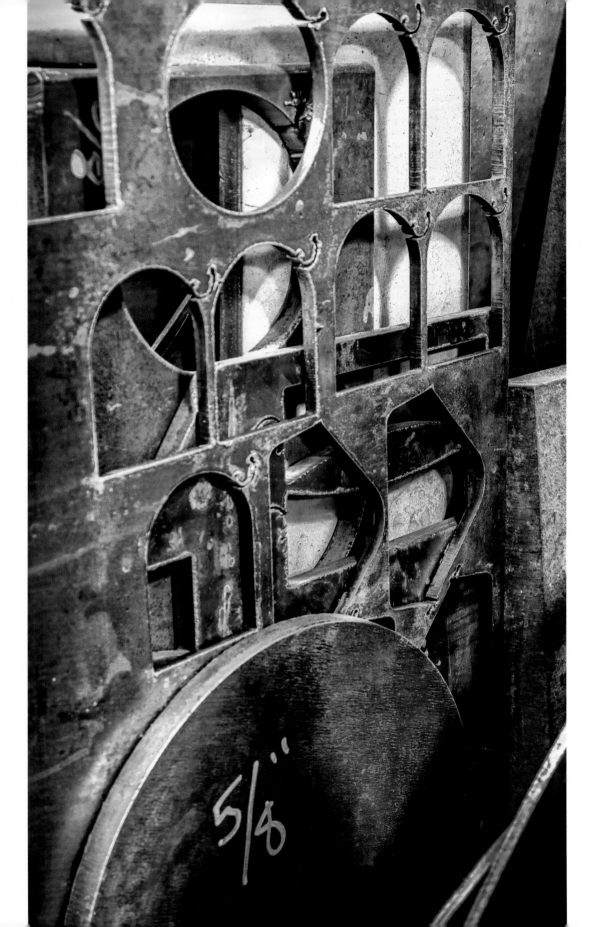

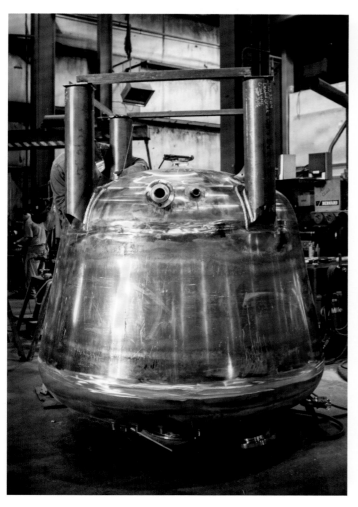

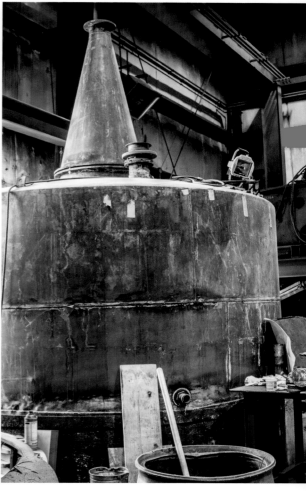

POT STILL BOTTOM

Vendome Copper and Brass Works, Louisville, KY. The legs are being welded onto the bottom of this pot still. Leg height will vary according to how heat is applied to the bottom of the still.

FACING

REMAINDER ABSTRACT

Vendome Copper and Brass Works, Louisville, KY. Often the remainder pieces of copper or steel create interesting abstracts.

STILL IN REPAIR

Vendome Copper and Brass Works, Louisville, KY. In addition to building new products for distilling, most copper works repair older distilling parts as well.

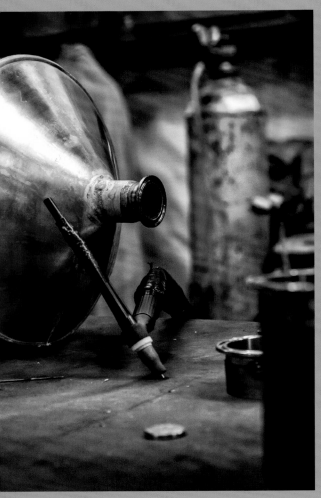

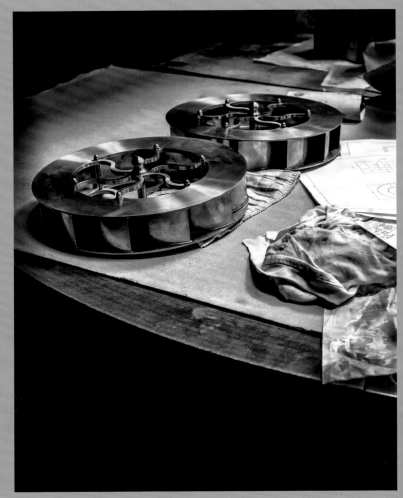

Welder's Tools

Rocky Point Stills, Paducah, KY. This soldering iron is one of the essential tools used by welders who work in the copper still-building industry.

Tail Box Wheels

Vendome Copper and Brass Works, Louisville, KY. These two wheels are part of an intricate tail box designed and produced for a craft distillery in the Bluegrass of Kentucky.

FACING

Copper Column and Still

Vendome Copper and Brass Works, Louisville, KY. Of the two types of stills, the column still allows for continuous operation. This completed column still combination is ready for shipping.

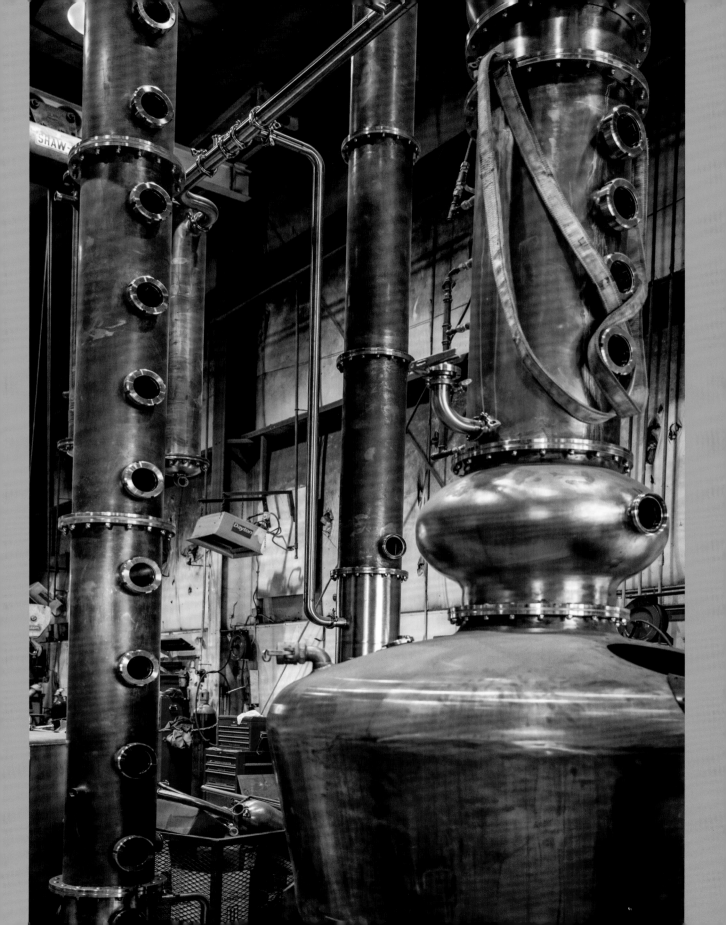

Three Yellow Handles

Vendome Copper and Brass Works, Louisville, KY. The handles on this older machine show the wear of the years.

FACING

Brass Shavings and Drill

Vendome Copper and Brass Works, Louisville, KY. The brass shavings left after this drill has done its work seem to shimmer like gold.

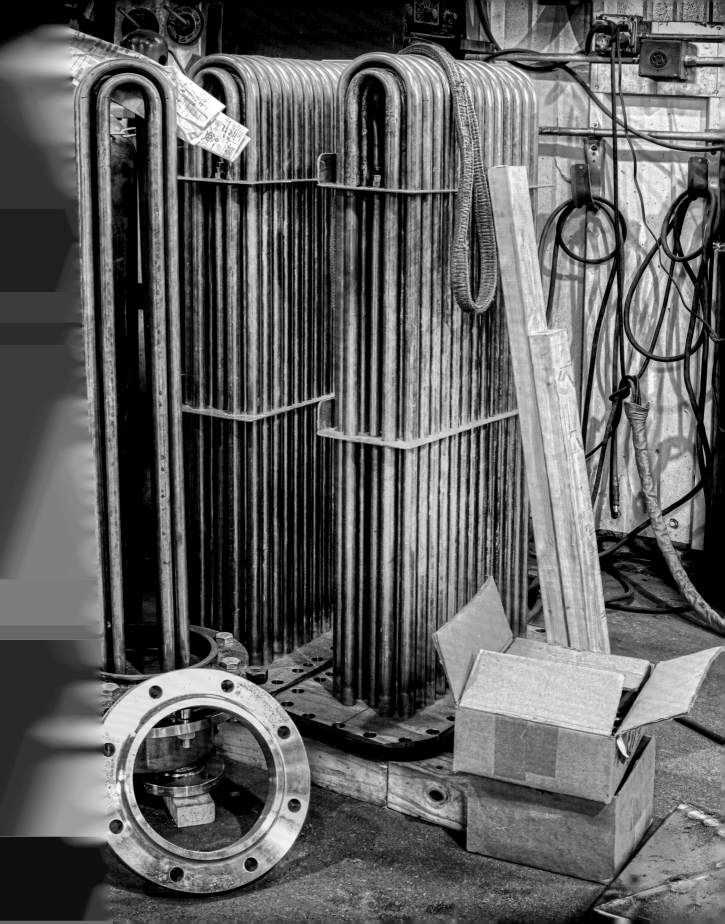

FACTORY FLOOR

Vendome Copper and Brass Works, Louisville, KY. In this part of the factory, each worker is responsible for a single project. This photo shows three separate workstations and their current production.

LONG COLUMN STILL ON FACTORY FLOOR

Vendome Copper and Brass Works, Louisville, KY. The length of an entire factory warehouse is needed to assemble this continuous column still. Other projects can be seen in the background.

FACING

COOLING PIPES

Vendome Copper and Brass Works, Louisville, KY. These pipes will be used in the coils that assist the condensation and cooling processes of distilling.

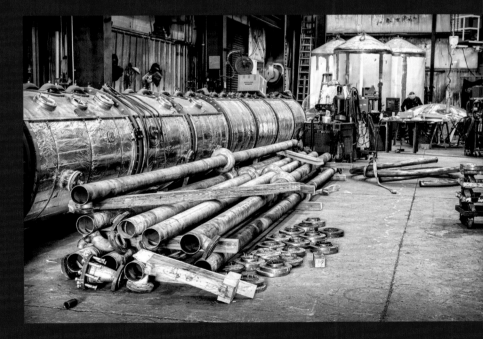

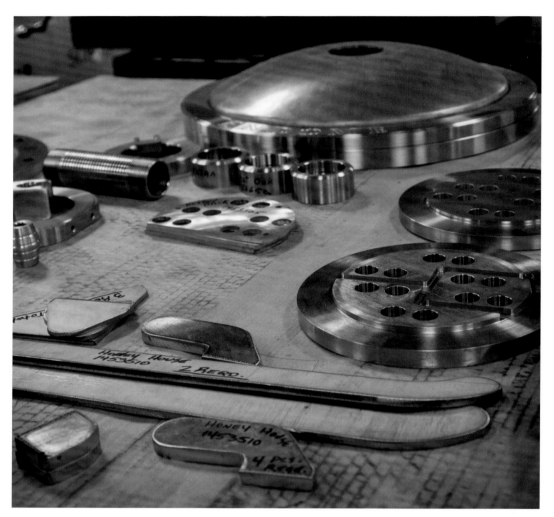

STILL PARTS

Vendome Copper and Brass Works, Louisville, KY. Many parts of copper, brass, and steel must be made before being assembled to create a whole still, tail box, or other distillers' equipment.

FACING

GRINDER AND SPARKS

Vendome Copper and Brass Works, Louisville, KY. Grinding and sanding the legs of this future pot still make certain it is finished and level.

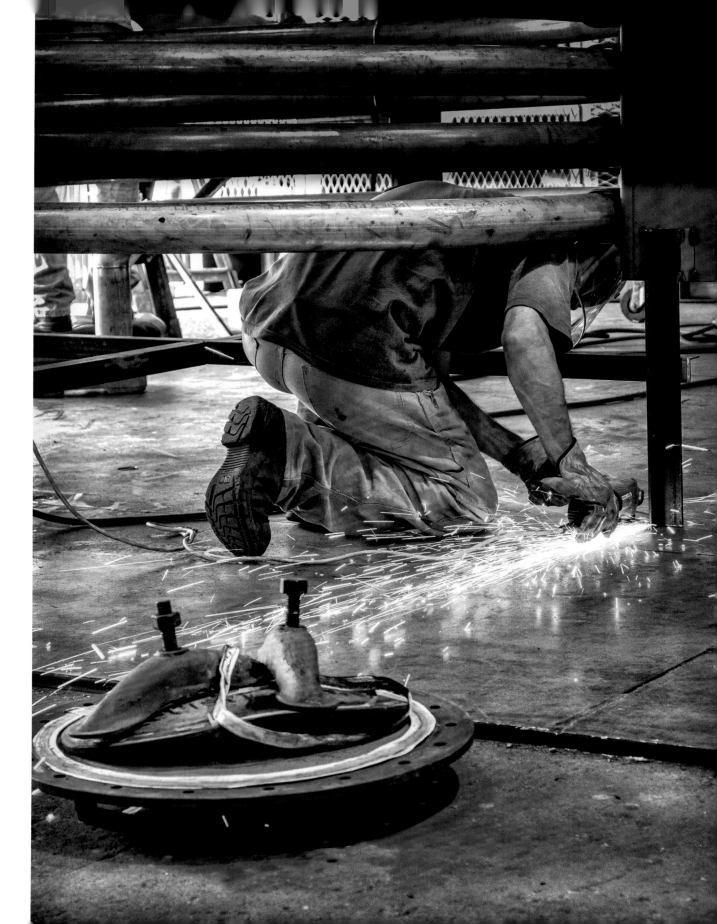

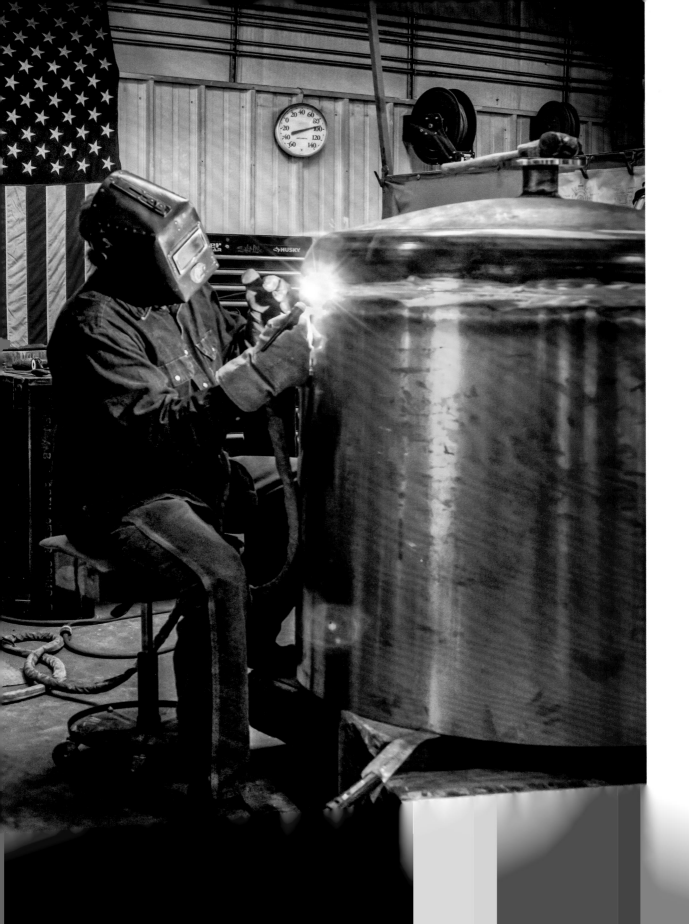

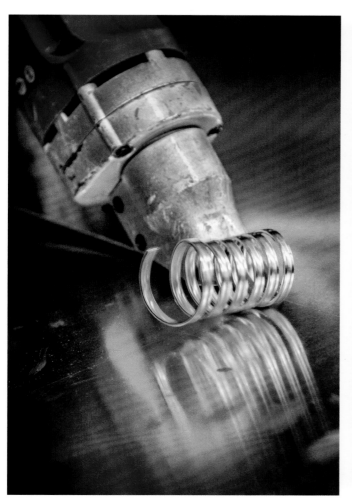

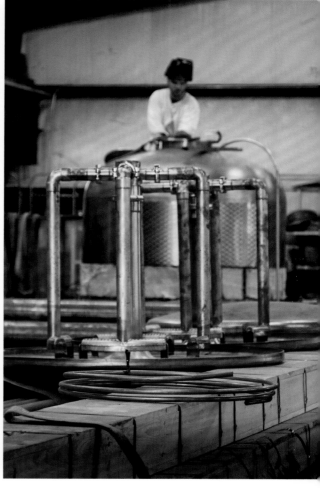

OPPER RINGS

Rocky Point Stills, Paducah, KY. As the sheet of
copper is cut in a round pattern to create a pot
still top, copper coils form tight rings.

FACING

ᵂELDING THE STILL TOP

Vendome Copper and Brass Works, Louisville,
KY. The welder is the backbone of the still-making
workshop, regardless of the size of the company.

ᵂELDER AND COPPER PIPING

Vendome Copper and Brass Works, Louisville,
KY. Workers often scale ladders to work
on large stills and tanks like this one.

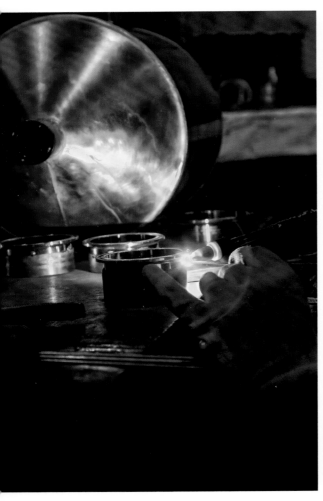

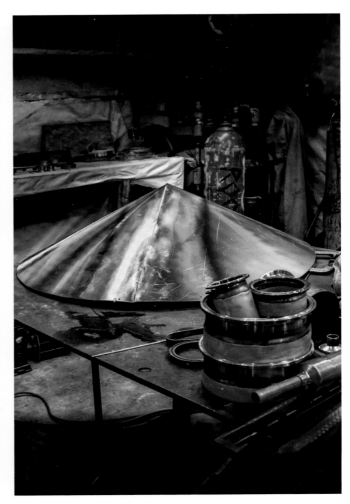

Soldering Rings and Fittings

Rocky Point Stills, Paducah, KY. In this small, two-man copper workshop, every item is handmade, and everyone is a welder.

Welded Cone Still Top

Rocky Point Stills, Paducah, KY. The completed still top sits on the workbench along with other parts, awaiting assembly in this artisan copper works.

FACING

Fitting the Still Top on the Bottom

Rocky Point Stills, Paducah, KY. In this craft-oriented copper works, the top of a pot still is fitted to the bottom before the two are welded together.

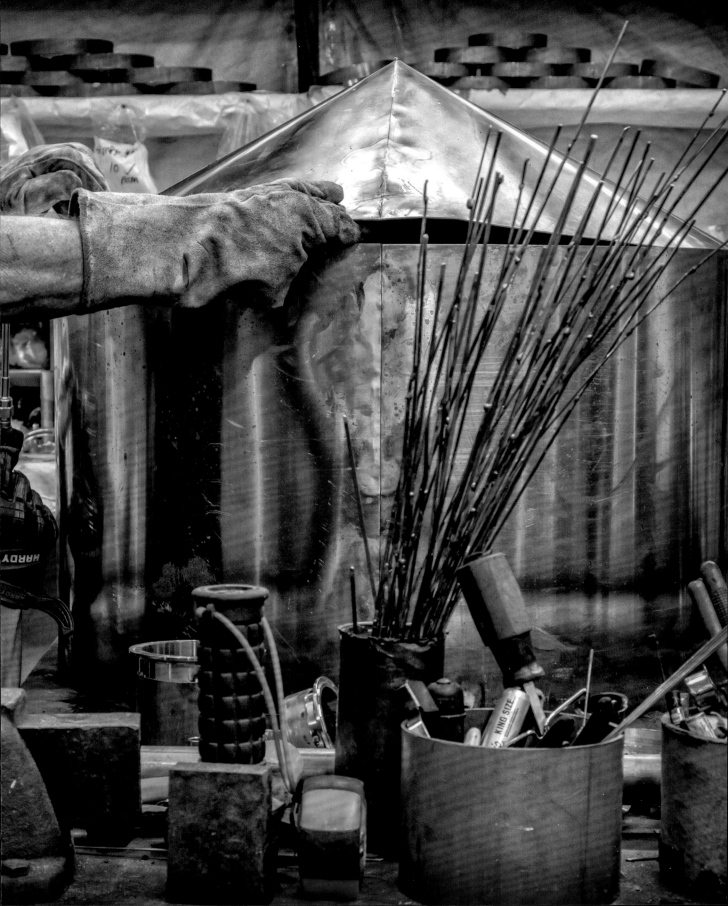

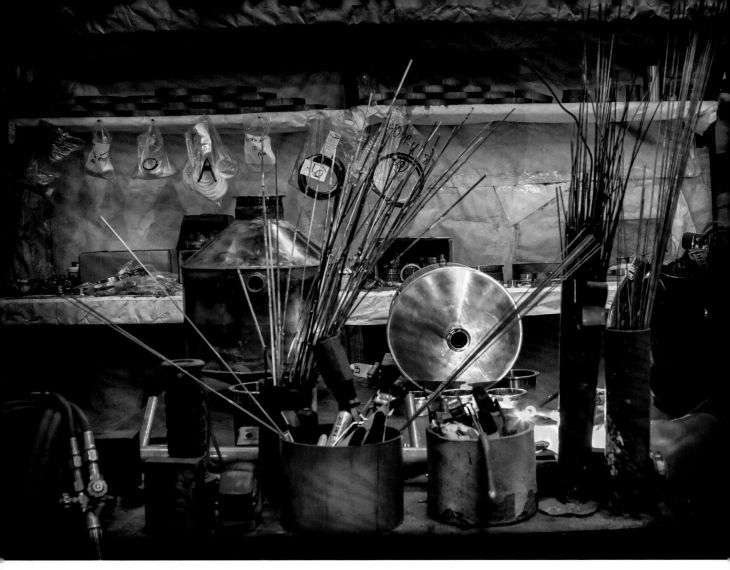

Copper Workshop

Rocky Point Stills, Paducah, KY. The workbench in this image shows all
the main components used by a typical copper still maker.

FACING

Welding the Still Top

Rocky Point Stills, Paducah, KY. Once the cone-shaped top is cut and bent
to the shape that will fit on the still bottom, the seam is welded.

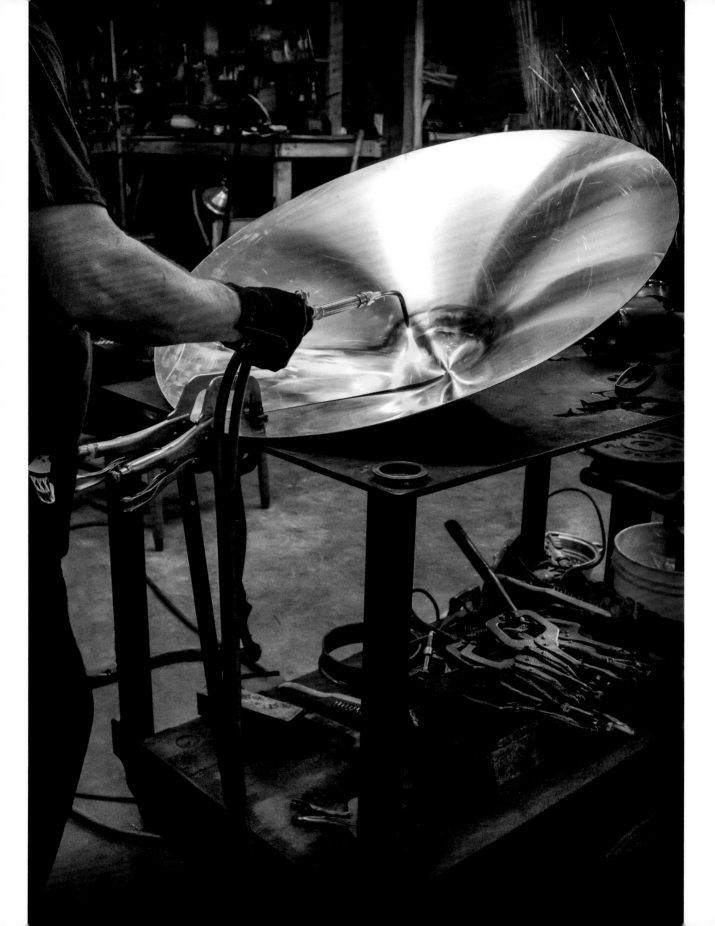

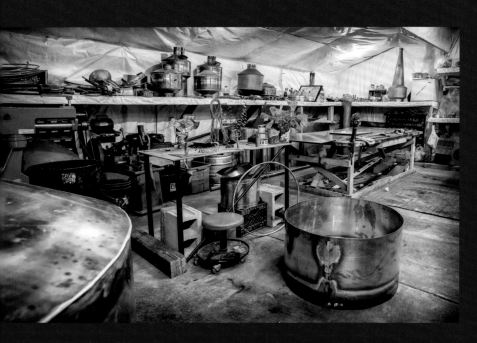

Workshop

Rocky Point Stills, Paducah, KY.
The craft copper workshop area
is the equivalent of one workshop
station in a larger copper works.
The work done here is in the same
tradition as early still makers,
with a few modern tools.

FACING

Copper and steel rods

Vendome Copper and Brass Works,
Louisville, KY. While pot stills are
completely copper, column stills
can combine steel and copper, with
the copper parts at the sections that
come into contact with the alcohol.

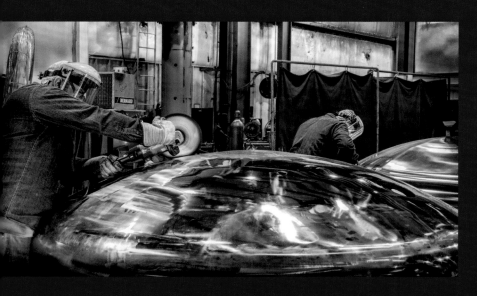

Smoothing stainless domes

Vendome Copper and Brass Works,
Louisville, KY. These two workers use
fine grinders and buffers to smooth
the stainless domes to a high shine.

FOLLOWING

Round copper ring coils

Rocky Point Stills, Paducah
KY. Beautiful copper rings are
the result of cutting a circular
pattern with a motorized tool.

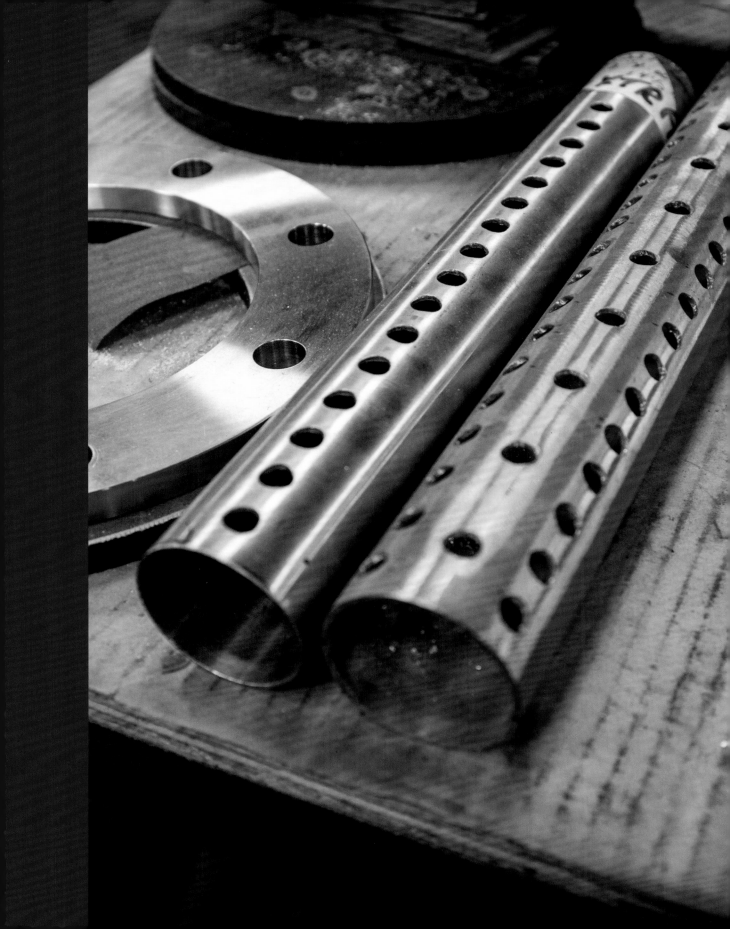

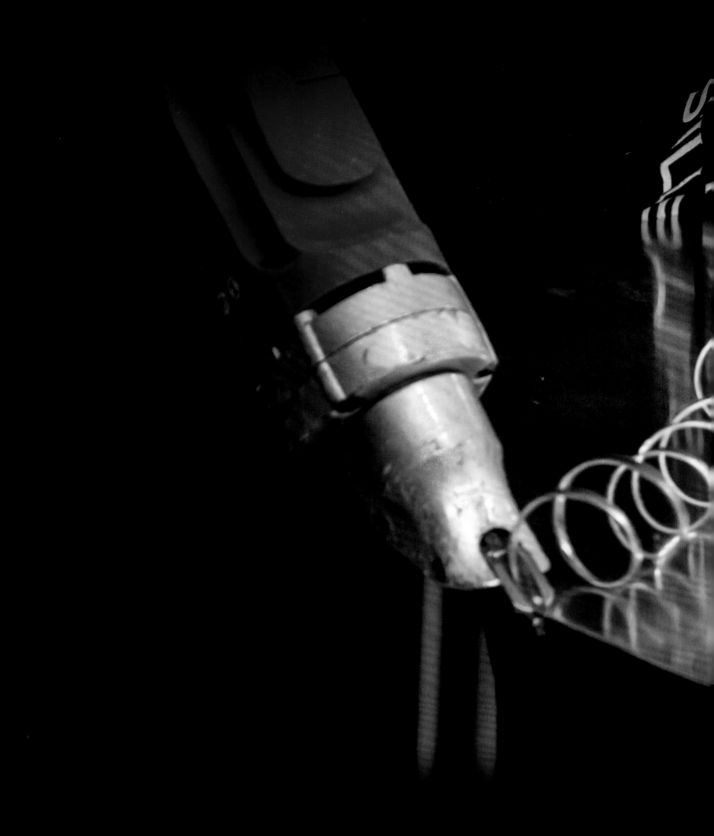

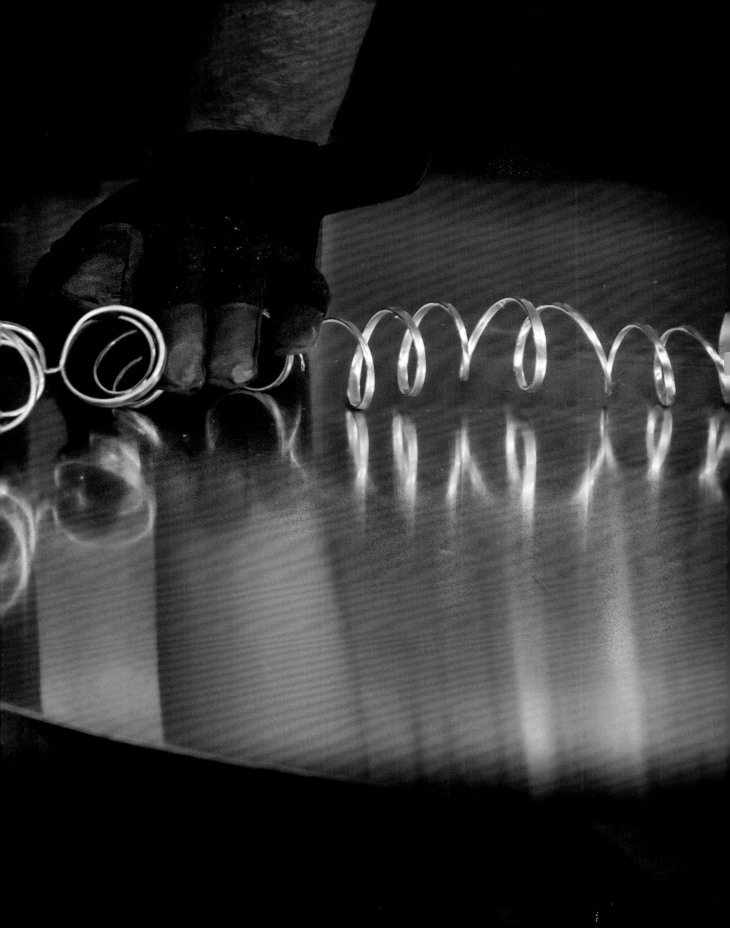

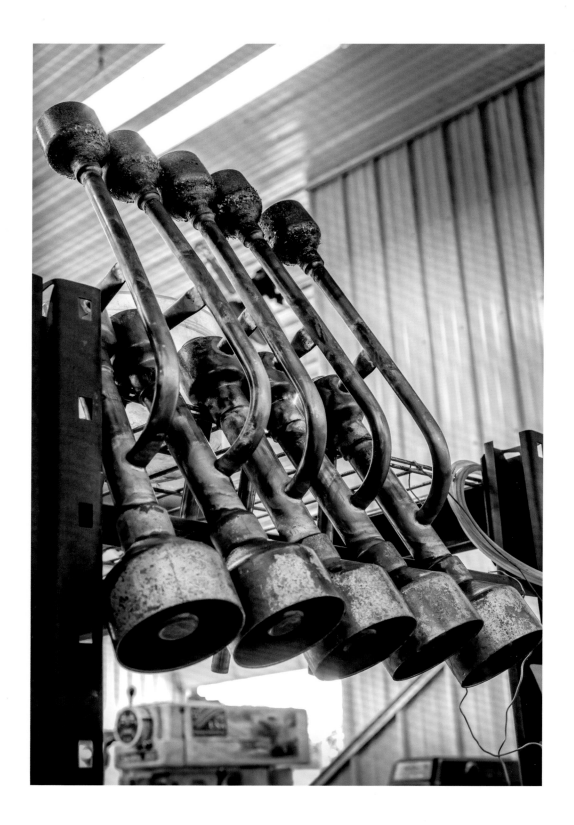

CLEANING THE SOLDERING

Hillbilly Stills, Barlow, KY. After soldering or welding seams and connections together, the line of weld or solder needs to be cleaned by fine grinders to smooth it out and create a beautiful finish.

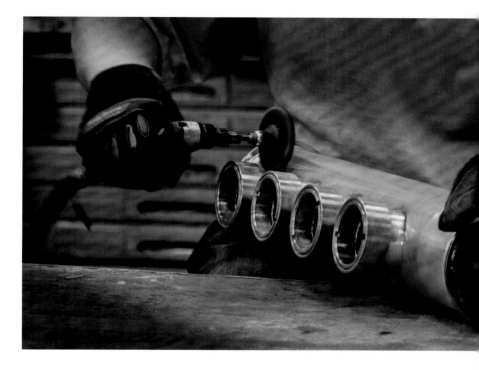

SMALL HOME STILL

Woodford Reserve Distillery, Versailles, KY. This small setup of still, scales, and grinder might have been used for individual, small-batch whiskey.

FACING

COPPER PARROT'S BEAKS

Hillbilly Stills, Barlow, KY. The parrot's beak gets its name from its shape, which supposedly resembles a bird. Also known as the parrot, this part is used for proofing and holds a hydrometer, allowing the distiller to get a highly accurate reading of the ABV (alcohol by volume). It is the last piece of copper touching the bourbon as it collects and cools the distilled alcohol coming out of the still.

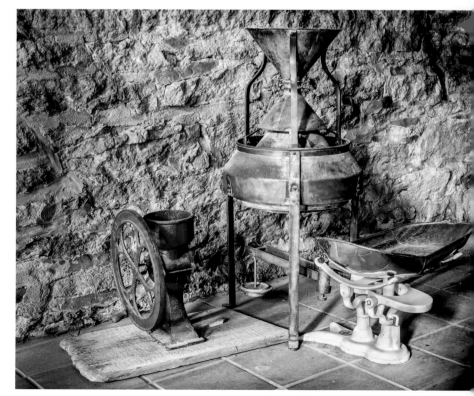

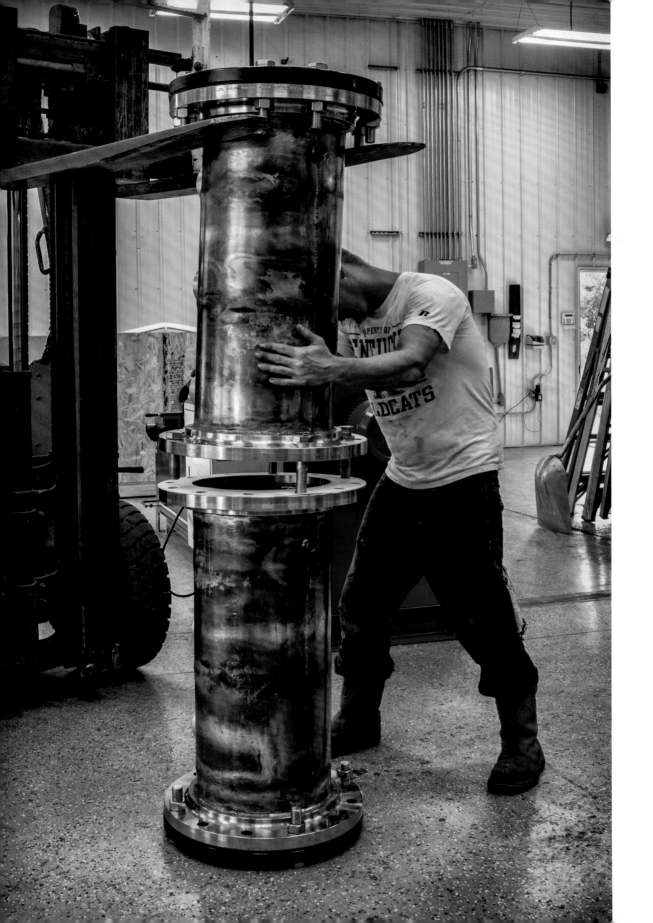

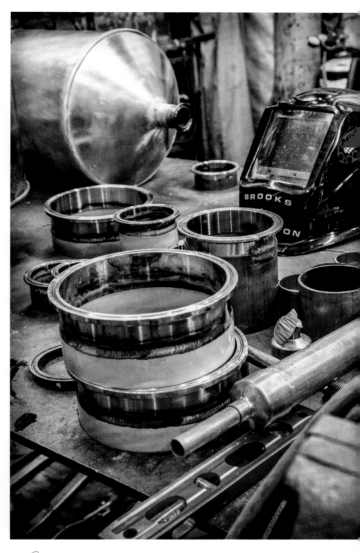

ORIGINAL STILL

Old Pogue Distillery, Maysville, KY. The original Old
Pogue still used in the late 1870s sits in the historic home
on the distillery site, now used as a museum and gift shop.

SOLDERED RINGS

Rocky Point Stills, Paducah, KY. All the copper parts
used in this craft still maker's workshop are made on site.

FACING

STACKING COLUMN SECTIONS

Hillbilly Stills, Barlow, KY. To create distilling
columns, several sections can be stacked and
bolted together. In this small business copper
works, a forklift is used to do the job.

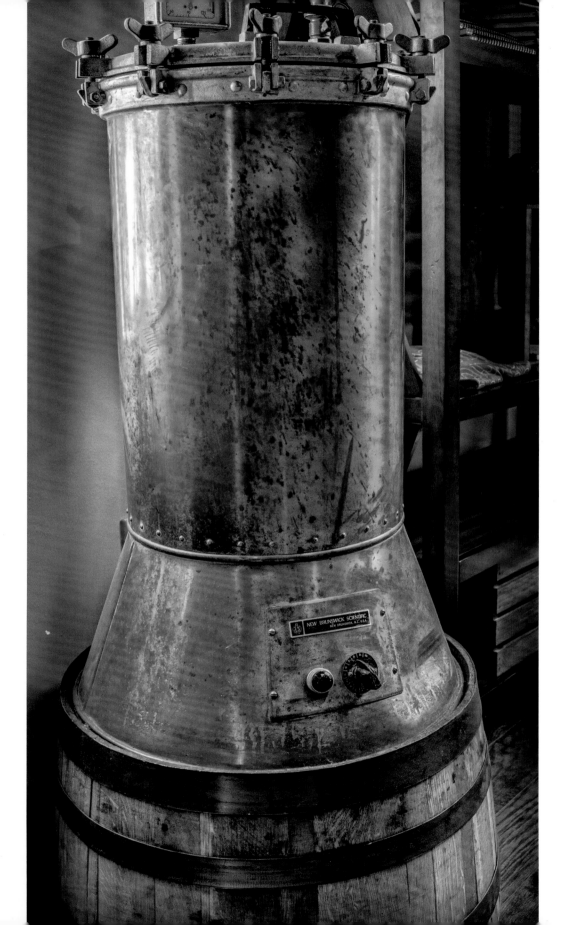

STILL

Casey Jones Distillery, Hopkinsville, KY. Casey Jones's grandson A. J. made this still following the plans of his grandfather; it is an exact replica.

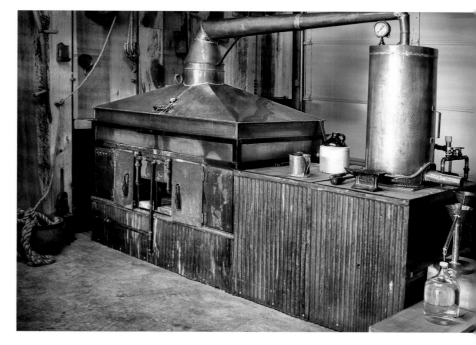

HISTORIC STILL

T. W. Samuels Distillery, Deatsville, KY. T. W. Samuels Distillery was owned by Bill Samuels's father and grandfather before they bought Burks Spring Distillery, the site of the current Maker's Mark Distillery. Now in private hands, this old personal still and condenser sit in an empty room.

FACING

HISTORIC STILL TOP ON BARREL

Bulleit Distillery, Louisville, KY. Sitting in the gift shop is this historic still, made by combining a copper still top with a barrel for the still bottom.

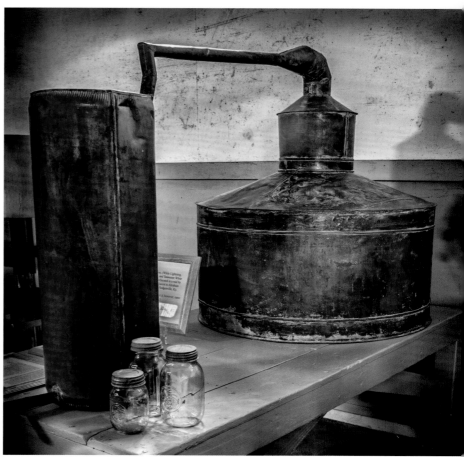

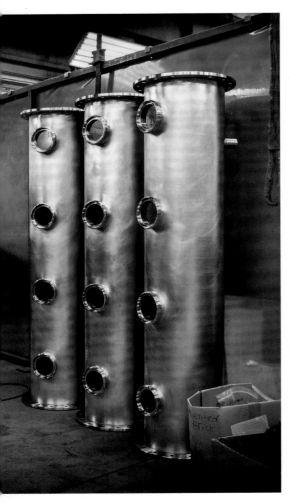

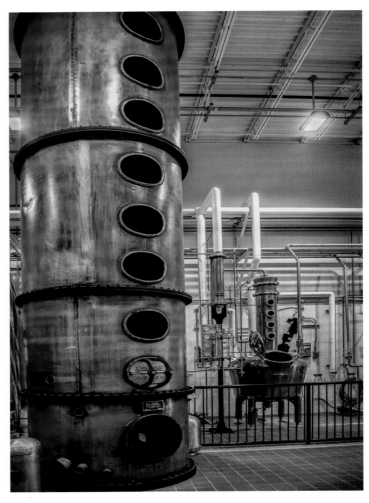

COLUMN STILL SECTIONS

Vendome Copper and Brass Works, Louisville, KY. Column still sections are constructed and then bolted together to create the tall columns seen at the many distilleries in Kentucky.

HISTORIC COLUMN STILL

Bulleit Distillery, Louisville, KY. This historic still sits quietly in the craft distillery section of Bulleit Distillery, on the site of the once well-known Stitzel-Weller Distillery. No longer in use, the still serves as an example of the Coffey still, also known as a patent still and as the continuous still.

FACING

STILL

Old Taylor Distillery, Frankfort, KY. This still is no longer in existence. It originally was a five-story-high continuous distillation still put in place at the Old Taylor Distillery by E. H. Taylor. The distillery was recently purchased and now operates as Castle and Key Distillery with a brand-new continuous column still and pot still combination.

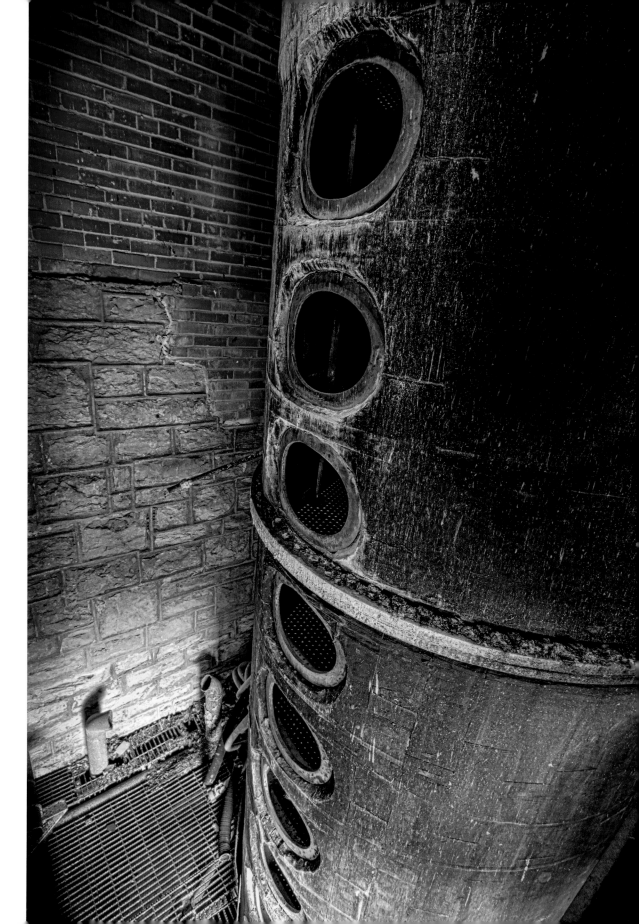

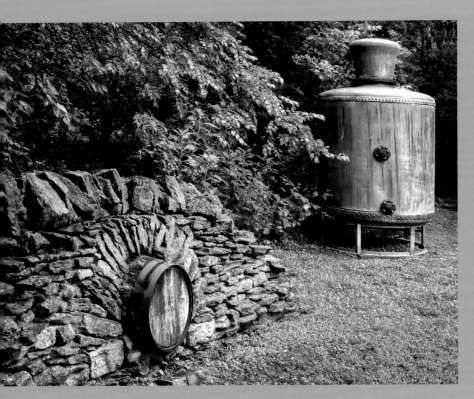

BARREL WALL AND STILL

Woodford Reserve Distillery, Versailles, KY. Outside of the Woodford Reserve Distillery this interesting arrangement can be found. The still is an old pot still brought from Tennessee to the Woodford site decades ago by a worker who collected pieces of distilling history.

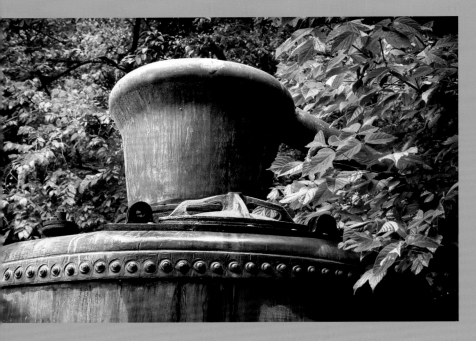

DETAIL OF OLD STILL

Woodford Reserve Distillery, Versailles, KY. Left outside, the copper on this old still has attained a beautiful patina. Notice the large size of the rivets around the seam of the still top.

FACING

OLD STILL

Woodford Reserve Distillery, Versailles, KY. This still was brought to Kentucky from Tennessee; perhaps it originated in Kentucky and just returned home.

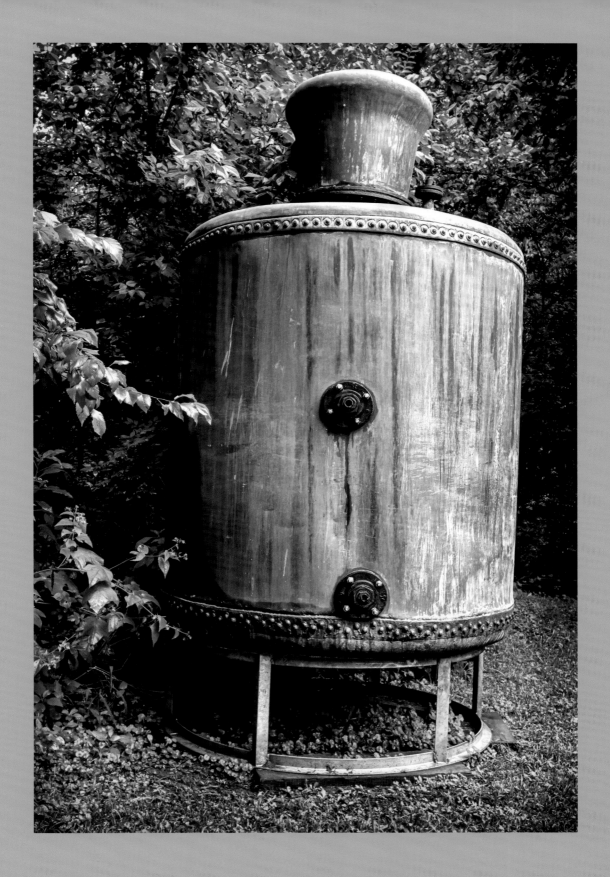

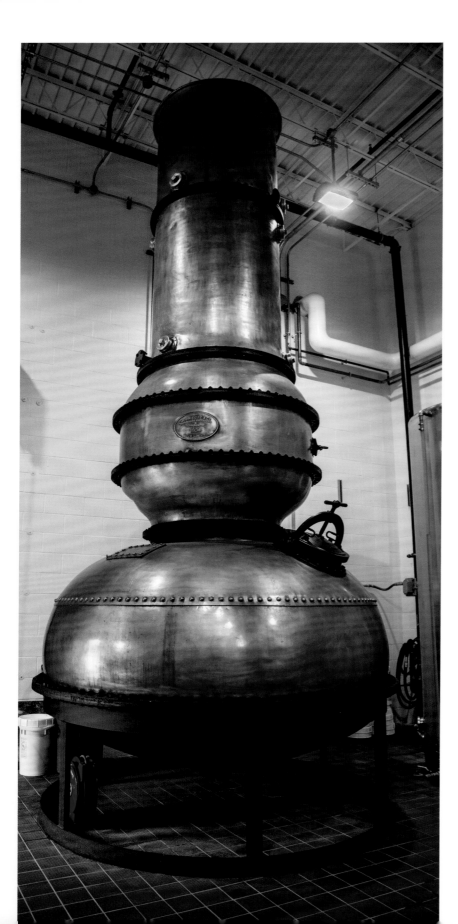

Pot and Column Still

Bulleit Distillery, Louisville, KY. This historic still is an early example of a hybrid column still, combining a pot still base and a column top.

FACING

Historic Still and Pot

Kentucky Artisan Distillery, Crestwood, KY. Kentucky Artisan Distillery has a fine collection of historic artifacts related to distilling, as well as historic machinery and stills. This arrangement of still and pot is in the tasting room.

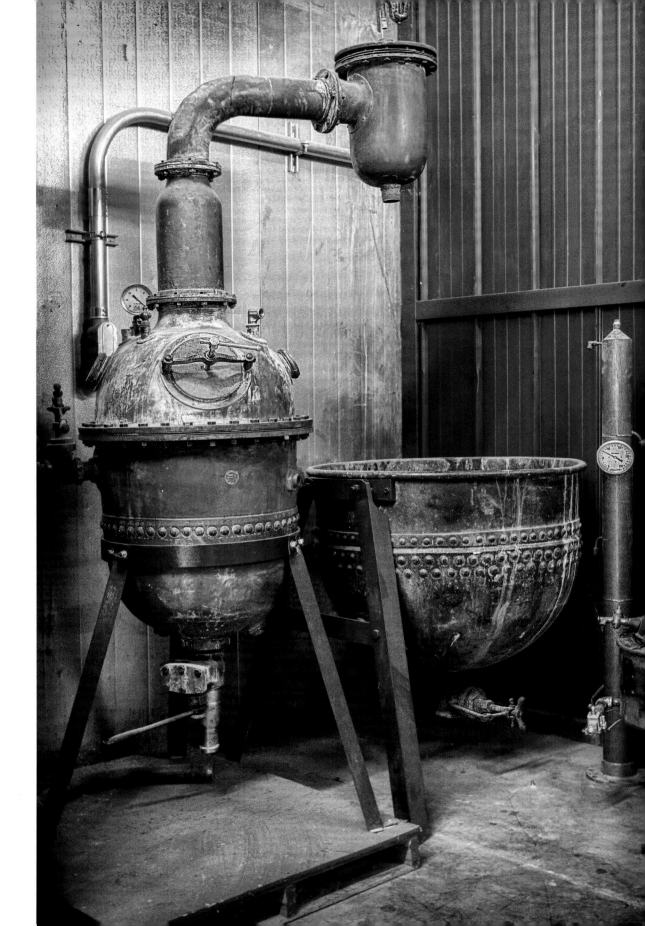

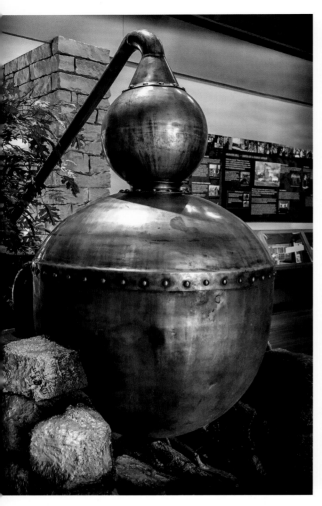

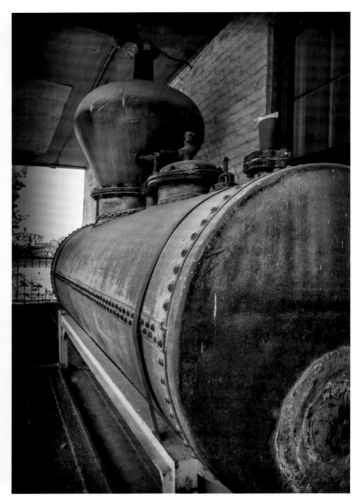

OLD POT STILL

Bourbon Heritage Center, Heaven Hill
Bourbon Distillery, Bardstown, KY. As a
display in the visitor center at Heaven Hill,
this pot still reflects part of the early whiskey-
making process. The visitor center serves as
a museum for distilling, with many historic
artifacts and interesting displays depicting
historic and current distilling practices.

HISTORIC STILL

Vendome Copper and Brass Works, Louisville, KY. This
still was found in Mexico and returned to Vendome, which
had originally made it. The still may have belonged to
Mary Dowling's DW Distillery. Mary moved her family's
Waterfill & Frazier distillery to Mexico to make bourbon
under the DW Distillery label during Prohibition.

FACING

BURKS SPRING DISTILLERY MILL FOUNDATION

Maker's Mark Distillery, Loretto, KY. In the basement of Maker's
Mark Distillery is the foundation of the old water-powered
gristmill that once operated here alongside the old Burks Spring
Distillery. Also in the basement are old pot stills modeled after
the earliest stills the Samuels family used, still operational.

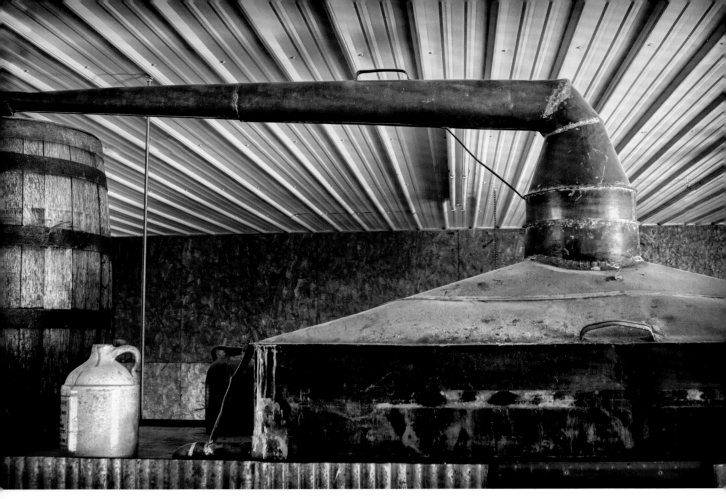

CASEY JONES'S ORIGINAL STILL

Casey Jones Distillery, Hopkinsville, KY. Casey Jones was a notorious moonshiner and still maker in the Golden Pond area of Kentucky during Prohibition who did prison time for his passions. His grandson A. J. has carried on the family legacy at the Casey Jones Distillery, this time legally. This original still made by Casey is on display at the distillery.

FACING

ORIGINAL STILL AND BARREL

MB Roland Distillery, Pembroke, KY. The first still used at MB Rowland Distillery has been replaced by two beautiful hammered copper stills. The original still stands outside as a symbol of the craft distillery's beginnings.

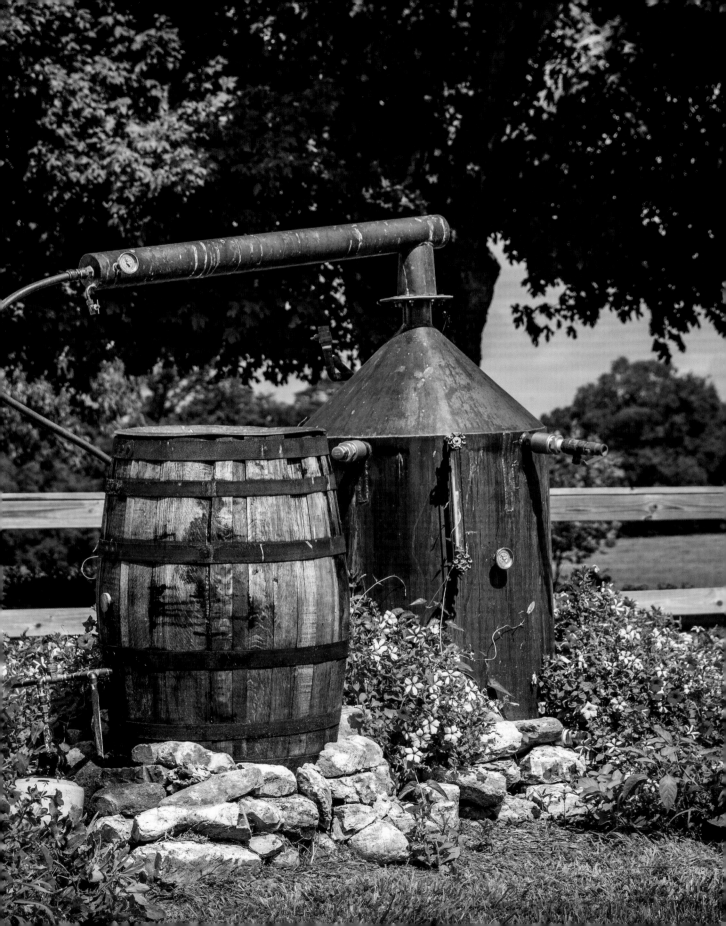

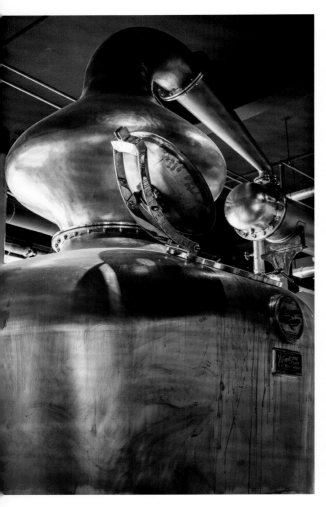

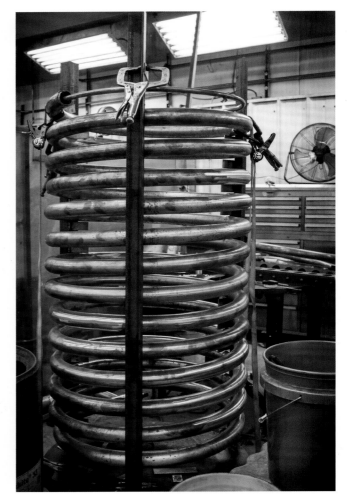

℘OT STILL BEND

Copper and Kings Distillery, Louisville, KY.
The centerpiece of each distillery is the still.
The craft distilleries in particular showcase
beautiful stills, such as this pot still.

ℐTILL COILS

Vendome Copper and Brass Works, Louisville, KY.
Inside a pot still, fermented liquid is heated. The
alcohol boils first, turning to vapor that rises and is
drawn off through the arm at the top of the still into
a coil that is submerged in cool water, causing the
alcohol to condense back into liquid alcohol. The
liquid will then run out of the coils and is collected.

FACING

ℐTILL

Old Pogue Distillery, Maysville, KY. The resurrection
of the Pogue Distillery from the 1870s into today's
Old Pogue craft distillery has been accomplished
using this pot and column still hybrid.

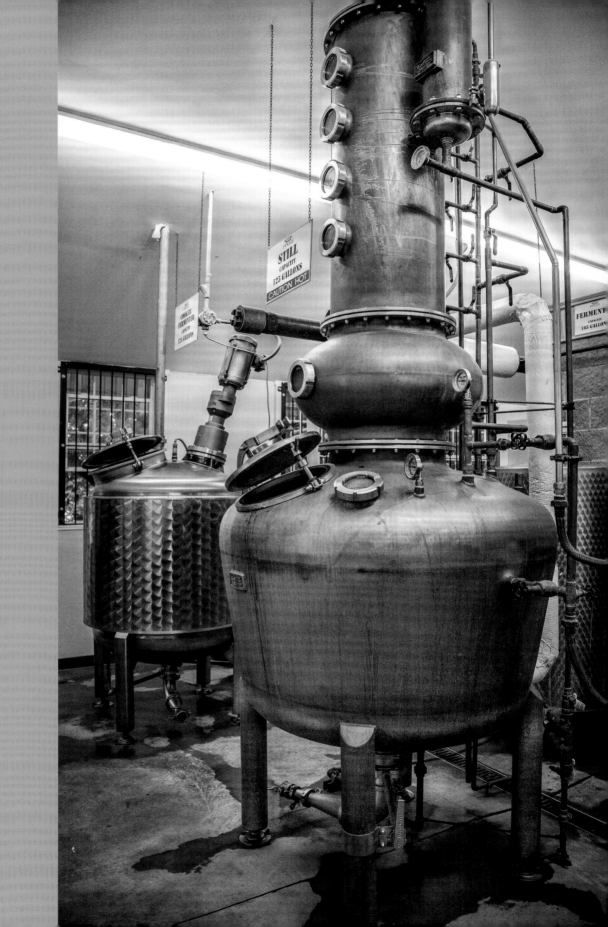

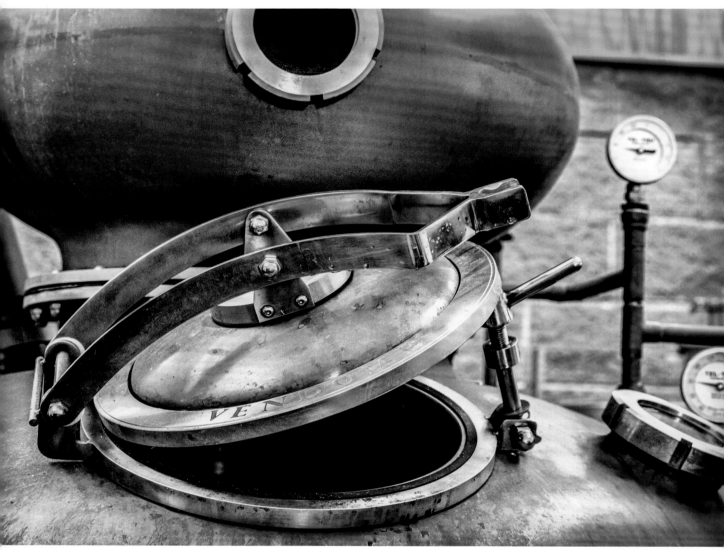

STILL DETAIL

Old Pogue Distillery, Maysville, KY. The current boom of craft distilleries includes distillers new to the industry and distillers who have a family background in distilling. Although the still at Old Pogue is new, the owners are descendants of the original Pogue Distillery's owners.

FACING

DISTILLERY EQUIPMENT

Second Sight Spirits, Ludlow, KY. The distillers at Second Sight Spirits had their still handcrafted by a copper worker to reflect their vision of distilling spirits: telling the future of bourbon!

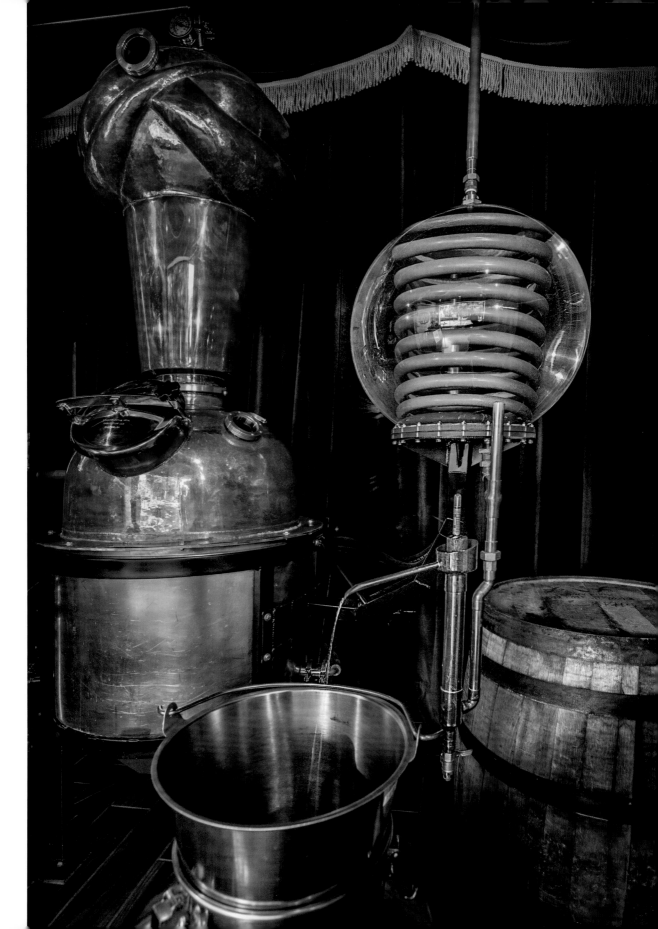

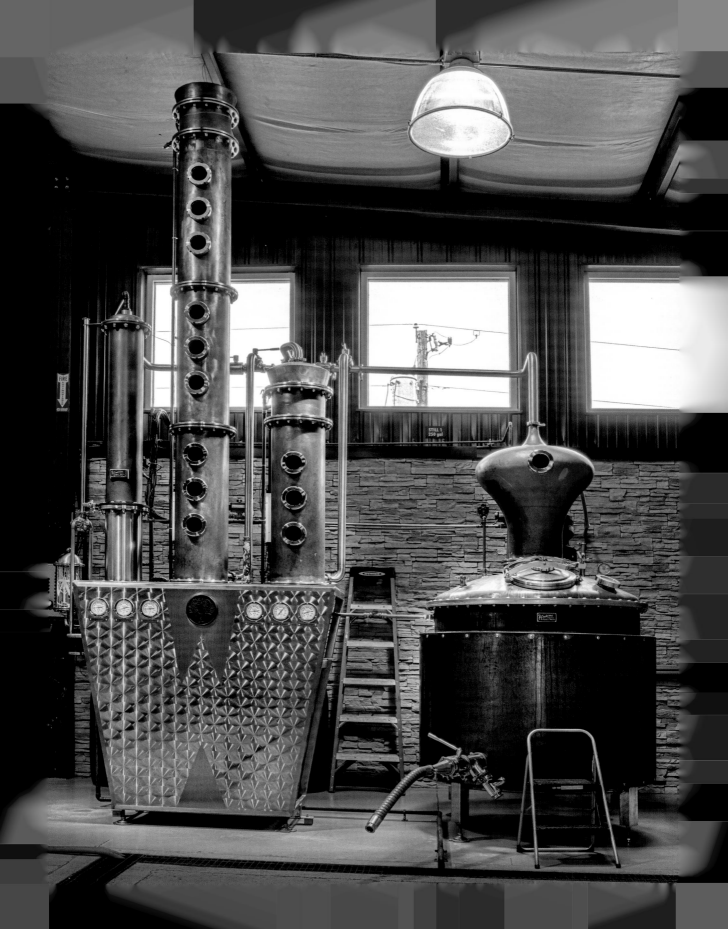

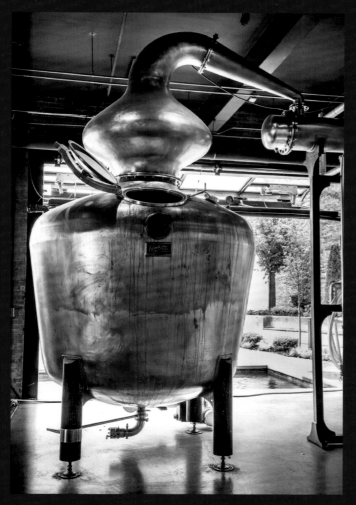

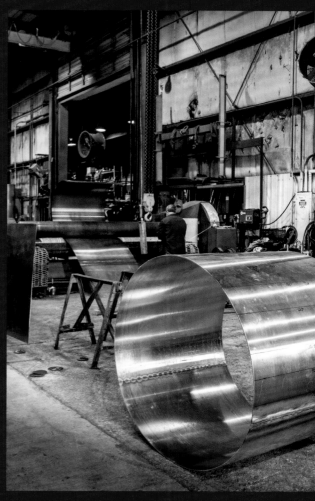

ONE OF TWO POT STILLS

Copper and Kings Distillery, Louisville, KY. Most of the larger craft distillery stills are made in Kentucky, such as this one, which is one of a pair of pot stills.

FACING

EARLY STILLS

Wilderness Trail Distillery, Danville, KY. This is a hybrid column still and doubler. The doubler is a copper pot still that receives the steam after the alcohol has been extracted from the still, allowing for a second distillation and improving the taste of the whiskey.

CURLED COPPER

Vendome Copper and Brass Works, Louisville, KY. To achieve the curl needed to create the large stills and tubs, a curling machine turns a flat sheet of copper into the shape needed.

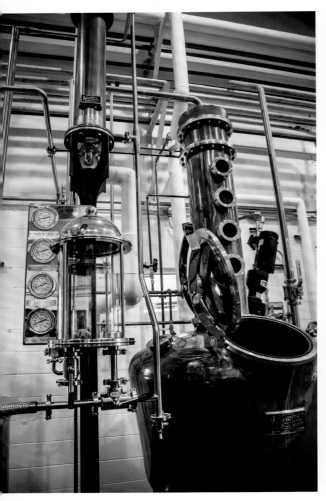

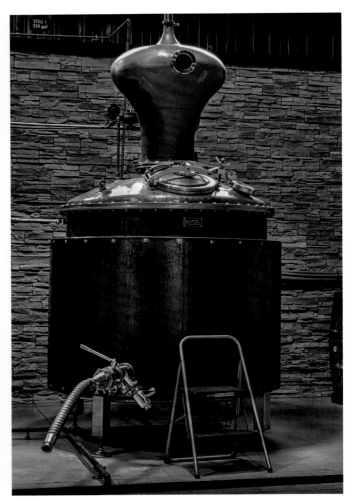

CRAFT STILL

Bulleit Distillery, Louisville, KY. Most of the large distilleries now contain a craft section as a way of giving visitors accessibility to their production that the multistory continuous column stills don't allow. Inside the Bulleit Distillery is this craft-sized still and tail box.

SMALL STILL CLOSE-UP

Wilderness Trail Distillery, Danville, KY. This pot still is actually a companion to a multicolumn still and is used as a doubler for the setup.

FACING

STILL

Corsair Distillery, Bowling Green, KY. The hybrid still with its pot still base and column top allows flexibility to produce different types of spirits and better control of distillation overall.

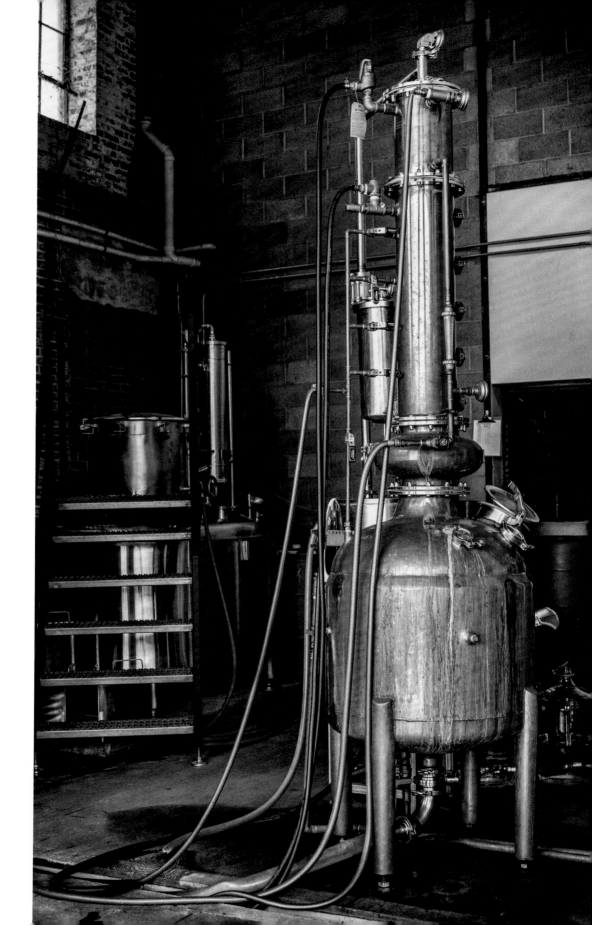

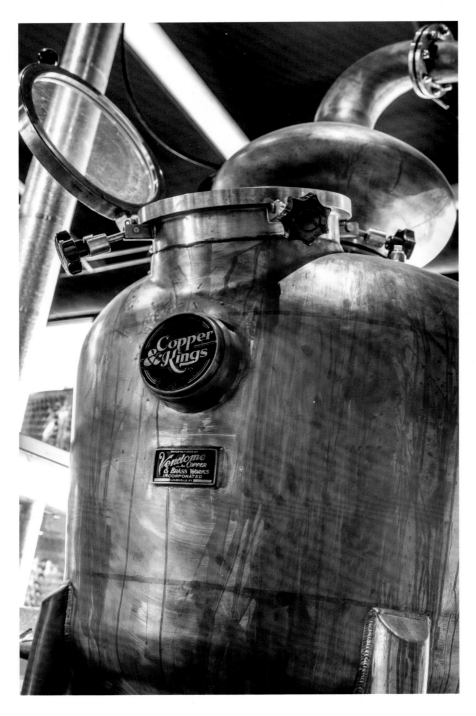

OPEN STILL

Copper and Kings Distillery, Louisville, KY. When the stills are not in use, most distilleries leave them open for cleaning and maintenance. A pot still allows a distiller to make only one batch of bourbon at a time, so the still needs to be emptied and cleaned before the next batch can begin.

FACING

COLUMN STILL

New Riff Distilling, Newport, KY. The New Riff craft distillery uses several different stills in varying capacities, but it is the tall column in the still tower that gets all the glory.

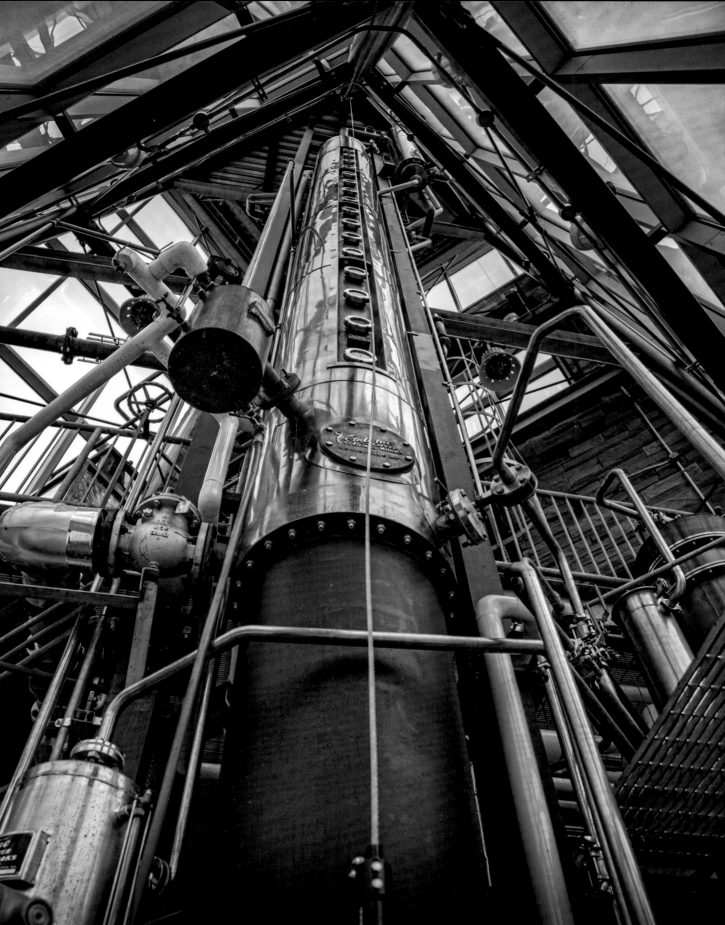

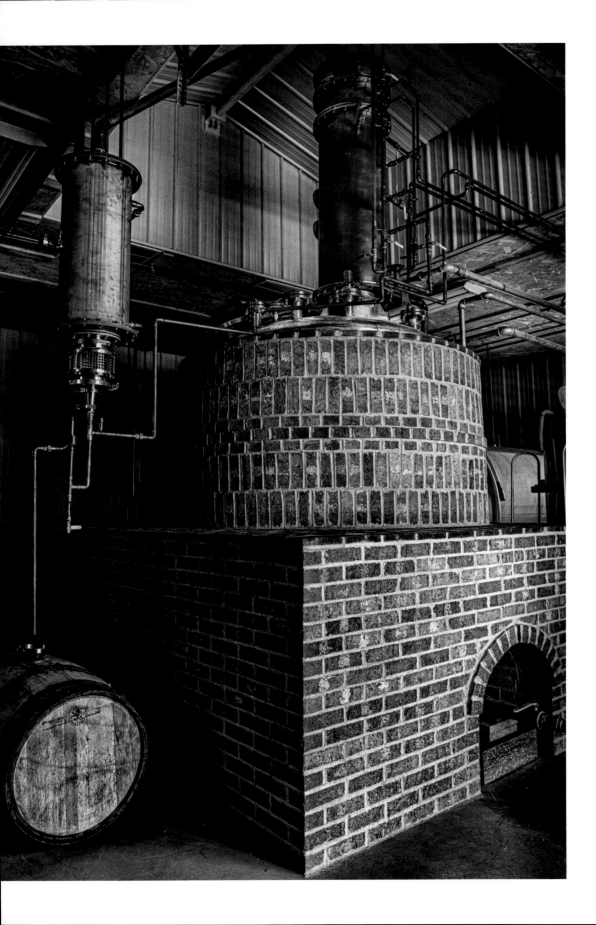

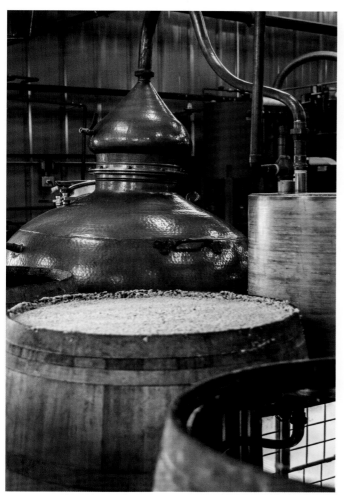

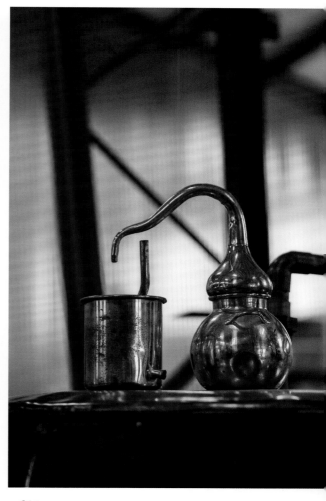

*S*TILL AND FERMENTING BARREL

Limestone Branch Distillery, Lebanon, KY. All the elements
of the distilling process can be seen in this image: water,
mash fermenting, the pot still and condenser, and a barrel.

FACING

*S*TILL

Wade-Lyn Ranch Distilling, Waynesburg, KY.
Wade Daniels, the distiller at Wade-Lyn Ranch,
made his own still out of copper and bricks. He is
the third generation of distillers in his family.

*M*INIATURE POT STILL

Limestone Branch Distillery, Lebanon, KY. On top
of the functioning pot still at Limestone sits this
miniature of a copper still and cup.

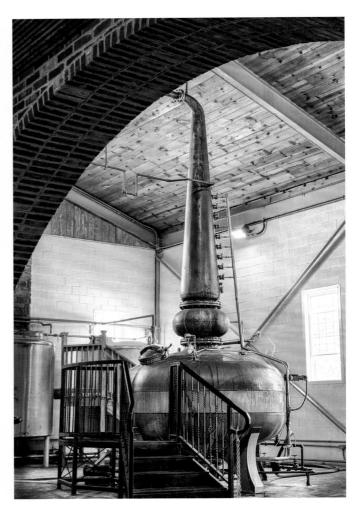

TILL

Barrel House Distilling, Lexington, KY. Barrel House Distilling operates out of the old barrelhouse of the former James E. Pepper Distillery with this beautiful hammered copper pot still.

*S*TILL

Willett Distillery, Bardstown, KY. Willett has immortalized this still by creating a bottle in the same shape as the still.

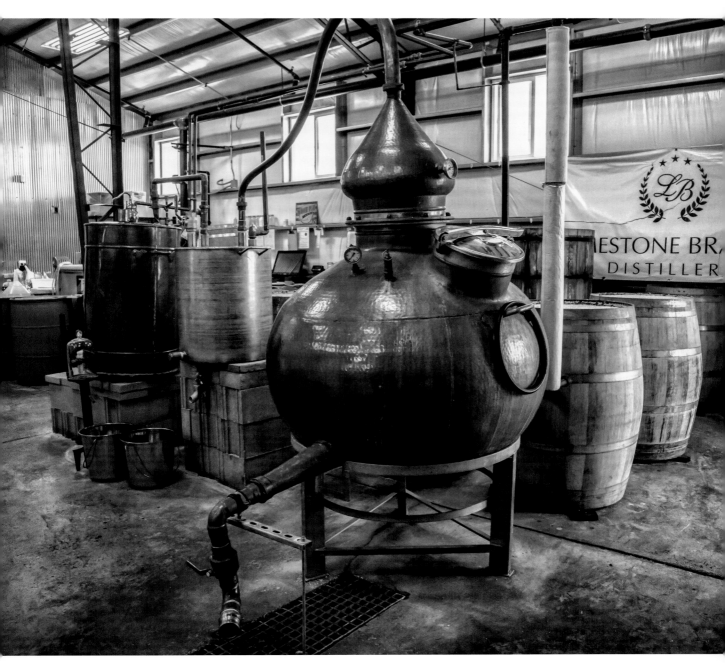

HAMMERED POT STILL

Limestone Branch Distillery, Lebanon, KY. This still shows the distinctive markings of a hand-hammered copper pot still, this one made in Spain.

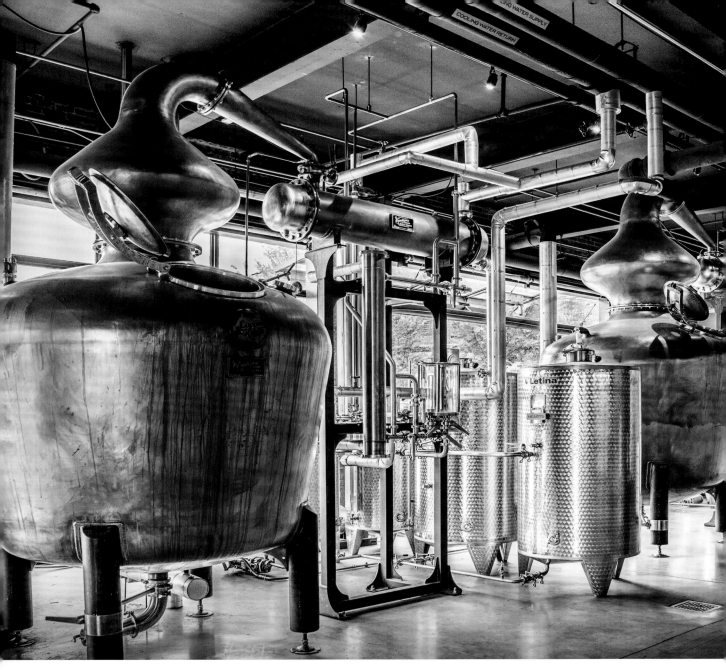

Double still

Copper and Kings Distillery, Louisville, KY. This pair of pot stills allows double production, or two different types of spirits to distill at the same time.

FACING

Second still

New Riff Distilling, Newport, KY. In addition to the tall column still, this craft distillery has two other smaller stills that operate in various capacities.

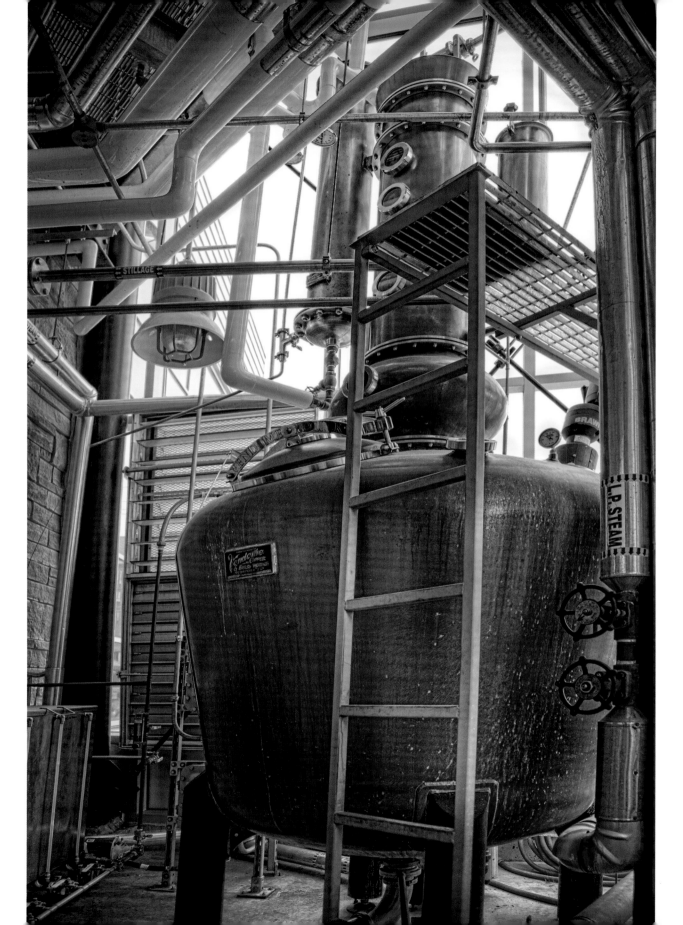

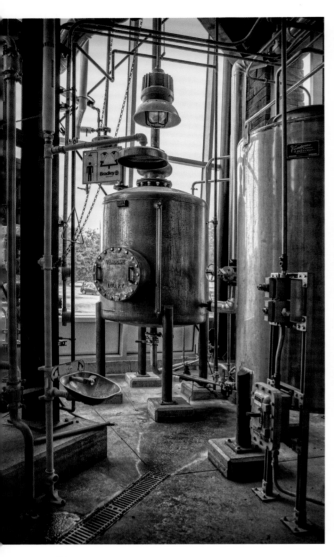

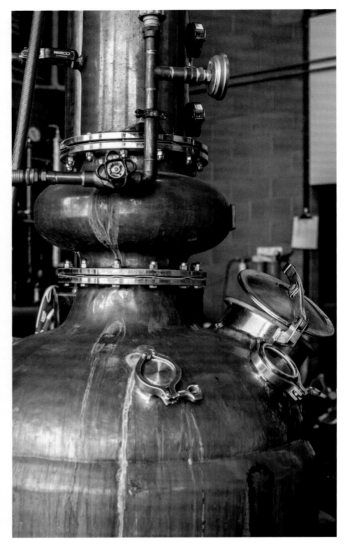

THIRD STILL

New Riff Distilling, Newport, KY. The third still on site in this craft distillery is a pot still, up on legs.

STILL UP CLOSE

Corsair Distillery, Bowling Green, KY. As a still is used the copper patina is changed, turning various colors, affected by both the heat and overflow of liquids.

FACING

SECOND STILL UP CLOSE

New Riff Distilling, Newport, KY. In this second still, a pot still and short column are combined, a common pairing.

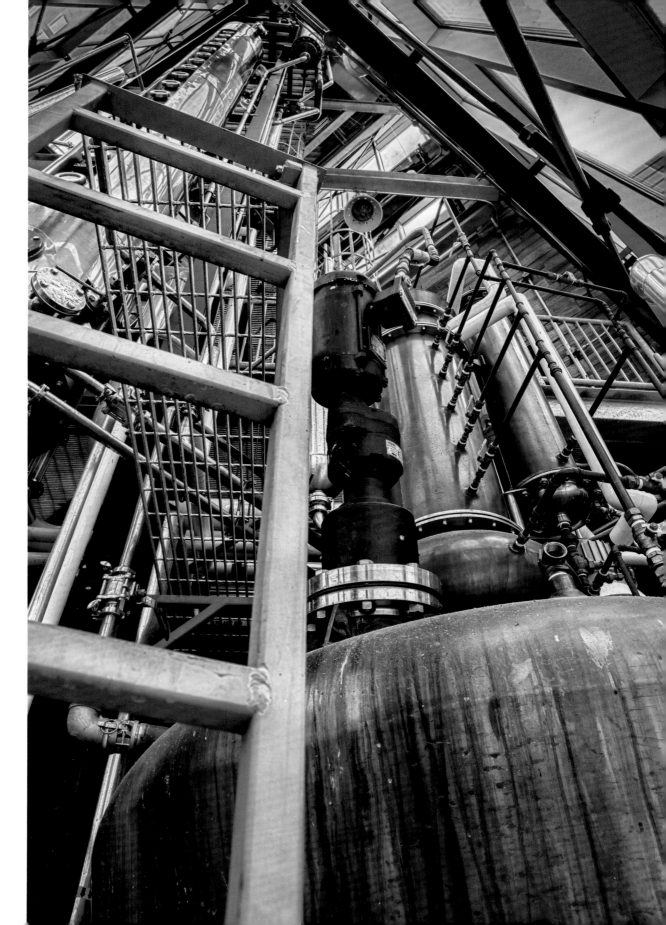

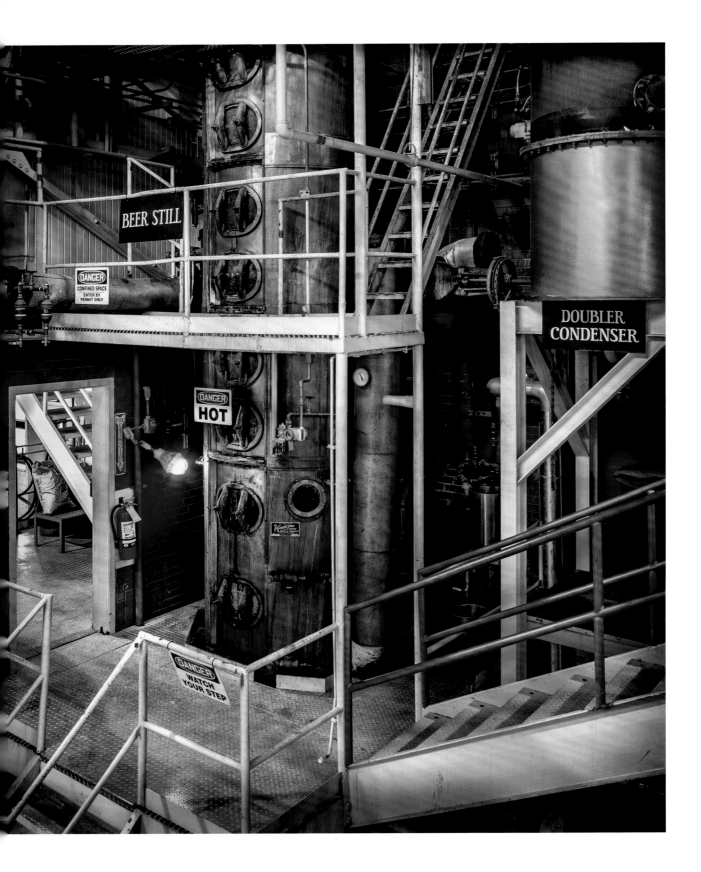

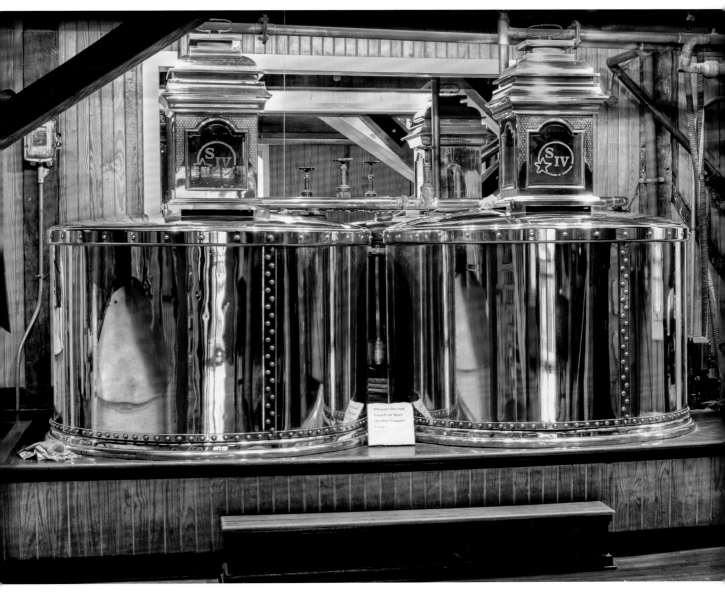

STILLS

Maker's Mark Distillery, Loretto, KY. On display and operational at Maker's Mark are these two craft stills with accompanying tail boxes on top. In the basement of the distillery are additional stills crafted in the shape of historic stills. In another part of the distillery are large column stills, forty-five feet tall with three-foot diameters and seventeen plates.

FACING

COLUMN STILL

Four Roses Distillery, Lawrenceburg, KY. A portion of the main column still is visible in this image. It is accompanied by a large pot still in another section of the still room.

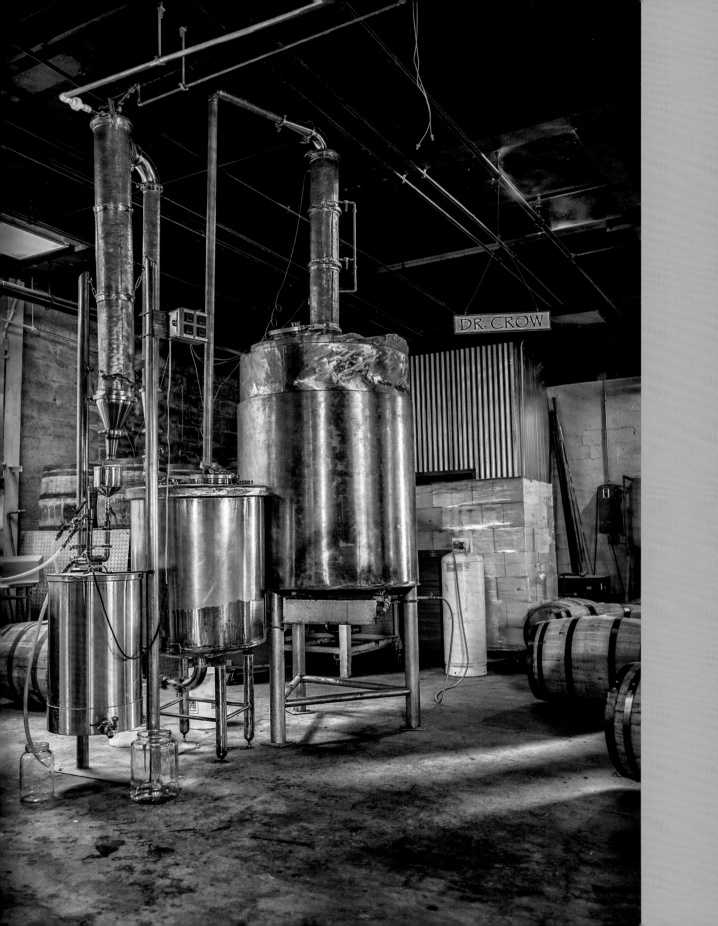

Upper pot still

Vendome Copper and Brass Works, Louisville, KY. The upper part is made up of several basic areas. The first is the spherical lid, which covers the top of the lower pot. This lid is attached to the conical neck via the intermediate connection. Finally, the lyne arm is connected to the neck by the bend. In this photo the upper part of a pot still is almost complete.

FACING

Old Crow still

Glenns Creek Distillery, Frankfort, KY. Glenns Creek Distillery is located inside the old bottling building of the former Old Crow Distillery. This is one of three stills handmade by distiller David Meier, used to distill a bourbon made from original yeast found at the Old Crow fermenting tanks.

BELOW

Copper tubes

Vendome Copper and Brass Works, Louisville, KY. On the factory floor at this large copper works, all sorts of projects can be seen in process at once. In this image are copper tubes as well as other still parts ready for further assembly.

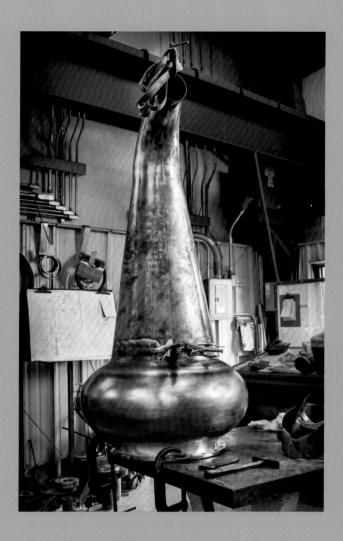

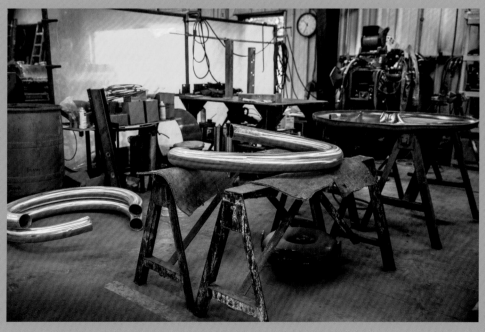

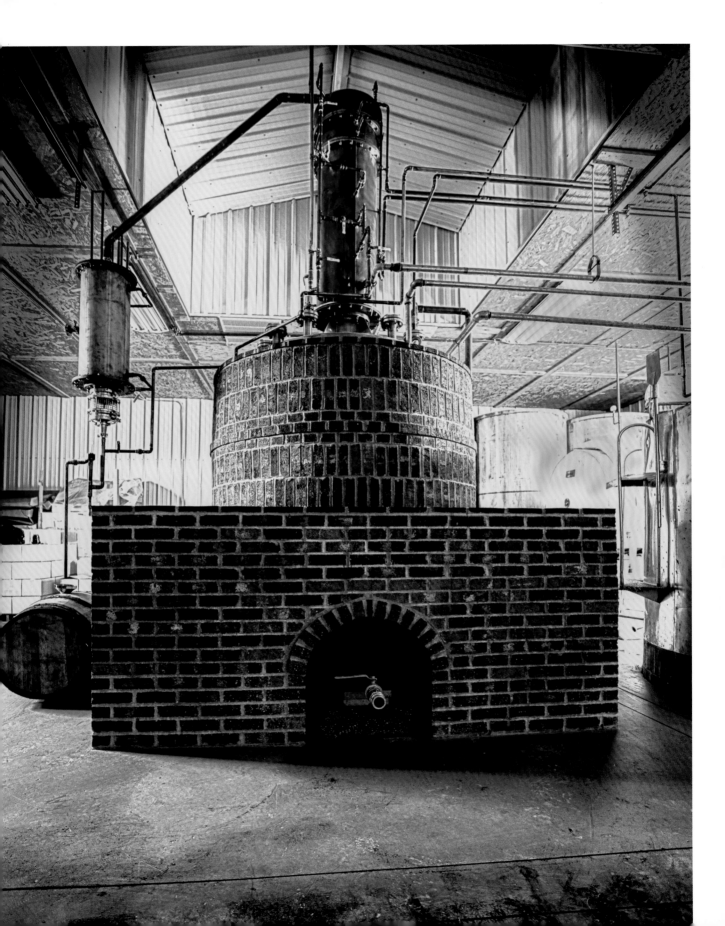

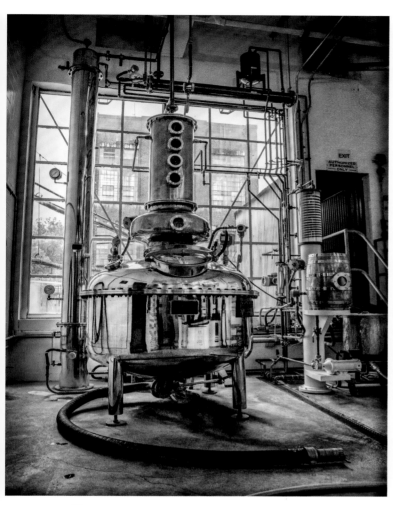

CRAFT STILL AND TAIL BOX

Buffalo Trace Distillery, Frankfort, KY. The craft still at Buffalo Trace, along with the copper barrel-shaped tail box, can be found in a room dedicated to historic fermenting equipment and tanks

FACING

STILL FRONTAL VIEW

Wade-Lyn Ranch Distilling, Waynesburg, KY. Third-generation distiller Wade Daniels built his own still and did the brickwork with help.

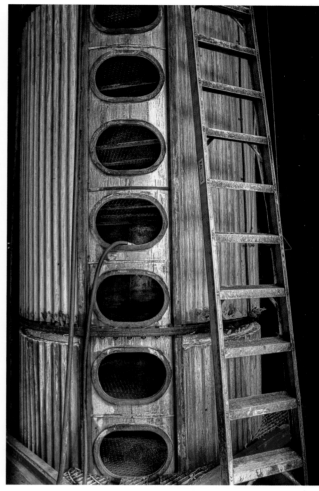

STILL

Barton 1792 Distillery, Bardstown, KY. During the summer the distilling ceases while stills are cleaned and maintained. In this image the front caps have been removed and the inside of the still, as well as the caps, are thoroughly washed.

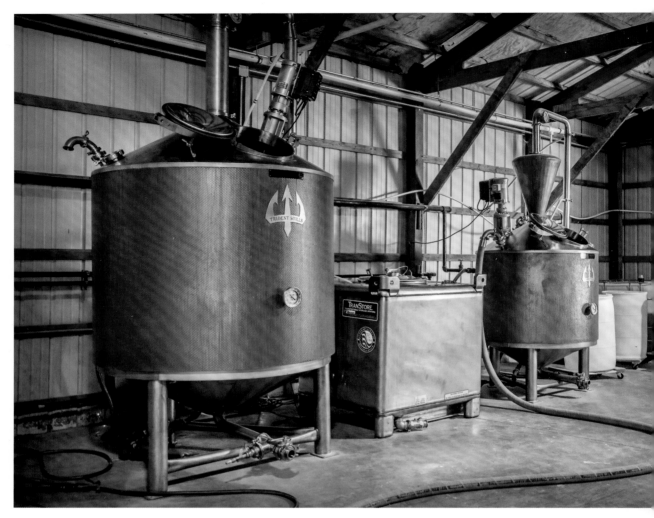

Pair of Stills

MB Roland Distillery, Pembroke, KY. These hammered copper stills were made in Maine. Although most craft distilleries use Kentucky-made stills, pot stills from around the country and around the world are represented along the Bourbon Trail Craft Tour.

FACING

Hybrid Still

Three Boys Farm Distillery, Graefenburg, KY. This still is a large example of the hybrid pot and column still.

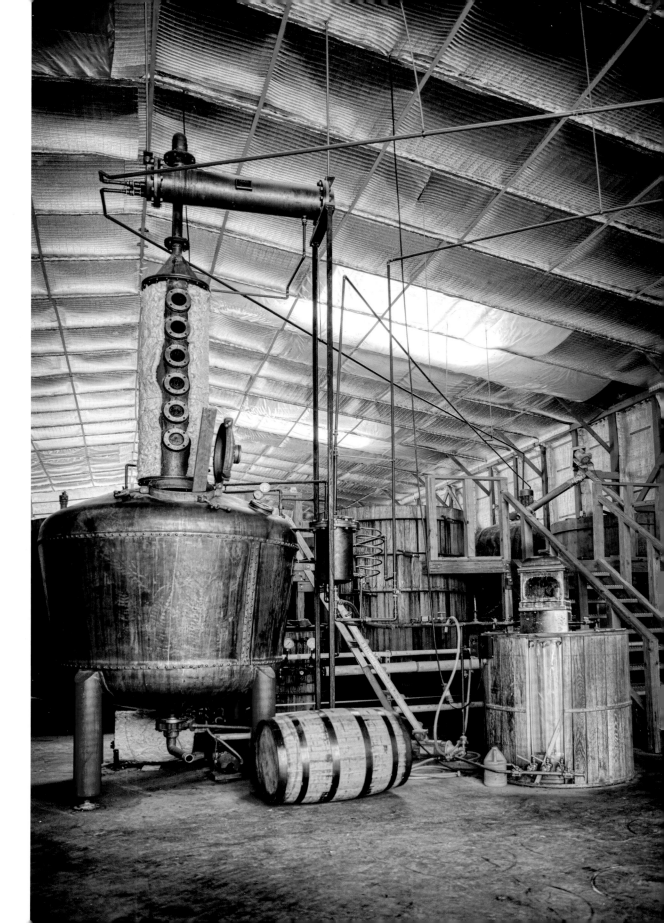

ꞙMALL STILL

Glenns Creek Distillery, Frankfort, KY.
One of three homemade stills, this one
combines steel and copper. Notice the
hydrometer in the right parrot's beak.

ꞙTILL HEAD

Second Sight Spirits, Ludlow, KY. Believing everything we do
should be good for our spirit, Second Sight Spirits distillers
designed this unique copper genie's turban still head for
their pot still. It was crafted at a copper works in Ohio.

FACING

ꝐOT STILL DETAIL

Bluegrass Distillers, Lexington, KY. This still is designed
as an authentic Portuguese alembic still, or pot still.

GRAINS *and* MILLS

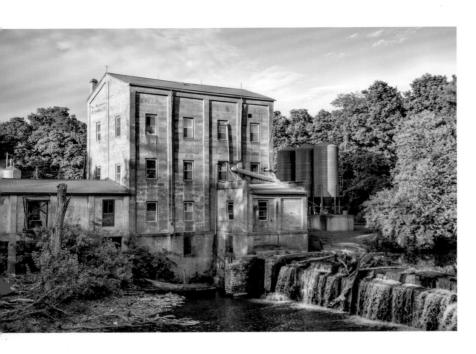

WEISENBERGER MILL

Midway, KY. Weisenberger Mill, founded in 1865, continues to operate today, run by sixth-generation family millers still using many of the same processes that would have been found in the earliest mill but with machinery that has evolved.

PREVIOUS

HAND MILL

Casey Jones Distillery, Hopkinsville, KY. For the small distiller, a handheld mill like this one would be sufficient to mill the corn for the mash.

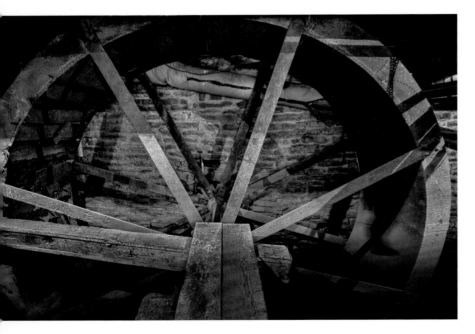

GRIMES MILL WATERWHEEL

Lexington, KY. Grimes Mill was operational from the early 1800s as a mill and later as a distillery. Preserved by its current occupant, the Iroquois Hunt Club, the mill retains the large waterwheel under the building that once turned the millstones.

FACING

GRAIN BINS

Maker's Mark Distillery, Loretto, KY. Malt and barley grains have been stored in these bins since 1954 when Bill Samuels Sr. purchased Burks Spring Distillery and started Maker's Mark.

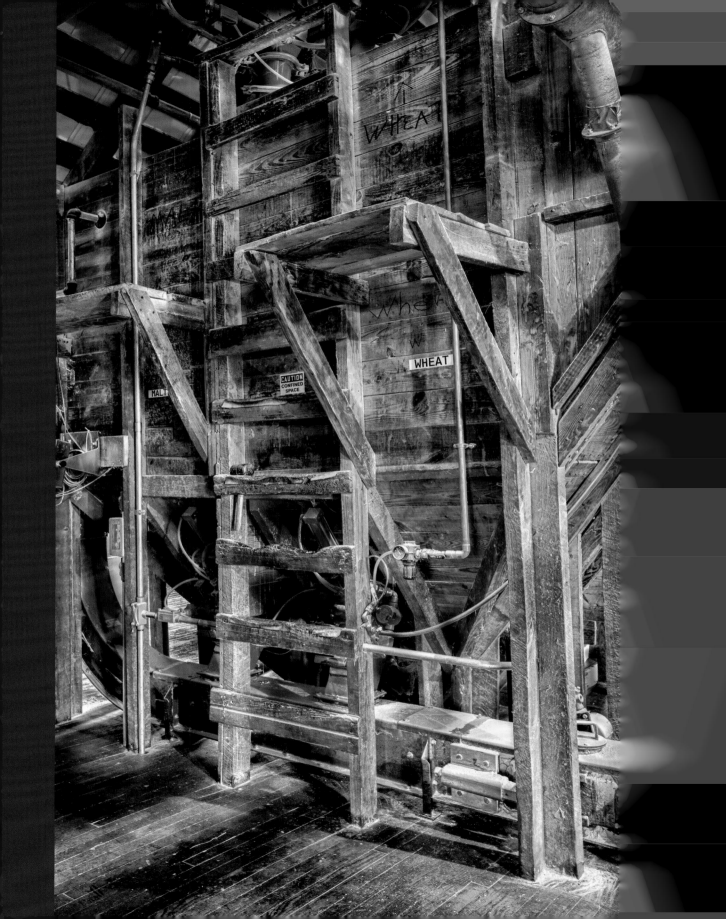

MILL HOPPER

Madison County, KY. Placed on top of the millstone grinding area, this hopper allows grain to be fed into the grinding stones.

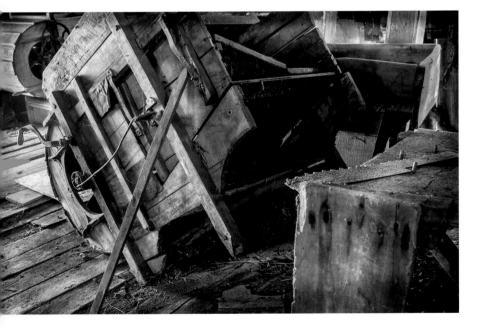

MILL EQUIPMENT

Madison County, KY. Various milling and sorting equipment lays around this mill site, abandoned in the mid-twentieth century.

FACING

OPEN GRINDER

Madison County, KY. In grain milling, two stones are put together with a space in between. The top stone is the only one that moves, and the bottom stone, or the bed stone, is stationary. In this view, with the grinding machine open, the lower bed stone is visible. The wooden wheel on top would have had belts that turned the runner, or top stone.

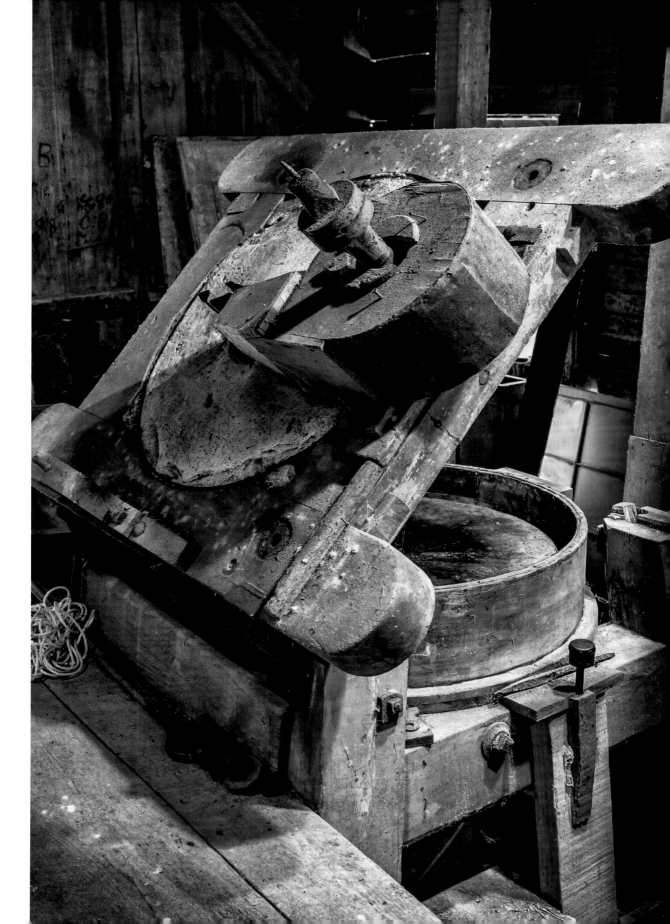

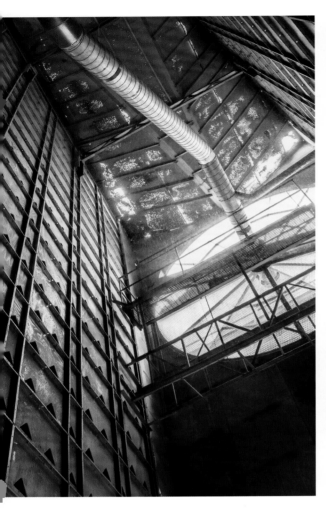

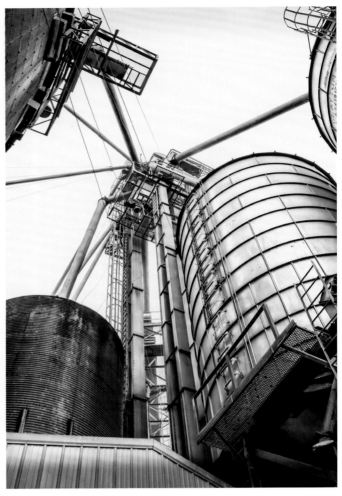

RAIN DRYER

Peterson Farms, Loretto, KY. When storing corn, moisture needs to be removed from the grain to prevent spoiling. This area is part of a cross-flow dryer, typical in modern granaries.

ILOS

Peterson Farms, Loretto, KY. Silos have been a part of the American landscape from earliest times. This granary is different only in size and material from those early distillers' silos.

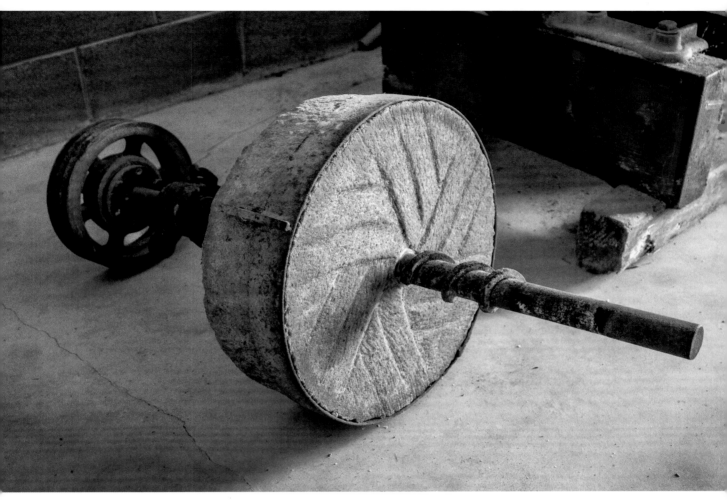

MILLSTONE AND TRANSMISSION ROD

Wade-Lyn Ranch Distilling, Waynesburg, KY. An old stone with the rod that
turns it in a grinder sits in the mill room at this craft distillery.

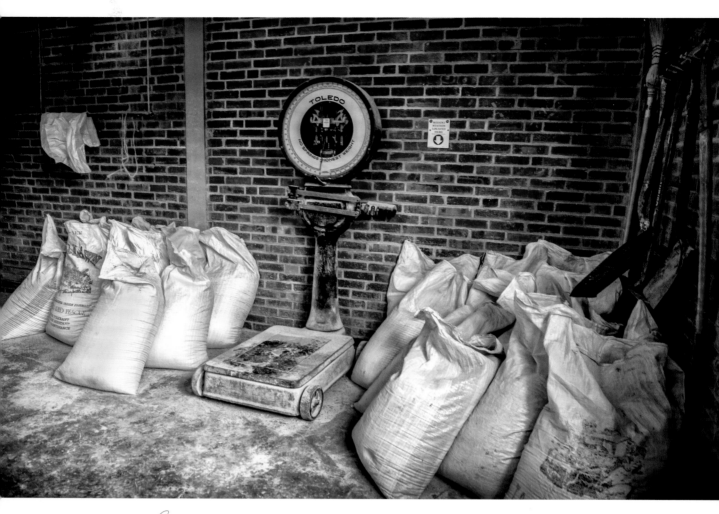

SCALES AND FLOUR BAGS

Barton 1792 Distillery, Bardstown, KY. Most of the larger distilleries mill their own corn on site.

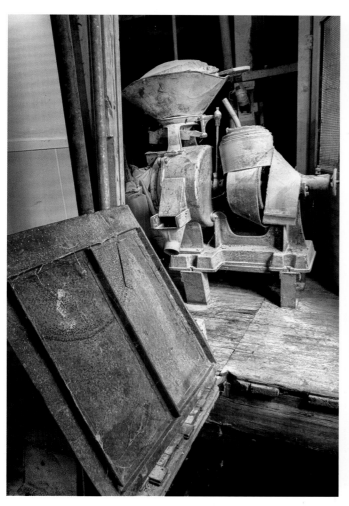

MILL WATER ACCESS

Weisenberger Mill, Lexington, KY. The open door in the foreground leads down to the water run under the mill. Worn belts and a grinder with hopper are also visible in the image.

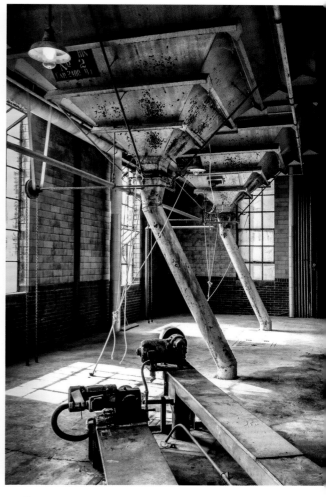

FLOUR BINS

Buffalo Trace Distillery, Frankfort, KY. The George T. Staggs Distillery operated on this site before Buffalo Trace Distillery, and the flour bins from that post-Prohibition operation are still in use.

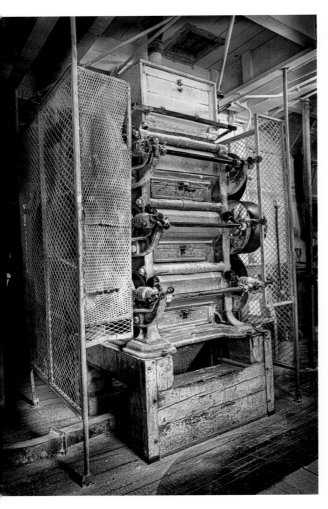

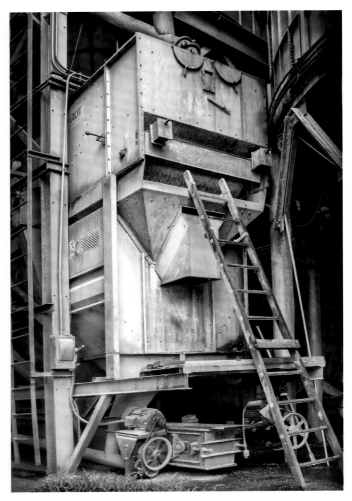

PRODUCT DRAWERS

Weisenberger Mill, Midway, KY. Opening the drawers on this machine allows the inspection of corn sent through a series of grinding mechanisms. This arrangement can be found in mills dating back to before 1920.

CORN HOPPER

Peterson Farms, Loretto, KY. A major supplier of corn to Maker's Mark Distillery, Peterson has a large operation nearby with ample drying and storage capabilities.

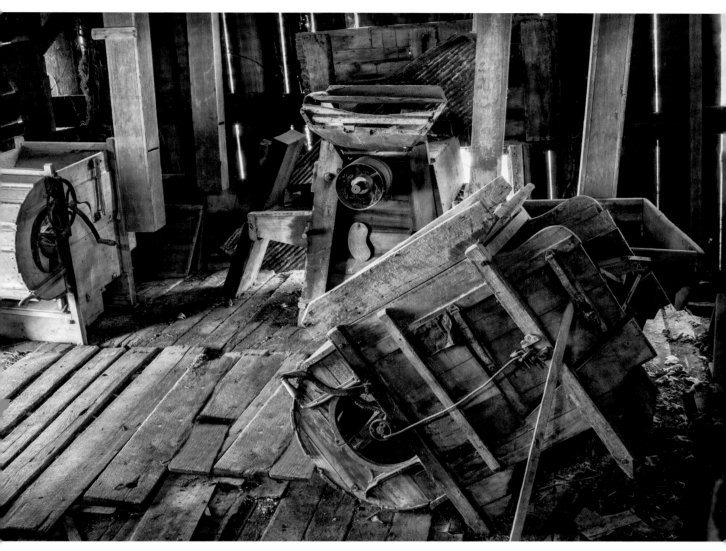

Madison County Flour Mill

Madison County, KY. Up and running by the mid-1800s, this mill was powered by steam. Inside one can see some of the equipment used as the mill continued to run into the 1930s.

FOLLOWING

Millstone Steps and Wall

Midway, KY. The used millstones from Weisenberger Mill, which has operated continuously since 1865, have been ingeniously used within the stone wall on adjacent properties.

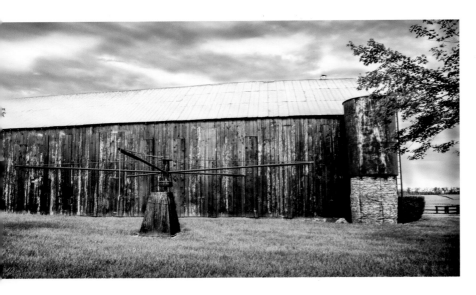

HORSE-PULLED MILL

Scott County, KY. A variety of mills have been used to grind grains needed for bourbon. In this image the millstone in the center would have been attached to pole. The animal's efforts would turn the pole, which would turn the stones, grinding the grain.

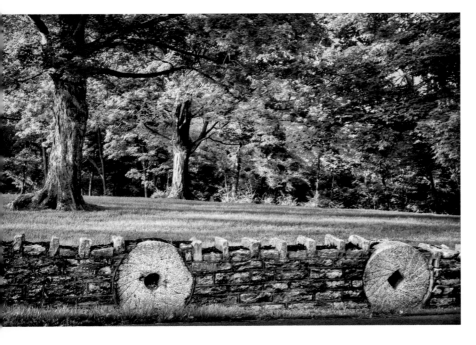

MILLSTONE FENCE

Midway, KY. Outside of Weisenberger Mill is a historic stone fence made of old millstones. The entire area, including an old bridge, is listed on the National Register of Historic Places.

FACING

BUSH MILL

Lower Howard's Creek, Boonesborough, KY. Bush Mill was a three-story mill that operated as a commercial mill and distillery within a thriving community. Now, like so many mills, all that is left are these stone ruins.

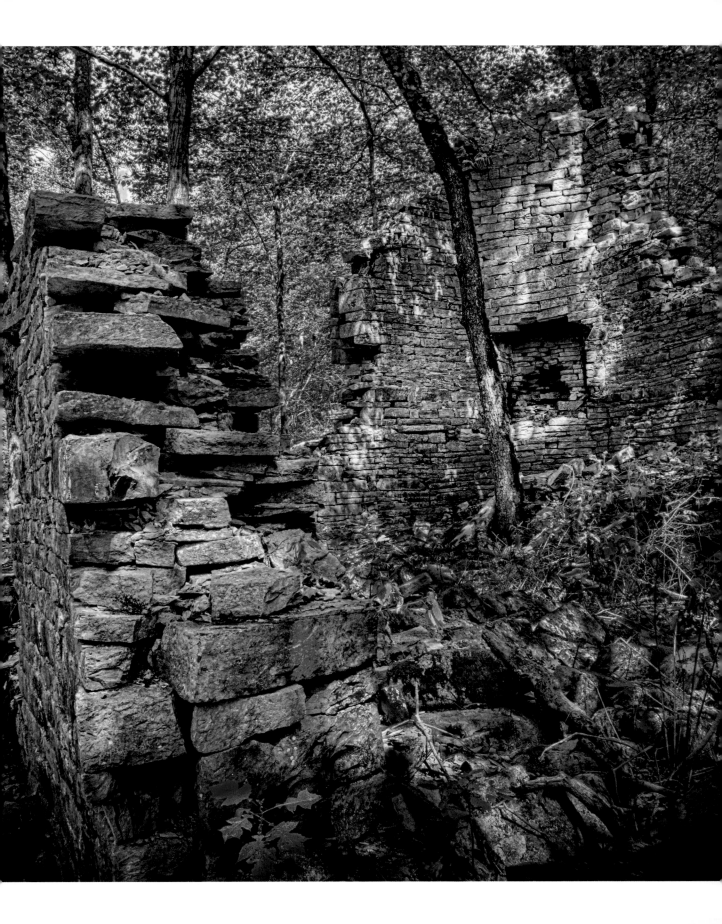

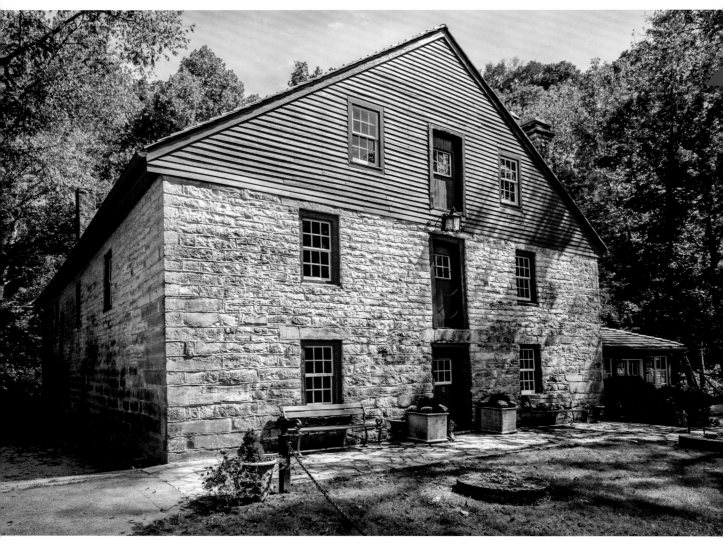

GRIMES MILL

Lexington, KY. Millers often operated distilleries because of the abundance of grains available to them. Often, too, millers were paid in extra grains for their labors. The Grimes Mill operated from 1805 as a mill and from 1817 as a distillery making Old Grimes Whiskey.

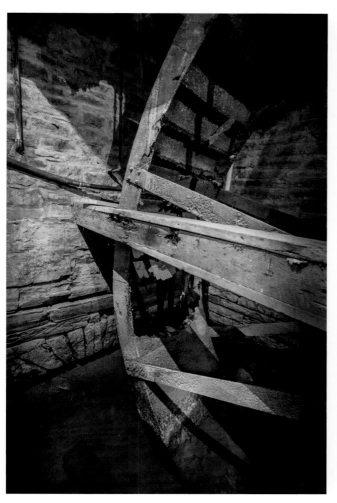

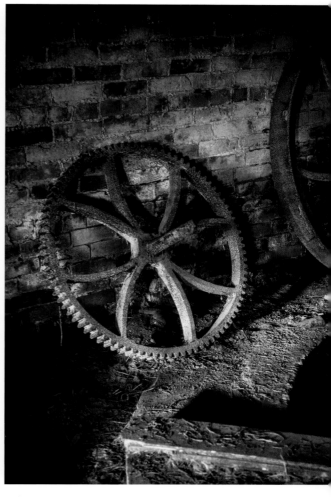

LEFT SECTION OF WATERWHEEL

Grimes Mill, Lexington, KY. The waterwheel under the mill is no longer in use but is retained by the hunt club that owns the building now.

MILL COG

Scott County, KY. This large cog was once part of the mechanism that turned a millstone, grinding corn into fine flour for the mash bill.

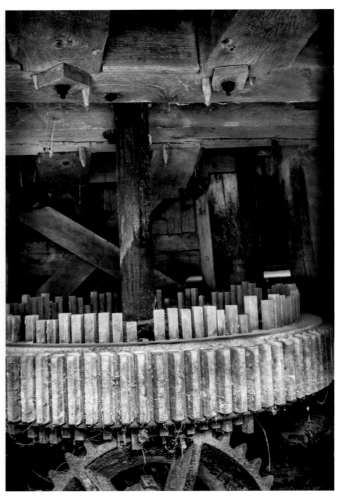

GRANARY HOPPER

Peterson Farms, Loretto, KY. A system of chutes, hoppers, and silos combine to make up the large contemporary granary.

WOODEN MILL WORKS

Guyn's Mill, Woodford County, KY. Guyn's Mill had both a gristmill, built in 1870, and a sawmill, built in 1840. Underneath the foundation of the gristmill one can still see the wooden gears and cogs that connected interior millstones to the steam engine outside.

FACING

BACK VIEW OF MILL WHEELS

Weisenberger Mill, Lexington, KY. These interior wheels spin to turn various grinding mechanisms in the mill.

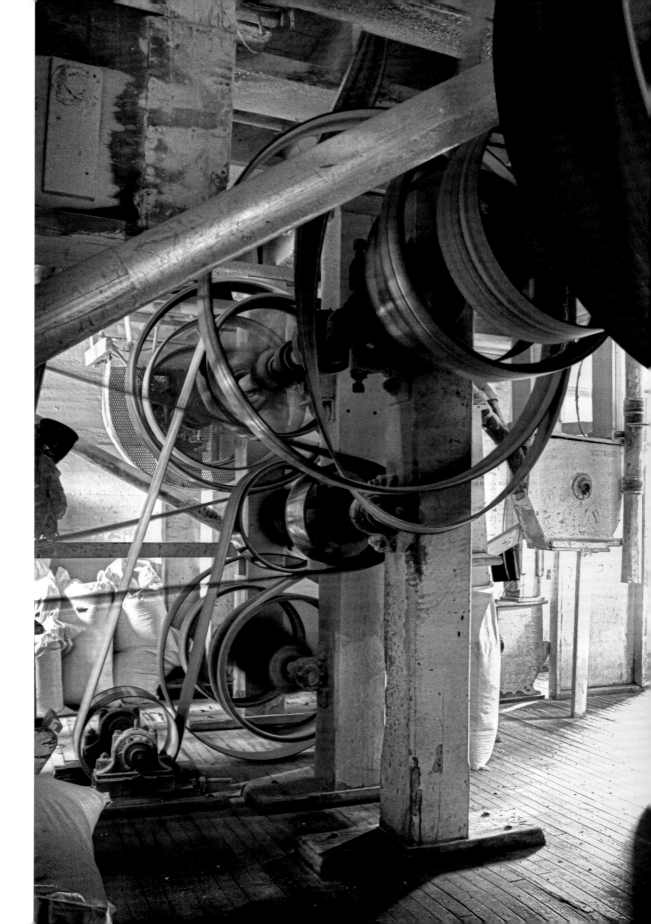

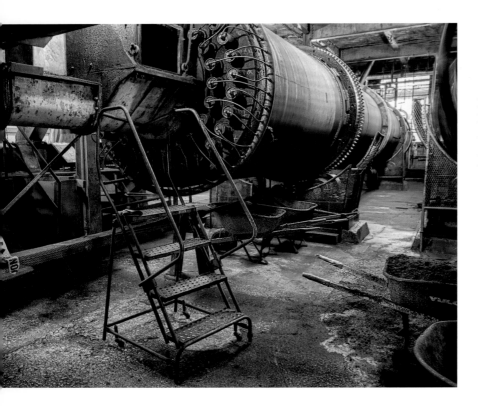

Dryer Room

Barton 1792 Distillery, Bardstown, KY. Recycled grain from the distilling process is dried in ovens and in these huge turning dryers before being sold as animal feed.

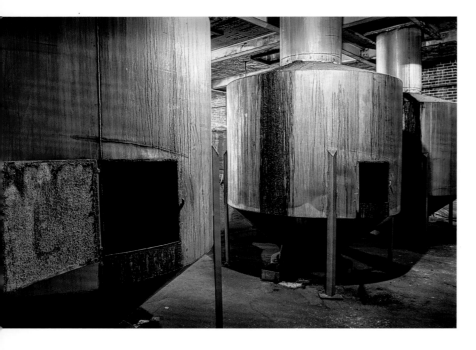

Grain Dryers

Barton 1792 Distillery, Bardstown, KY. After the grain is spent, or used in the distilling process, it is dried and recycled as animal feed.

FACING

Grain Chutes

Maker's Mark Distillery, Loretto, KY. Once the grain is fed from the grain hoppers outside the distillery, it goes through these chutes on its way to the fermenting process.

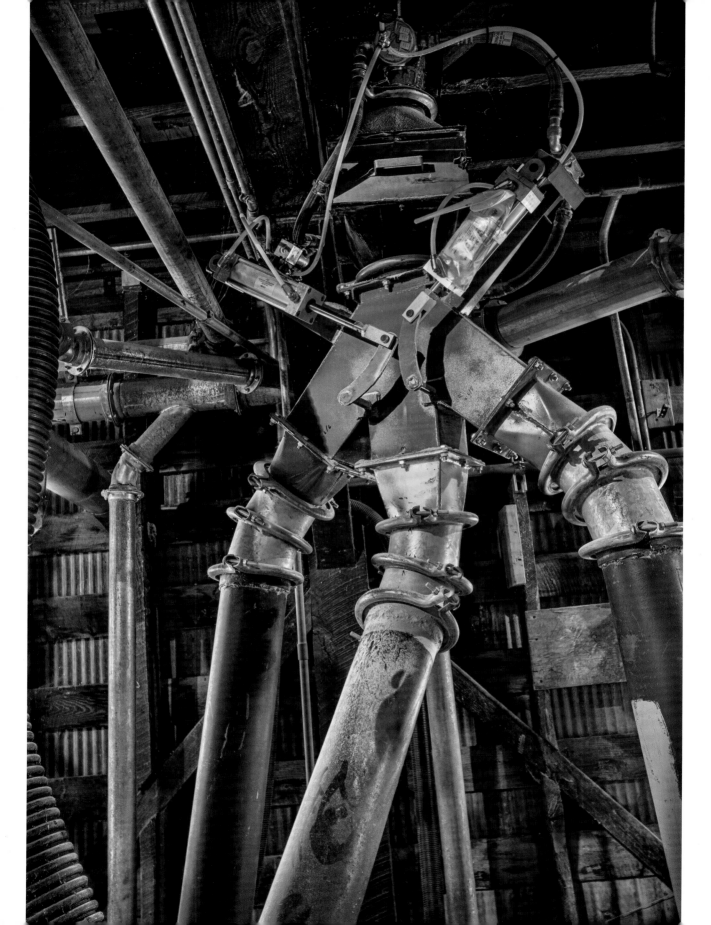

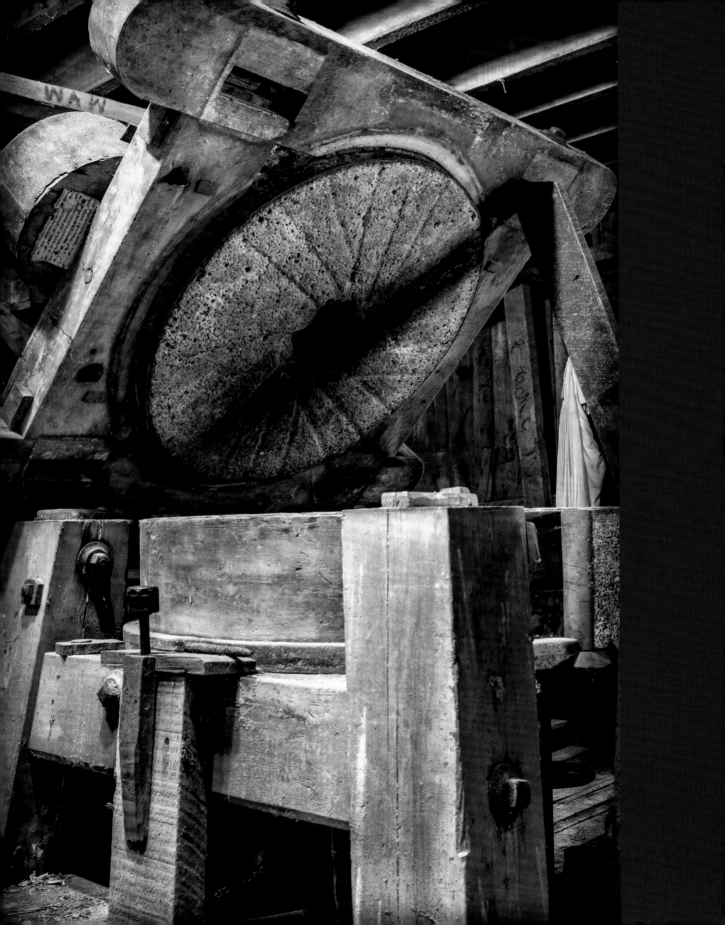

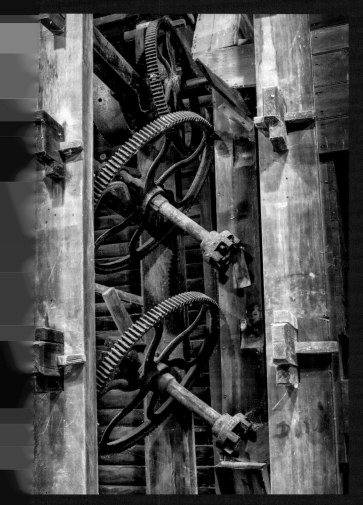

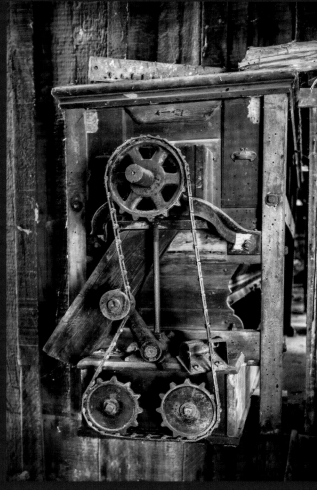

SIFTER GEARS

Madison County, KY. The gears that run the hopper and sifter system are held in place by hand-cut wooden pegs.

GEARING

Madison County, KY. Throughout all mills are multiple gears used to run power transmissions, sorting machinery, and grinding machinery. Note the cabinetry on this sorter.

FACING

RUNNER STONE IN GRINDER

Madison County, KY. In the grinding process, the top stone is known as the runner, since it is the only stone that moves, grinding the grain.

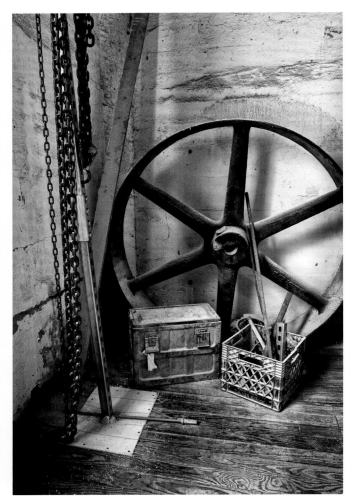

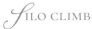ILO CLIMB

Peterson Farms, Loretto, KY. When climbing
any silo or tower straight up, it is good
to have these metal rings for safety.

𝒲HEEL AND TOOLS

Weisenberger Mill, Midway, KY. Weisenberger Mill has had
continuous operation for more than 150 years. Inside is a still
life typical of any mill: wheel, toolbox, and miscellaneous tools.

FACING

𝓜ILL WHEELS

Weisenberger Mill, Midway, KY. Inside, the mill
wheels still spin, turned by belts and powered by South
Elkhorn Creek. Weisenberger mills grains for several
local craft distilleries as well as bakers' flours.

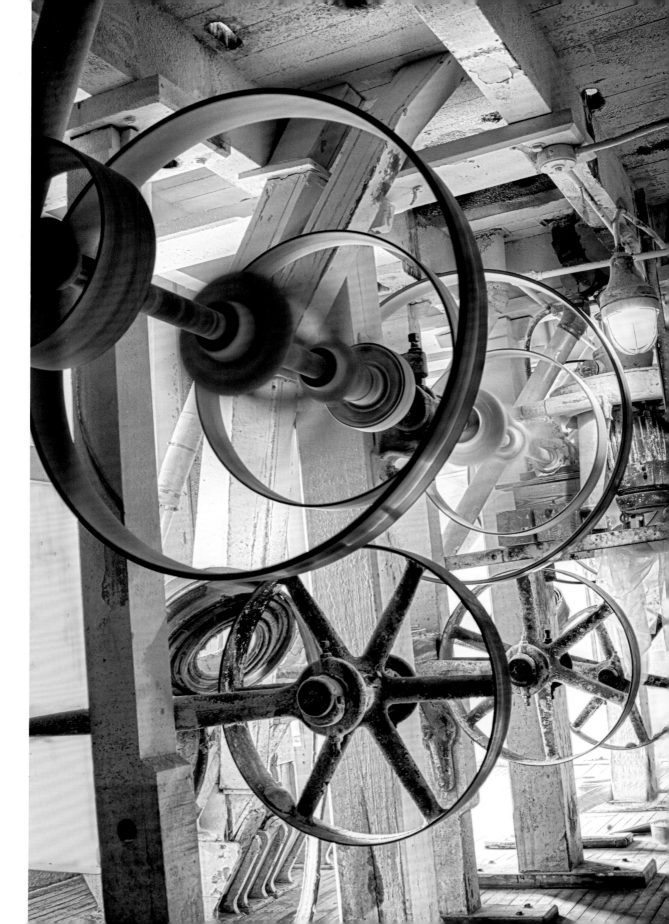

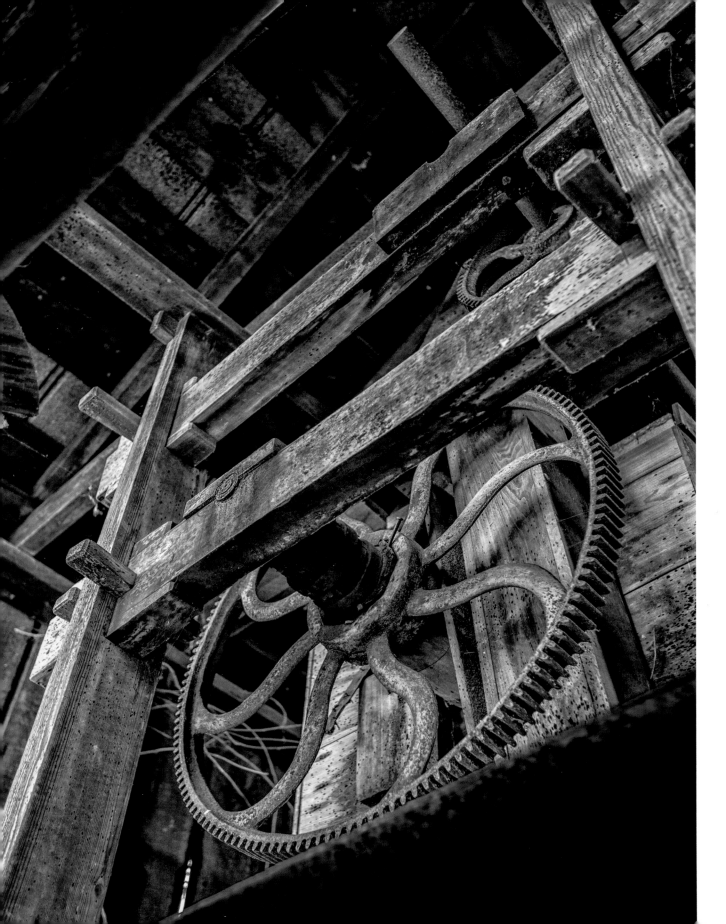

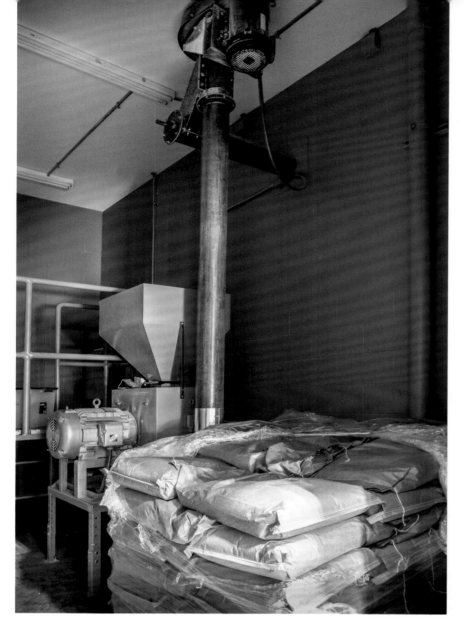

MILL AND FLOUR BAGS

Boone County Distilling Co., Boone County, KY. Many of
the small craft distilleries have begun to mill their own corn,
with areas of the distillery set aside for the mill works.

FACING

SIFTER GEAR

Madison County, KY. Elevated on the second floor of this mill that
operated from 1867 to 1920 are two sifters that turned the grain before
it was funneled through hoppers to the grinding area on the first floor.
This gear was part of several used for the sifter and hopper system.

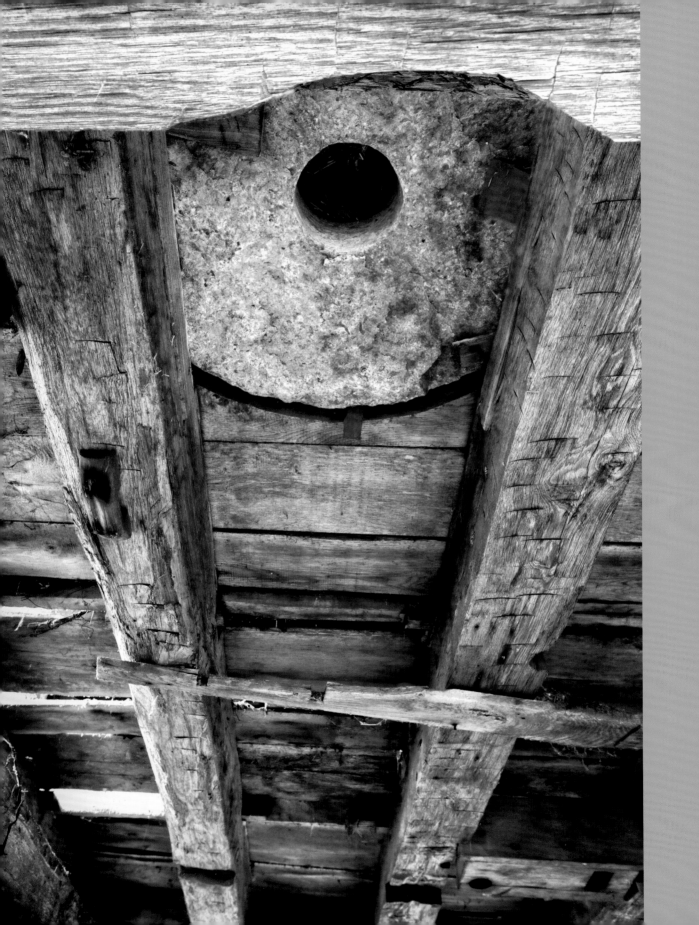

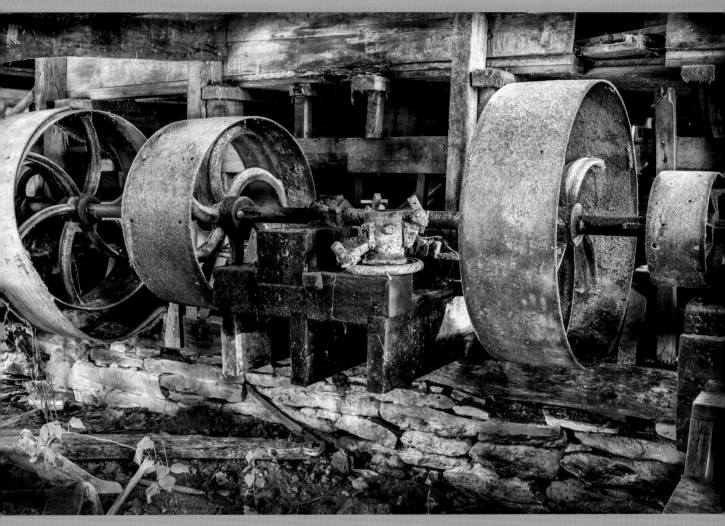

TWO FLYWHEELS

Madison County, KY. In this old flour mill, which operated from the mid-
nineteenth to the mid-twentieth century, a steam-powered transmission turned
these belt-driven flywheels to operate various milling machinery.

FACING

SAWMILL STONE

Guyn's Mill, Woodford County, KY. From underneath the sawmill,
next to the creek, a grist buhr can be seen still in place.

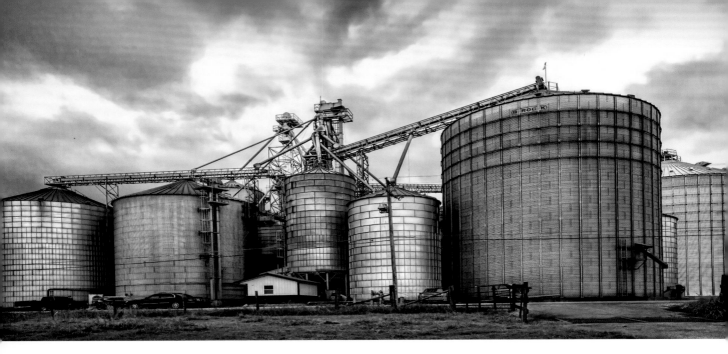

Peterson Farms

Loretto, KY. The role of the farmer and agriculture is rarely acknowledged in the marketing and promotion of bourbon. Yet grains are the essential ingredients in turning water to whiskey, and it is the farmer who makes that possible.

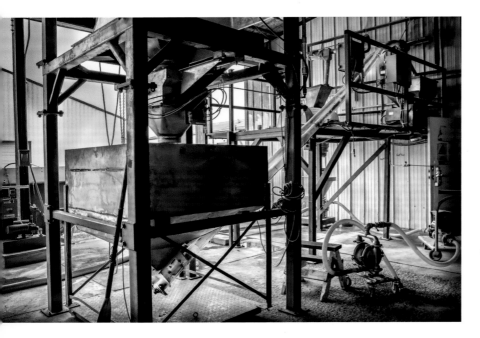

Milling

Kentucky Artisan Distillery, Crestwood, KY. As the craft bourbon industry expands, distillers distinguish their product and image by becoming as fully self-sufficient as possible, which can include maintaining their own milling operations.

FACING

Grain House

Old Crow Distillery, Frankfort, KY. No longer operating, the grain house of the Old Crow Distillery once was where corn and other grains were delivered, sorted, milled, and mixed into the mash bill. A craft distillery, Glenns Creek Distillery, now operates out of the bottling house of the Old Crow plant.

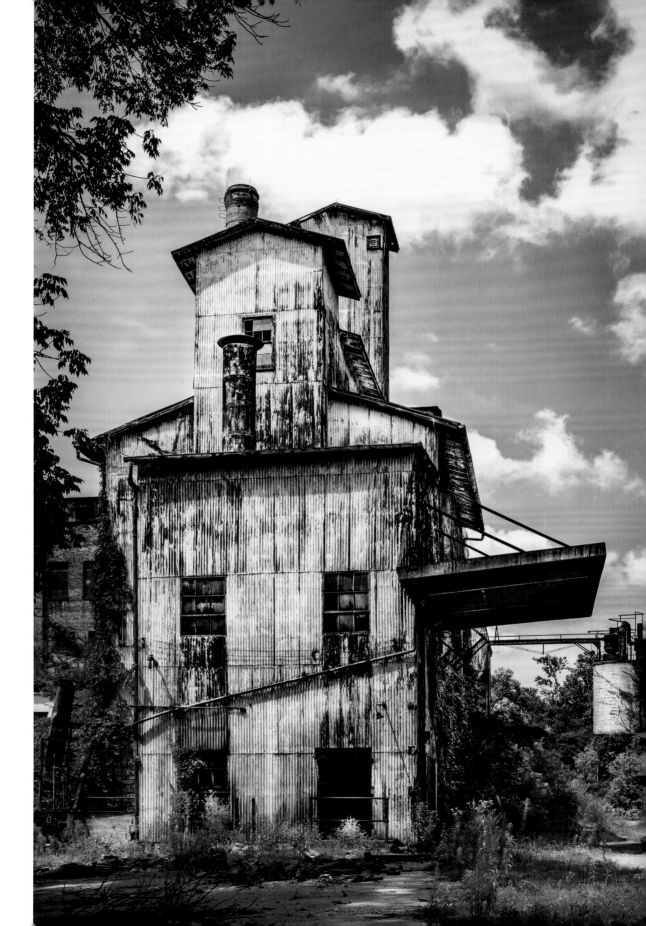

CORN AND COB MILL

Wade-Lyn Ranch Distilling, Waynesburg, KY. Wade-Lyn Ranch craft distillery grows and then mills its own corn using this electric-powered hammer mill.

FACING

GRAIN CHUTES

Maker's Mark Distillery, Loretto, KY. Large chutes deliver grain to the lower levels of the distillery to be mixed in the mash bill, or recipe.

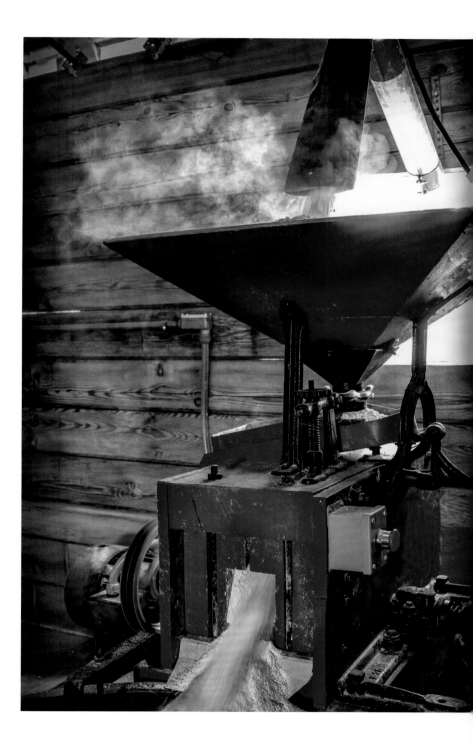

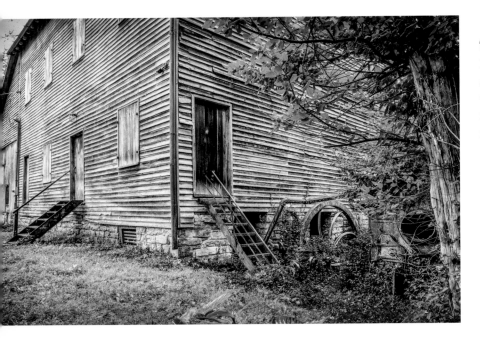

RISTMILL

Guyn's Mill, Woodford County, KY. The Guyn brothers developed a bustling community, starting with the two mills in the mid-1800s. This gristmill ran from 1846 until the 1920s.

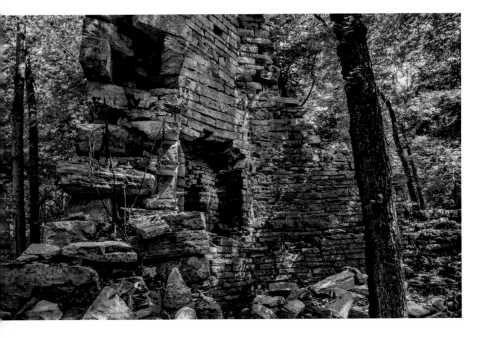

*F*IREPLACE

Bush Mill, Lower Howard's Creek, Boonesborough, KY. At one time mills were prolific in Kentucky, with 960 flour mills and sawmills in production across the state. Often the miller was also a distiller. Bush Mill operated as both a gristmill and a distillery in its day.

FACING

*F*LYWHEEL

Guyn's Mill, Woodford County, KY. This flywheel was part of the 1880s steam-powered transmission system that ran the gristmill.

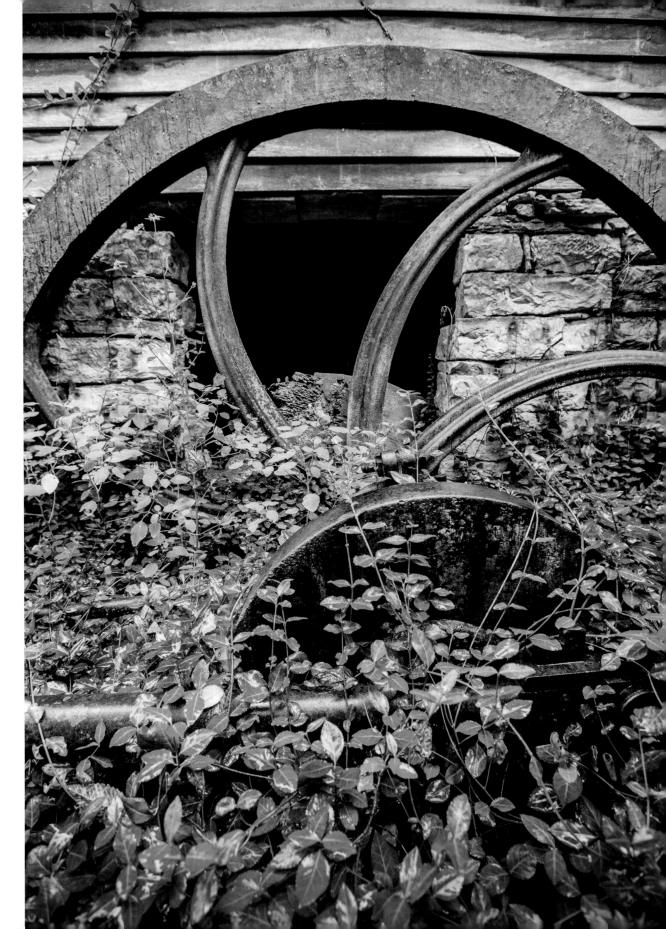

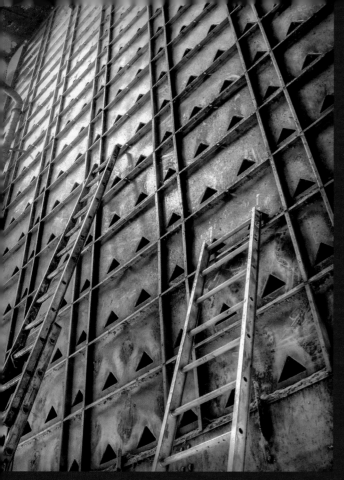

Ladders in the Dryer

Peterson Farms, Loretto, KY. Ladders leaning against the walls of the dryers allow for inspection of the drying process.

LEFT

Gears and Rafters

Madison County, KY. On the second floor of this old mill the gears and wheels that run the hopper and sifter systems still have old belts attached. They sit quietly among the hand-hewn rafters and wooden bins.

FACING

Vertical View of Gears

Madison County, KY. Typical of the mid-nineteenth- and twentieth-century milling industry, these gears and wheels are beautiful to look at, even when inoperative.

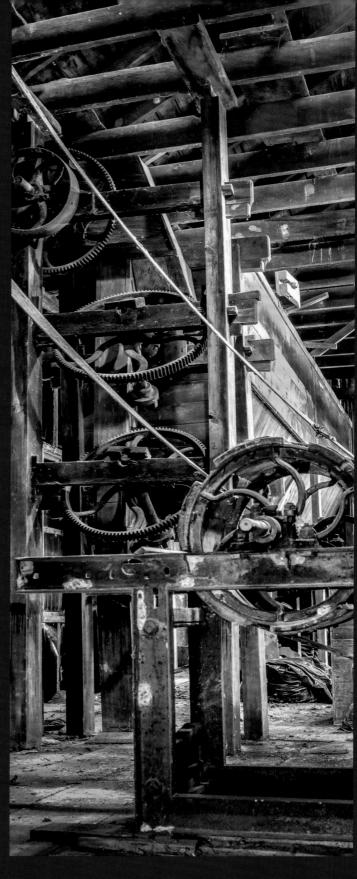

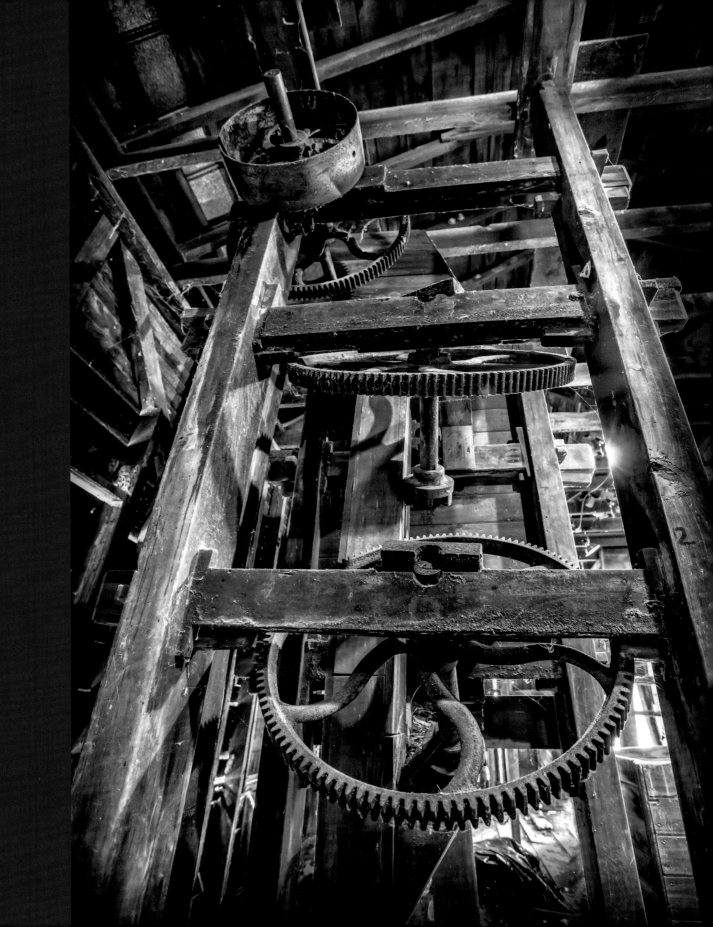

BARRELS

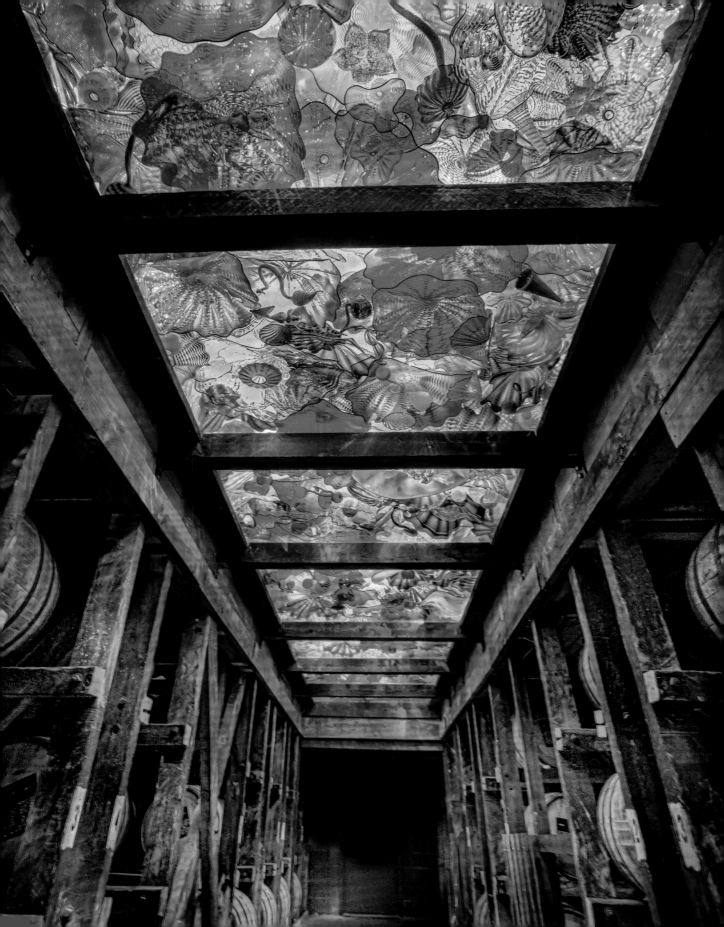

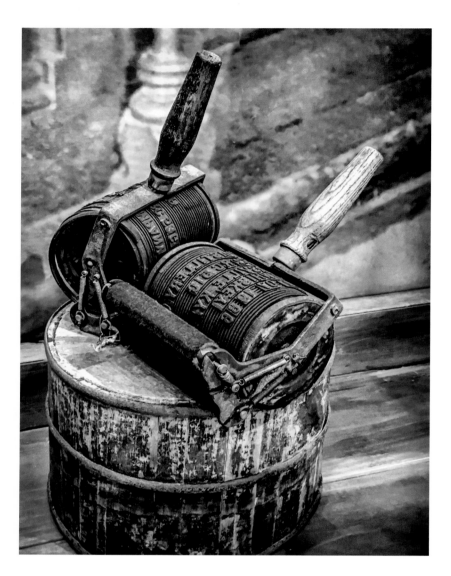

*H*ISTORIC BARREL STAMPERS

Bourbon Heritage Center, Heaven
Hill Bourbon Distillery, Bardstown,
KY. These rollers were inked and
run over barrelheads to mark the
barrels with distillery name, dates,
and other important information.

PREVIOUS

*C*HIHULY GLASS
WAREHOUSE CEILING

Maker's Mark Distillery, Loretto, KY. Following
a long tradition of art and embellishment on
distillery sites, Maker's Mark commissioned
artist Dale Chihuly to craft a magnificent
glass ceiling for this warehouse.

FACING

*R*USTED RINGS

Buffalo Trace Distillery, Frankfort,
KY. In Warehouse B, one of the earliest
warehouses in the historic distilleries
that preceded Buffalo Trace on its current
site, two old barrel rings hang.

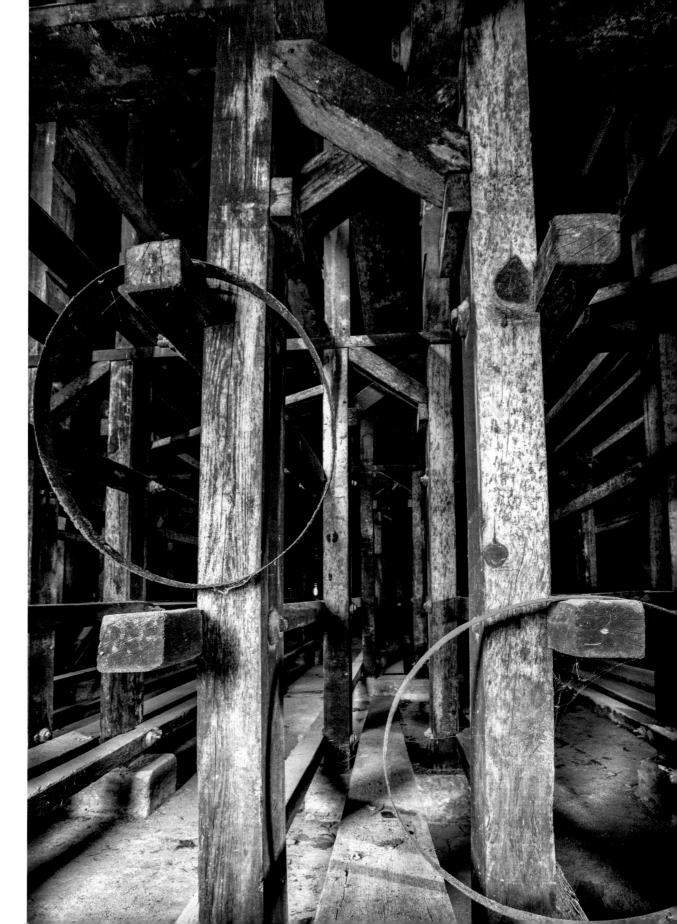

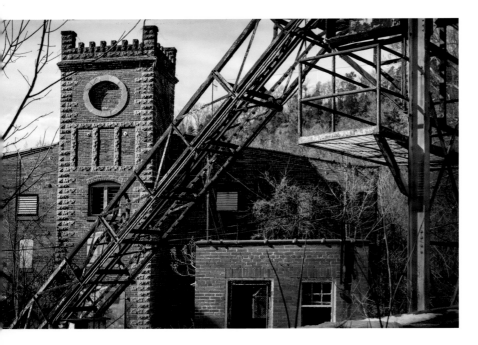

Overhead Barrel Run

Old Taylor Distillery, Frankfort, KY. The Old Taylor Distillery had an elaborate system of gear-driven barrel runs that transported barrels from the warehouses across the street to the bottling house and other buildings on the plant site.

Smoke and Branding

Wade-Lyn Ranch Distilling, Waynesburg, KY. Wade-Lyn Ranch Distilling uses several different ways to brand the barrelhead. In this image, a locally made branding iron is used.

FACING

Branding Iron

Wade-Lyn Ranch Distilling, Waynesburg, KY. An unusual way to mark the barrelhead is to heat a branding iron. A more typical way is to use spray paint with a stencil.

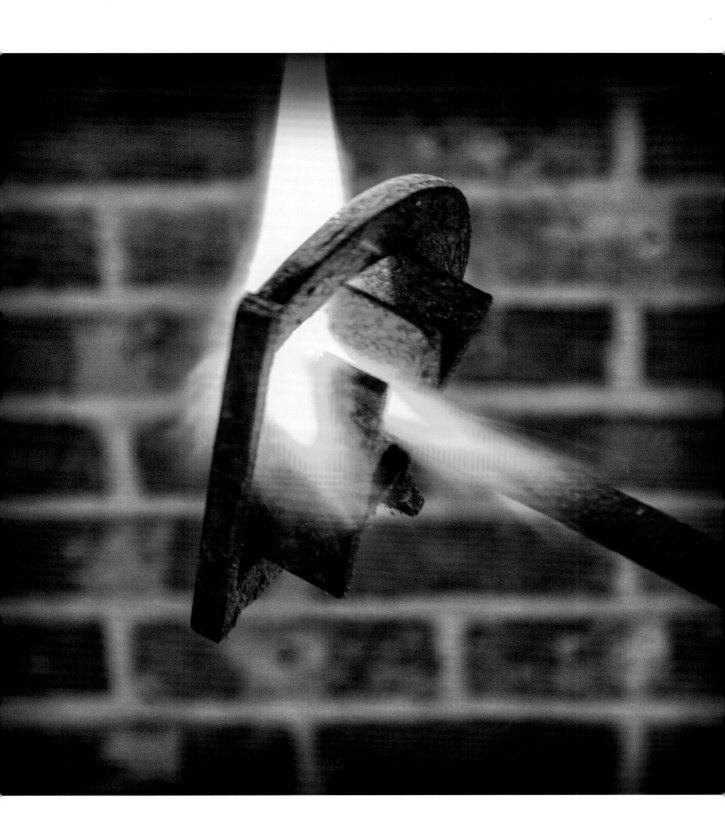

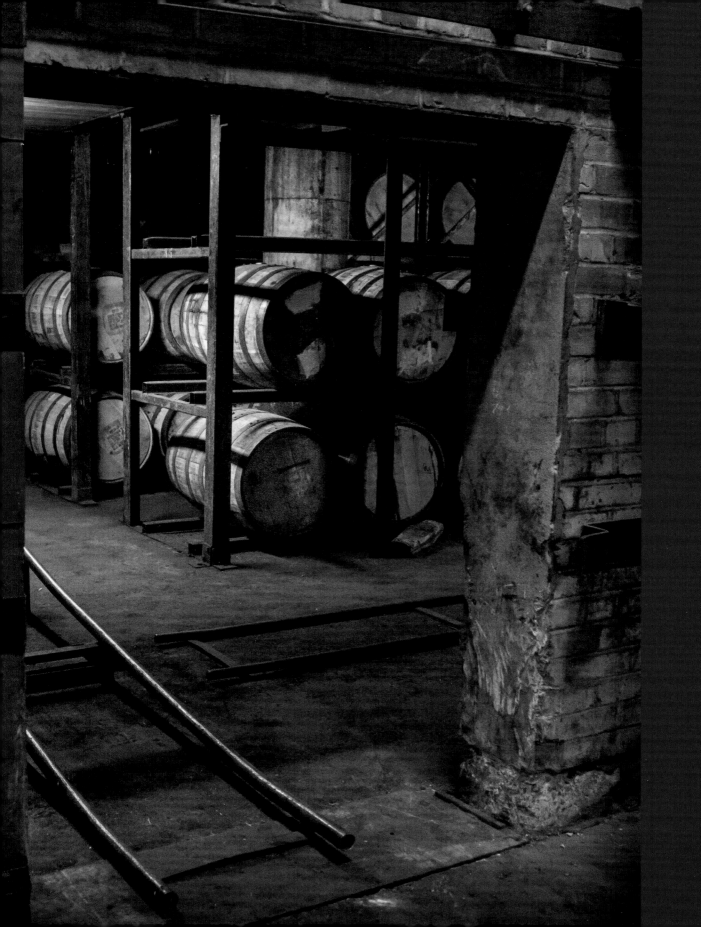

BARRELS READY FOR BRANDING

Buffalo Trace Distillery, Frankfort, KY. These barrels are ready to have information stamped on the barrelheads.

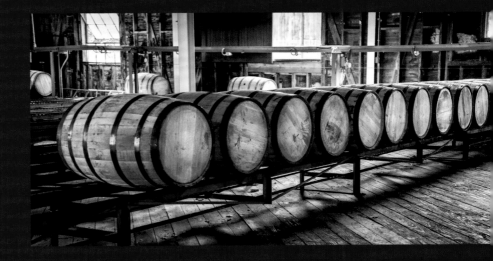

BARREL AND SCALES IN OLD COOPERAGE

Bulleit Distillery, Louisville, KY. A display replicating an old cooperage is on the former Stitzel-Weller Distillery site, now occupied by Bulleit Distillery.

FACING

WAREHOUSE BARRELS AND BARREL RUN

Brown-Forman Distillery, Louisville, KY. A barrel run is located inside the warehouse to help move barrels throughout.

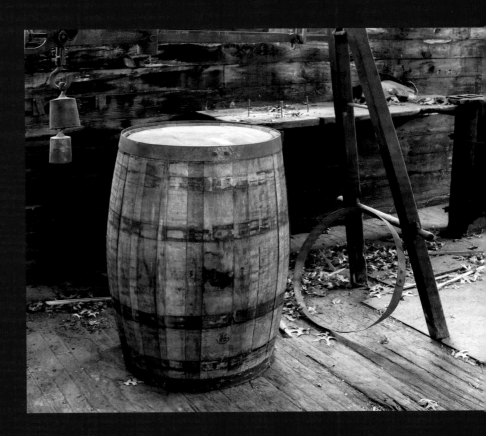

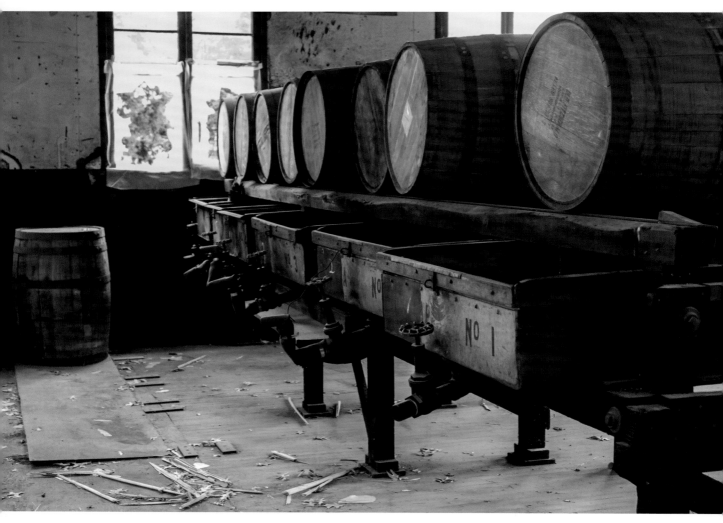

*H*ISTORIC DUMPING TROUGH

Bulleit Distillery, Louisville, KY. Barrels in this historic display are lined up and ready to dump bourbon into troughs after completing their aging process in nearby warehouses. From there the bourbon is cut and bottled.

FACING

*H*ISTORIC COOPERAGE DISPLAY

Bulleit Distillery, Louisville, KY. This image shows the old barrel scales and windows of the building that once operated a cooperage for an earlier distillery.

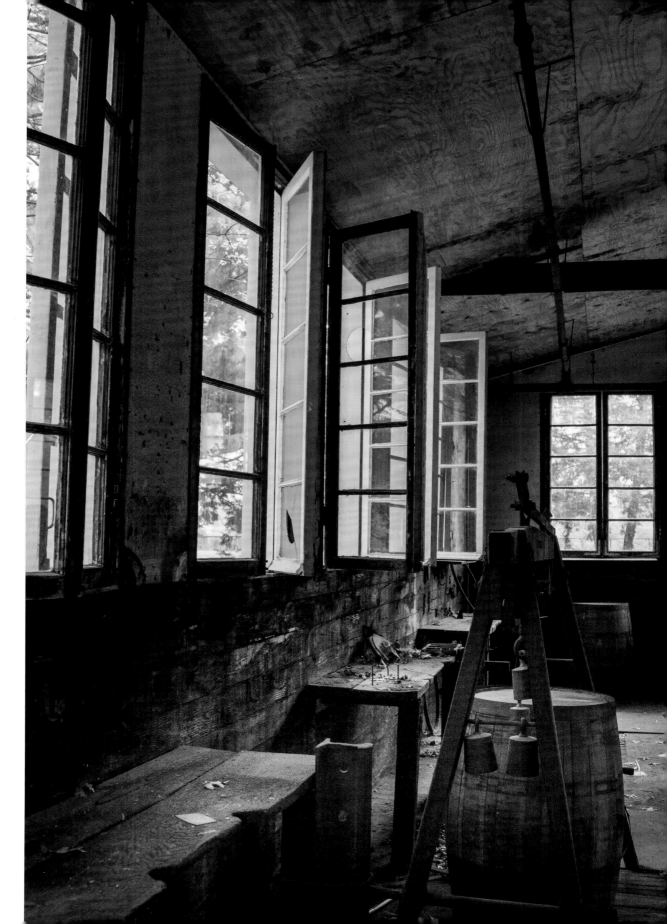

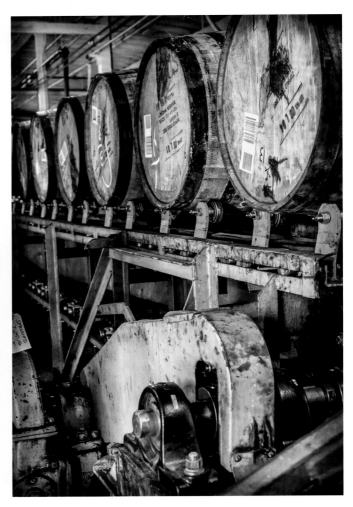

ℋISTORIC COOPERAGE AND RINGS

Bulleit Distillery, Louisville, KY. This section of the historic cooperage display shows where staves would have been prepared and assembled into barrels.

𝒜FTER THE DUMP

Buffalo Trace Distillery, Frankfort, KY. Once the bourbon is emptied from the barrels in the regauge room, the barrels continue on the conveyor line to be recycled and reused with other spirits.

FACING

ℬARRELHEAD CHARRING LINE

Kentucky Cooperage, Lebanon, KY. White oak fuels the fire as barrelheads are charred with wood at Kentucky Cooperage, a part of Independent Stave Co.

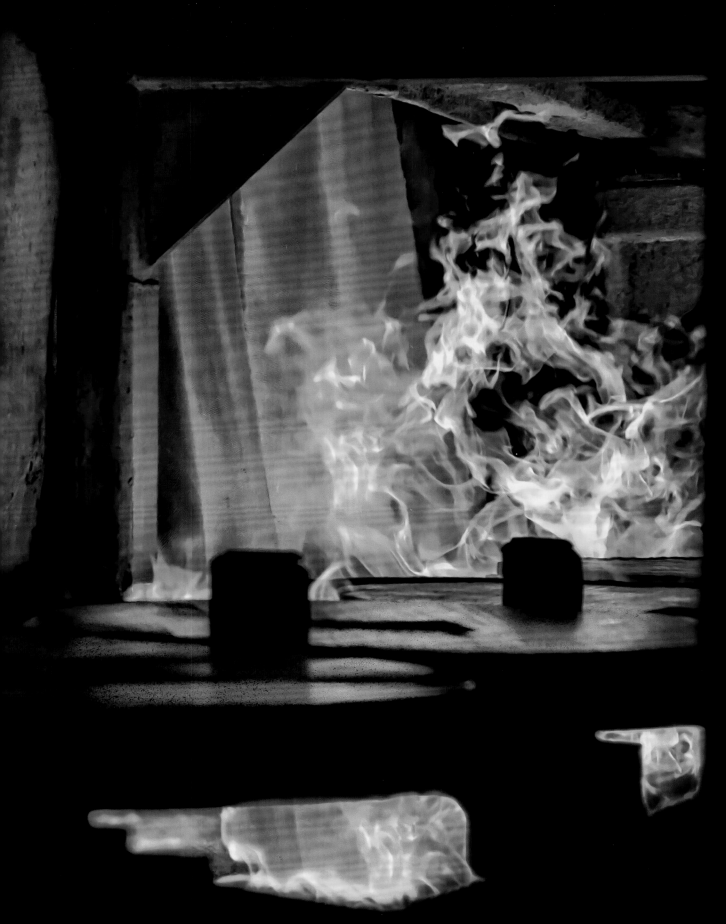

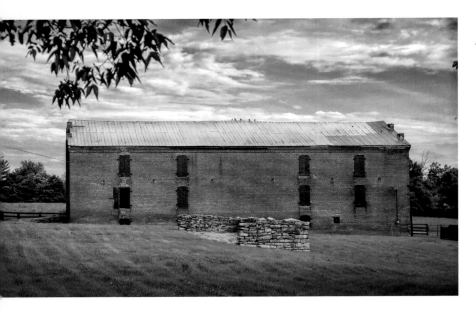

James Stone Distillery Warehouse

Scott County, KY. This is one of the oldest brick bourbon warehouses in the region, located on the banks of South Elkhorn Creek. The stone foundation of the old distillery can be seen in the foreground.

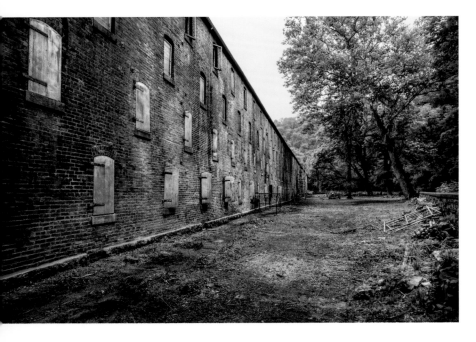

Longest Rick Warehouse

Castle and Key Distillery, Frankfort, KY. This rick house, once considered the longest in the world, is on the Old Taylor Distillery site, now the Castle and Key Distillery. It is almost six hundred feet long, the equivalent of two football fields.

FACING

Warehouse B Plumb Bob

Buffalo Trace Distillery, Frankfort, KY. Although no longer used, Warehouse B retains its plumb line after more than a century.

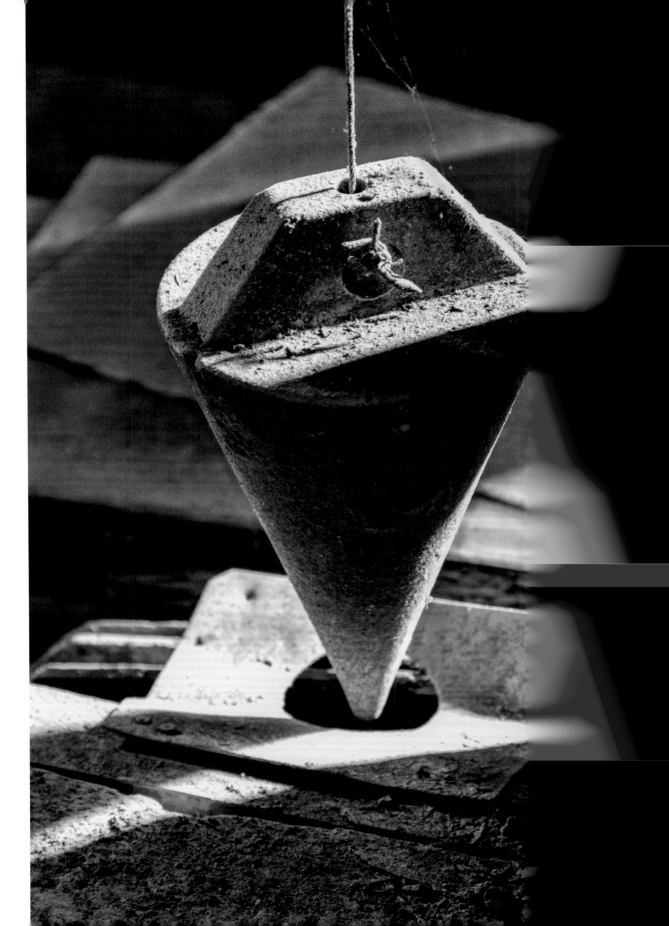

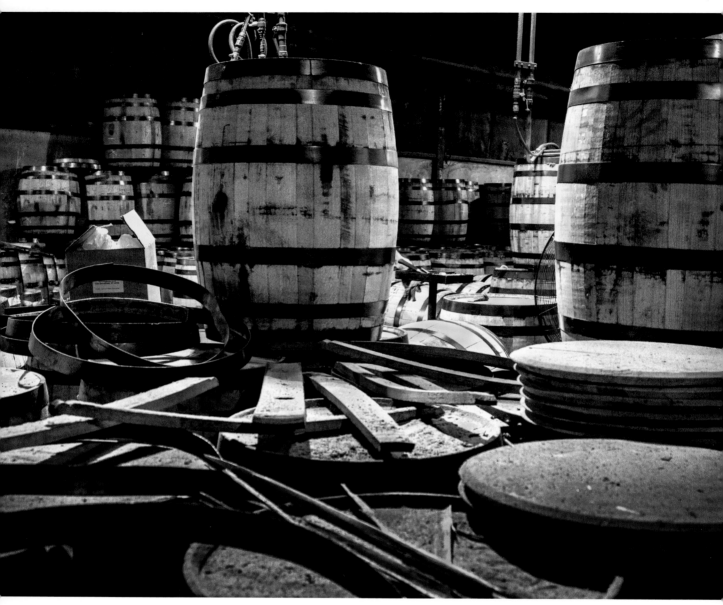

Testing the Barrels

Robinson Stave Company and East Bernstadt Cooperage, East Bernstadt, KY. After the barrels are complete and before they go into the truck, they are tested for leaks and quality.

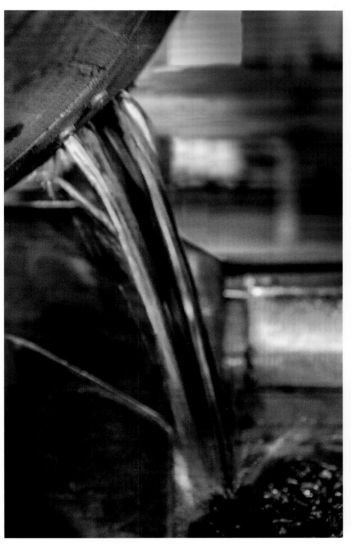

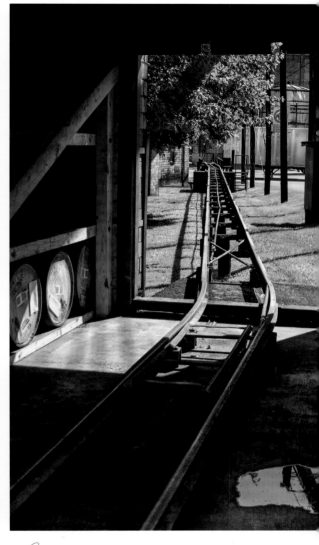

OURBON POUR

Buffalo Trace Distillery, Frankfort, KY. Barrels are lined up and moved along a conveyor. When the bung is removed, the barrels tip forward to empty their contents into a trough.

ƧECTION OF A BARREL RUN

Buffalo Trace Distillery, Frankfort, KY. All throughout distilleries are barrel runs, allowing the movement of barrels not only within distillery buildings but also across the distillery campus from building to building.

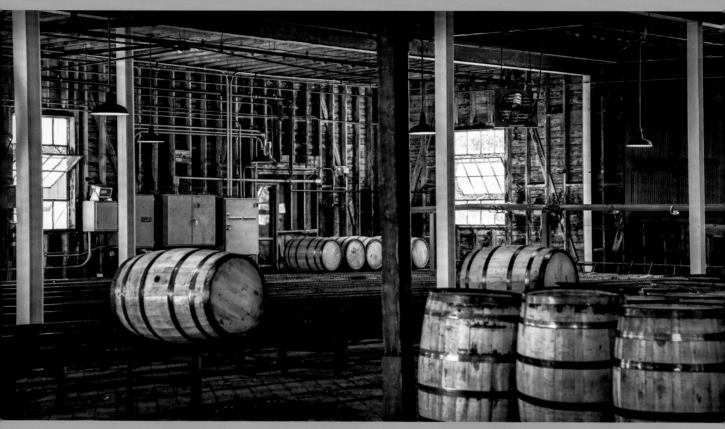

ℬRANDING SHED

Buffalo Trace Distillery, Frankfort, KY. When barrels arrive at the distillery from the cooperage, they are processed in the branding building, where, among other things, the stamping of the barrelheads with the distillery name and date is done.

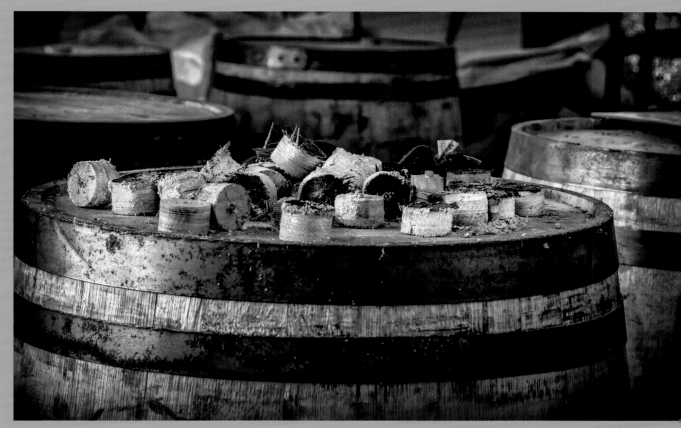

ℬUNGS ON A BARRELHEAD

Three Boys Farm Distillery, Graefenburg, KY. Hand-cut bungs sit on a barrelhead, waiting to close the barrel openings after the barrels are filled.

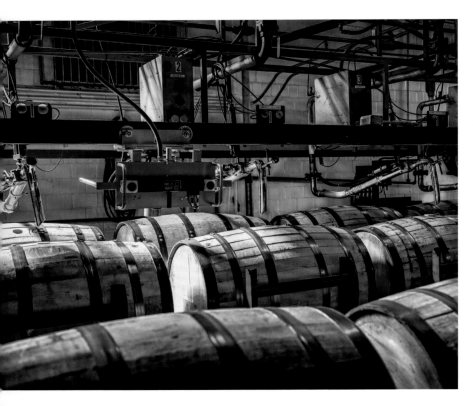

Barrel Filling in the Cistern Room

Buffalo Trace Distillery, Frankfort, KY. Once the barrels leave the branding shed, they go into the cistern room, where they are filled with whiskey before going to the warehouse to age.

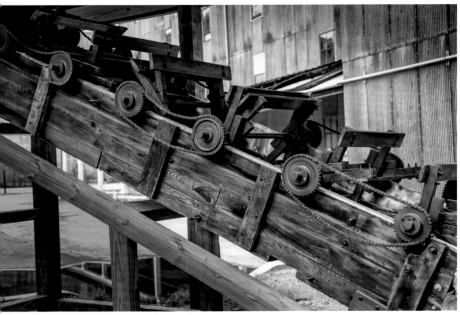

Historic Barrel Conveyor

Bulleit Distillery, Louisville, KY. This historic barrel conveyor is on display at Bulleit Distillery.

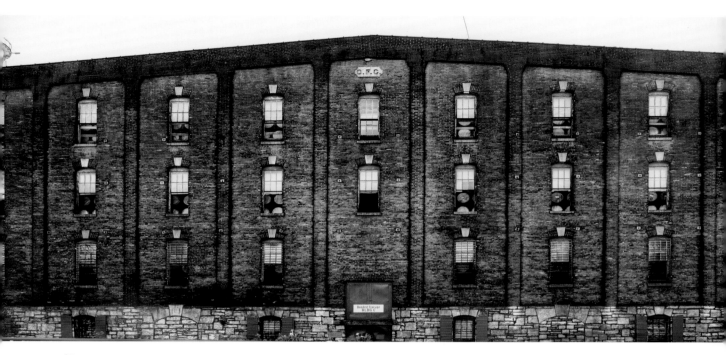

Only Fire and Copper Distillery Warehouse

Buffalo Trace Distillery, Frankfort, KY. The first distillery on the site that Buffalo Trace Distillery currently occupies was owned by E. H. Taylor and called Only Fire and Copper Distillery. This warehouse dates from 1870 and boasted a first-of-its-kind steam heating system, still used today.

Rick Warehouse Corner

Buffalo Trace Distillery, Frankfort, KY. This is a typical rick warehouse view, showing aging barrels stacked on wooden racks.

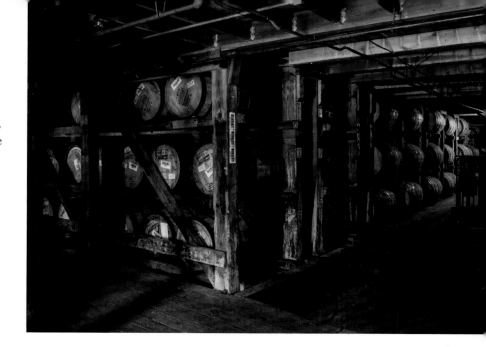

Single Barrel Fill

Bulleit Distillery, Louisville, KY. In the craft distillery section of Bulleit Distillery, one can observe a single barrel filled.

FACING

Warehouse Window Art

Buffalo Trace Distillery, Frankfort, KY. The chemicals from the "angels' share" of alcohol that escapes from the barrels create a colorful canvas on this window.

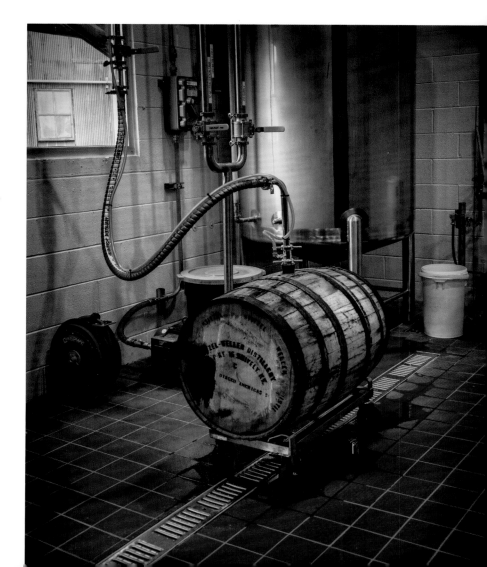

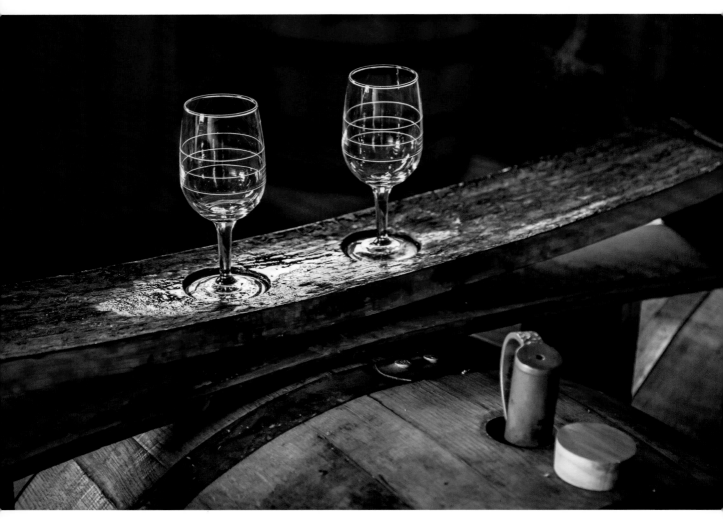

TWO GLASSES ON A STAVE

Buffalo Trace Distillery, Frankfort, KY. During a private barrel selection, many different barrels of bourbon are tasted using glasses such as these.

FACING

BARREL

Barton 1792 Distillery, Bardstown, KY. Barrels sit on display for tourists in one of the warehouses at Barton 1792 Distillery.

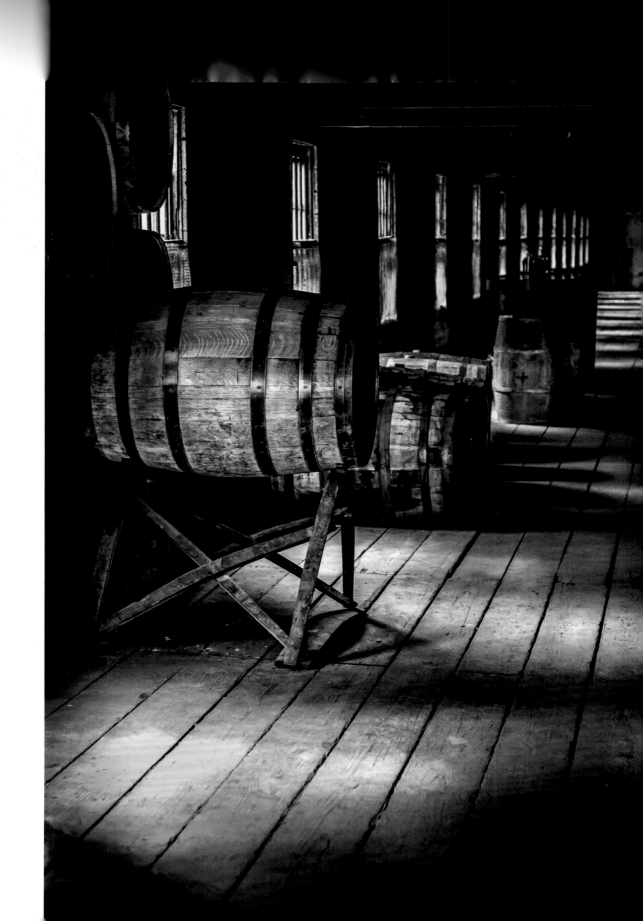

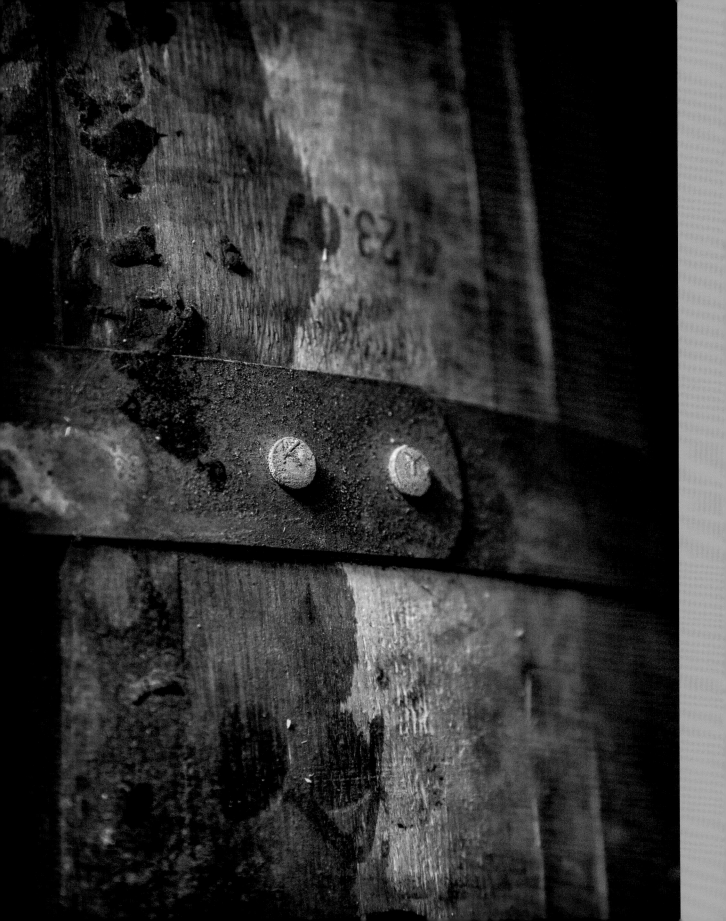

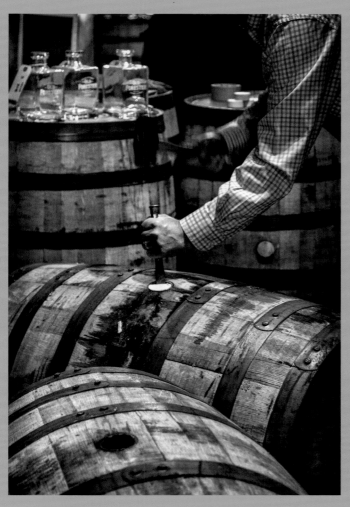

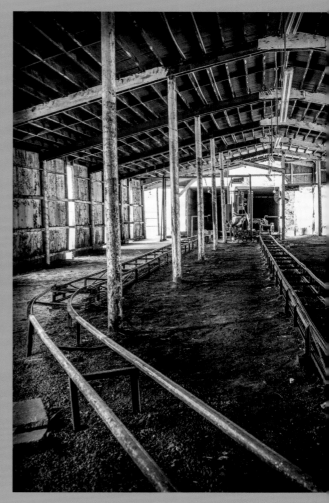

*B*UNG REMOVAL

Brown-Forman Distillery, Louisville, KY.
During a private tasting arranged for barrel
selection, a bung is removed from a barrel.

FACING

*B*ARREL RING STAMP

Barton 1792 Distillery, Bardstown, KY. The stamp
on the ring rivets identifies where the barrel
was made. "KY" indicates Kentucky.

*B*ARREL HOUSE RUN

Barton 1792 Distillery, Bardstown, KY.
Barrels are inspected and then run
down these rails after inspection.

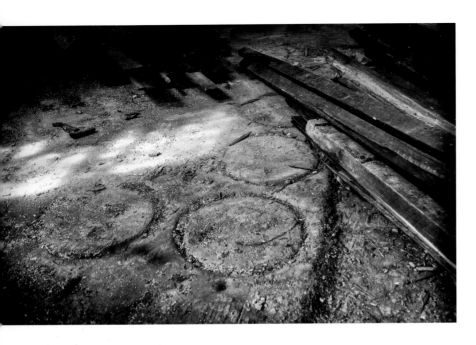

Barrel Rings

Old Crow Distillery, Frankfort, KY. Old Crow Distillery, when it was operating, had its own cooperage on site. In this image, impressions from barrel rings have been worn into the floor of the old cooperage building.

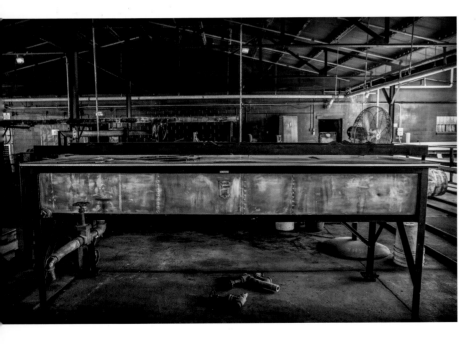

Copper Dumping Tub

Barton 1792 Distillery, Bardstown, KY. This trough, needing some repairs, is in the barrel sorting area outside of the cistern room.

FACING

Barrel on Barrel Scales

Buffalo Trace Distillery, Frankfort, KY. The barrel scale was a staple in the distillery.

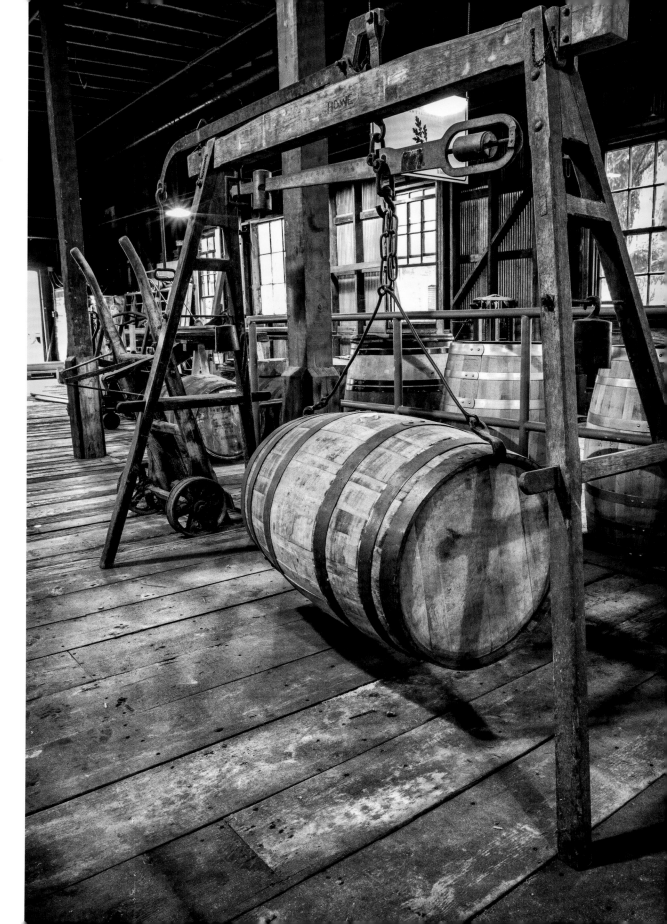

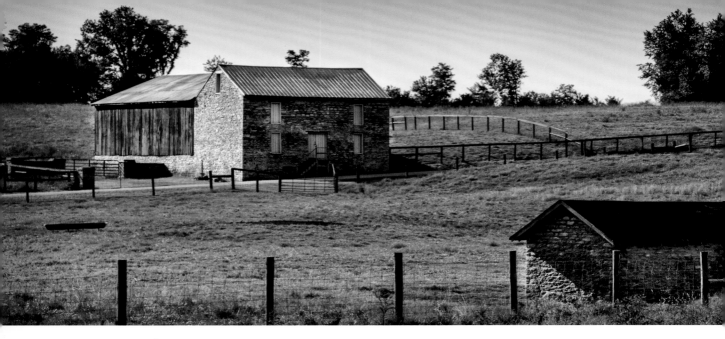

Jacob Spears Distillery Warehouse

Bourbon County, KY. One of the earliest distilleries in Kentucky, the Jacob Spears warehouse remains under the careful stewardship of the current owners. Barrels would have been stored here before being made available for local use or would have been shipped downriver to other ports.

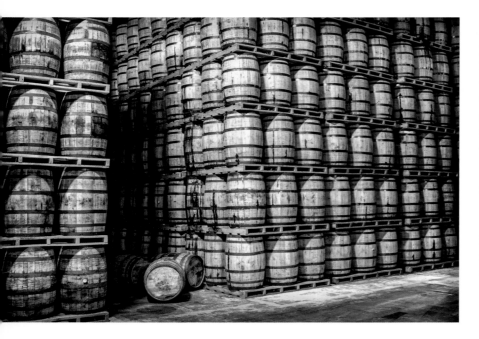

Barrel Pallets

Barton 1792 Distillery, Bardstown, KY. Experimenting with different ways of aging bourbon is part of the industry. An alternative to the rick system, where barrels are aged on their sides, is the pallet system, where barrels are aged end on end.

FACING

Barrels Aging

Boone County Distilling Co., Boone County, KY. There is a certain beauty when the sun shines on aging barrels.

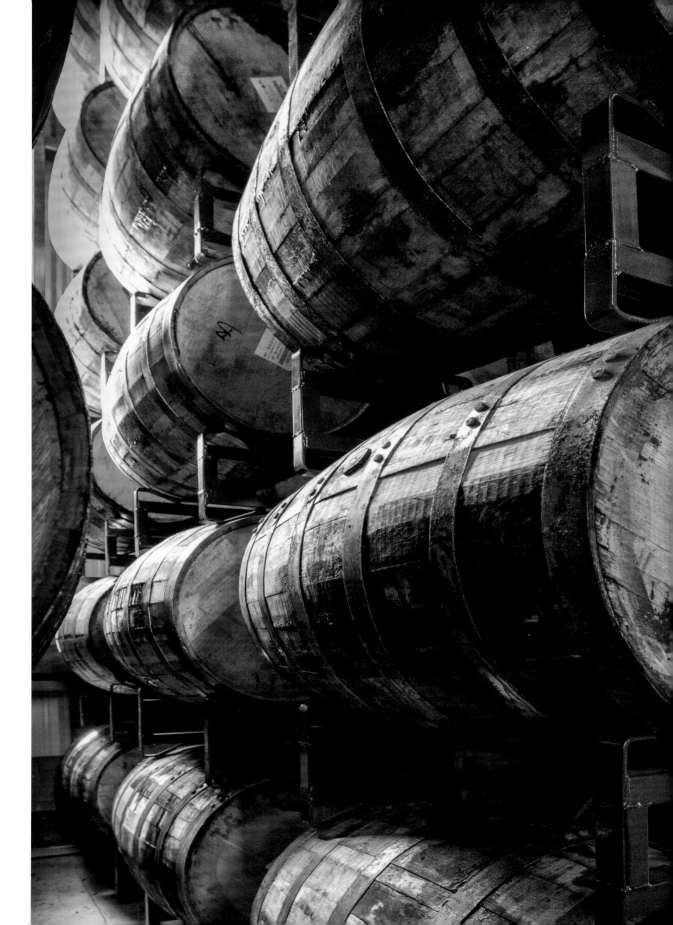

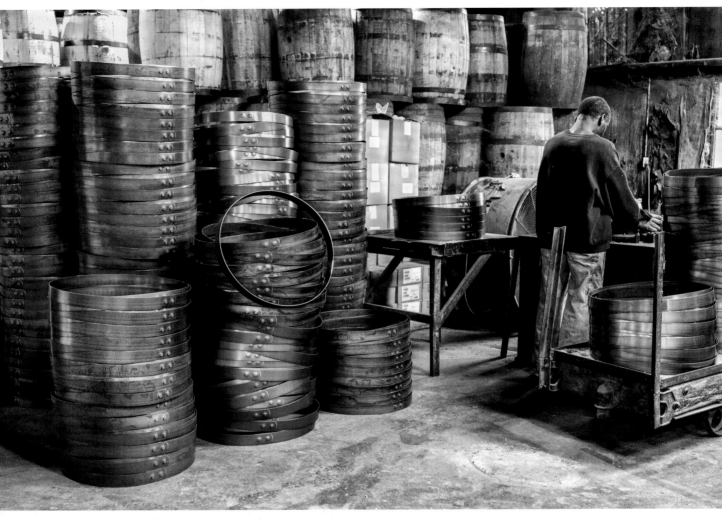

\mathcal{R}ING STACKS

Robinson Stave Company and East Bernstadt Cooperage, East Bernstadt, KY. After permanent rings are made, they need to be formed to fit specifications. At this station the rings are readied for the barrels.

Warehouse Reflection

T. W. Samuels Distillery, Deatsville, KY. This warehouse was designed by Bill Samuels Sr. and was once part of the old distillery owned by the Samuels family in Deatsville. This image was taken via a reflection in the firehouse windows on the site.

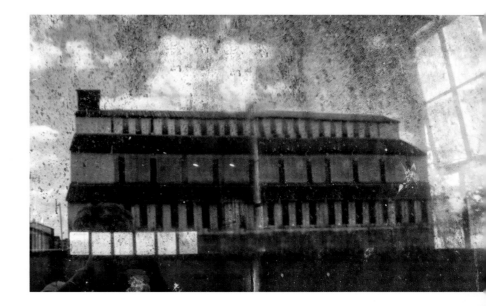

Charring the Barrels

Robinson Stave Company and East Bernstadt Cooperage, East Bernstadt, KY. The machines that char the inside of barrels close over both ends of the barrel and deliver gas-fed fire to reach the desired char level for that run. Most bourbon barrels are charred from fifteen to fifty-five seconds, or char levels 1 to 4.

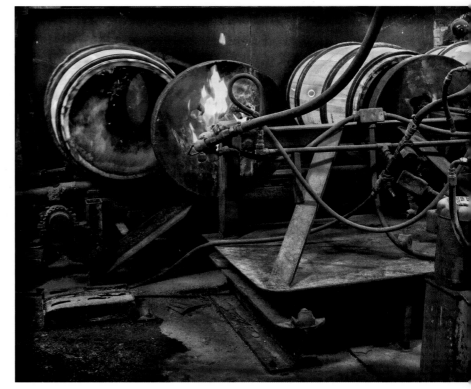

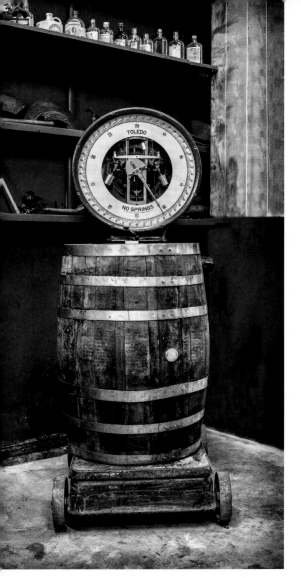

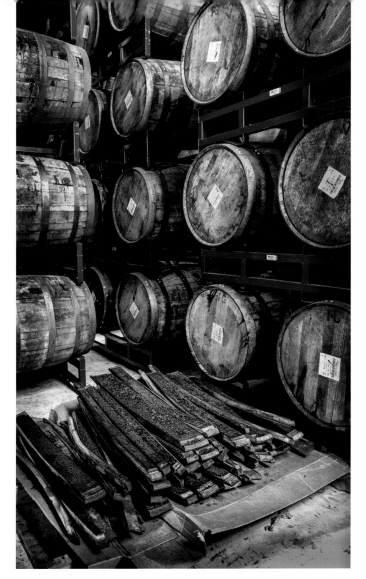

Barrel on Scales

Kentucky Artisan Distillery, Crestwood, KY. Post-Prohibition scales were used to weigh a variety of distillery products, including barrels.

Barrels on Racks with Charred Staves

Boone County Distilling Co., Boone County, KY. The modern craft distillery warehouse often uses metal racks, such as this one. The charred staves from used barrels can be seen in the foreground.

FACING

Smoking Barrel

Robinson Stave Company and East Bernstadt Cooperage, East Bernstadt, KY. Once the barrel is charred to the desired level, water is sprayed into it, creating the steam seen in this image.

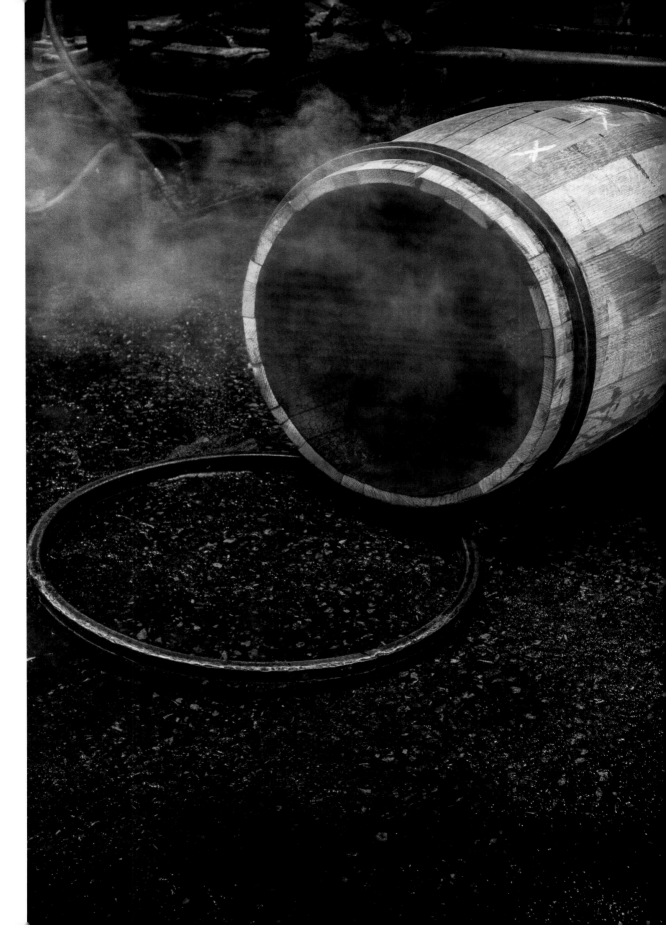

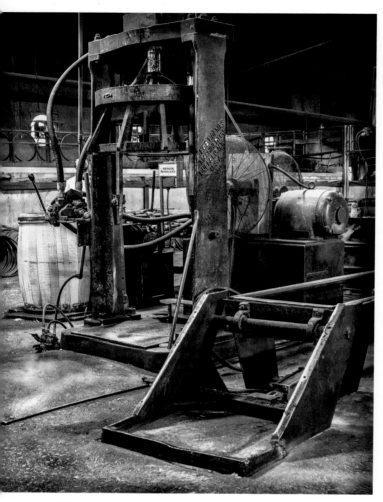

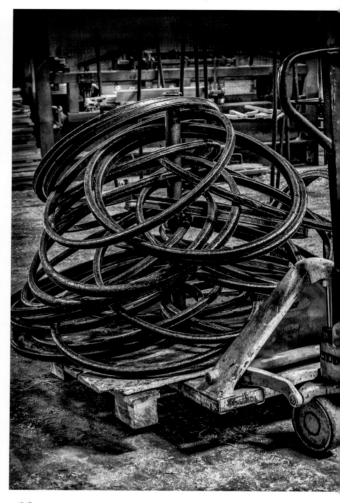

RING MACHINE AND BARREL LIFT

Robinson Stave Company and East Bernstadt Cooperage,
East Bernstadt, KY. The tall machine in the center of
this image places temporary rings on the barrel to ready
it for firing. In the foreground is the lift that will hoist
the barrel onto a conveyor and carry it to be charred.

BARREL RINGS

Robinson Stave Company and East Bernstadt
Cooperage, East Bernstadt, KY. Temporary
rings are put on barrels to hold them during
firing and initial preparation. They are removed
at various stages of finishing the barrel.

FACING

GLOVE ON MACHINE

Robinson Stave Company and East Bernstadt
Cooperage, East Bernstadt, KY. In this
cooperage, which relies on machinery and
manpower, every barrel is touched and handled
by humans over and over, maintaining the
industrial and cultural heritage of this trade.

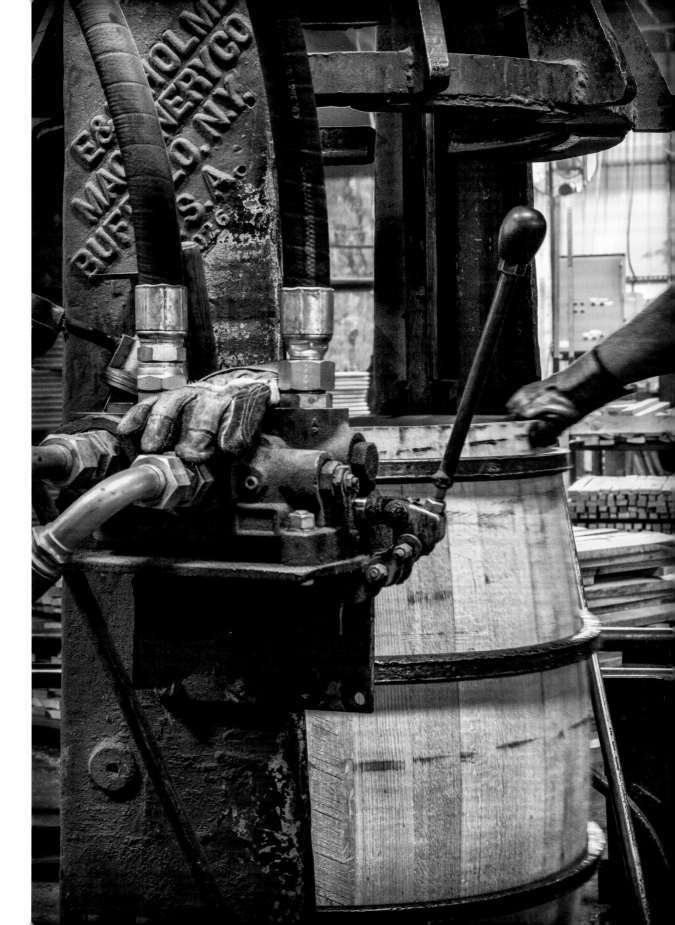

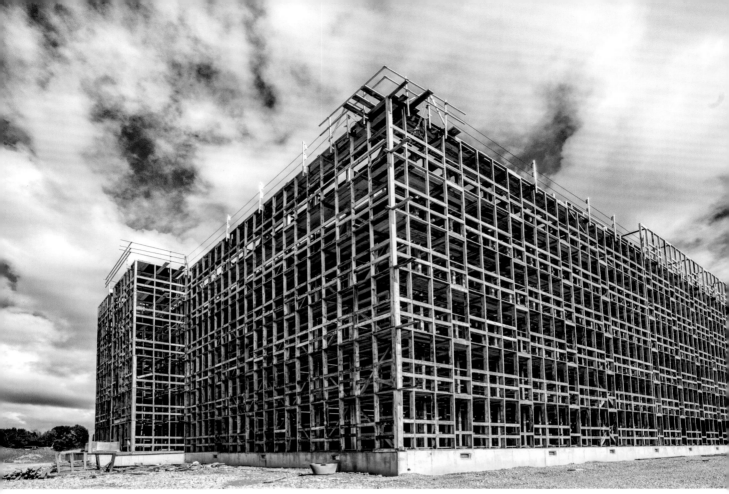

WAREHOUSE BUILD

Buzick Construction, Bardstown, KY. The skeleton of a new rick warehouse
being built in 2016 is exposed. There is little difference between this skeleton
and the skeleton of the Dowling Distillery warehouse, a post-Prohibition build,
"Warehouse Skeleton" shown on page 196, as it was torn down in 2013.

PREVIOUS

BARREL RINGS IN THE AIR

Robinson Stave Company and East Bernstadt Cooperage, East Bernstadt, KY. Temporary rings
are transported above the factory floor and reused once they are removed from the barrel.

Old Oscar Pepper / Labrot and Graham Warehouse

Woodford Reserve Distillery, Versailles, KY. The oldest stone bourbon warehouse still holds premium bourbon barrels using a rick system.

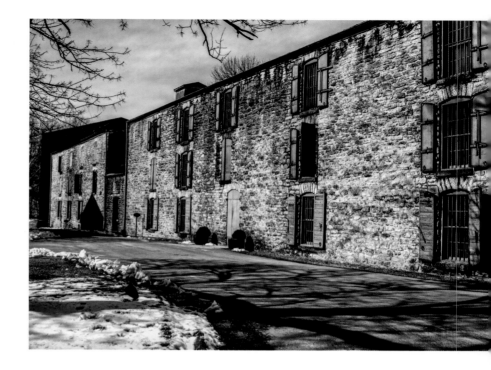

Ring Machine and Shop Floor

Robinson Stave Company and East Bernstadt Cooperage, East Bernstadt, KY. This image shows a barrel ready for temporary rings; a barrel in the machine placing a ring; and a barrel, with all three rings, on the barrel hoist ready to be lifted onto the conveyor line for charring.

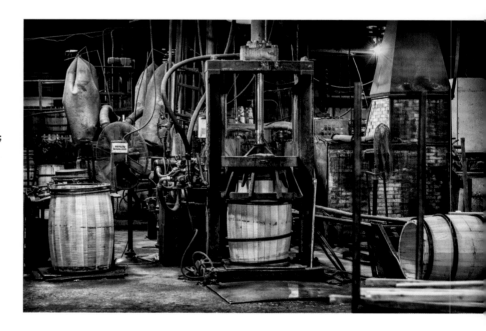

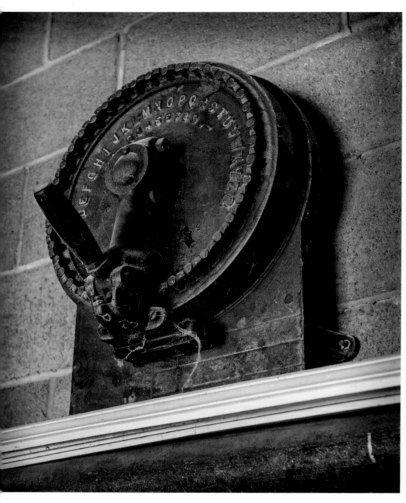

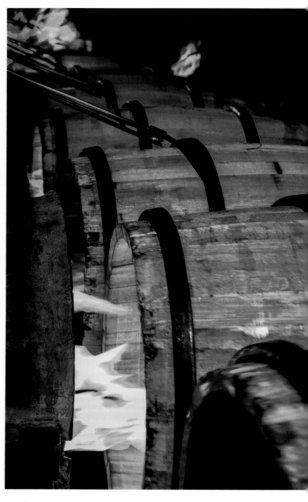

BARREL LABELER

Weisenberger Mill, Midway, KY. This iron label maker was used decades ago to label barrels filled with flour and distillers' grist.

BARREL LINE CHARRING

Kentucky Cooperage, Lebanon, KY. At Kentucky Cooperage the whole process is highly mechanized for efficiency. Here seven barrels are in line for charring at once using a gas-fed fire.

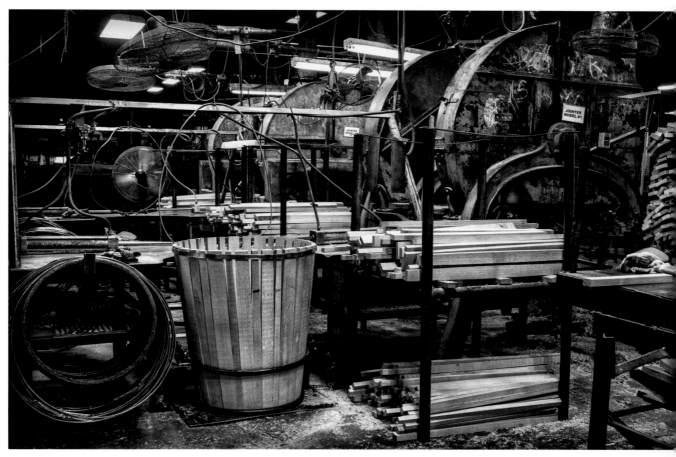

ℬARREL ASSEMBLY STATION

Robinson Stave Company and East Bernstadt Cooperage, East Bernstadt, KY. From this angle an almost completed barrel stands beside the assembly station. The station consists of the joiner wheel, the ready staves, the temporary rings that will be used to assemble the barrel, and the overhead rings that are transported around the shop.

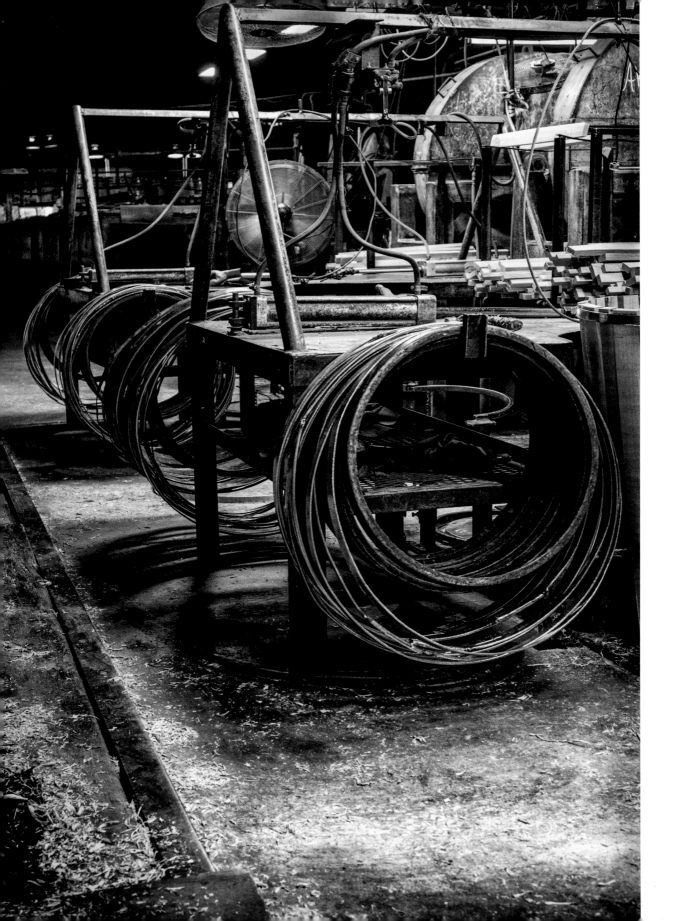

\mathcal{R}ING WORKS

Robinson Stave Company and East Bernstadt Cooperage, East Bernstadt, KY. This machine corrects the circumference of the ring to be certain it fits the barrel.

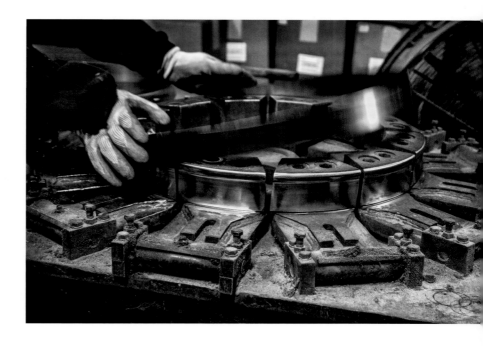

\mathcal{B}ARRELHEAD STATION

Robinson Stave Company and East Bernstadt Cooperage, East Bernstadt, KY. Tools and partially completed barrelhead sections can be seen in this image.

FACING

\mathcal{R}INGS AT THE ASSEMBLY STATIONS

Robinson Stave Company and East Bernstadt Cooperage, East Bernstadt, KY. Four assembly stations are still during lunch break.

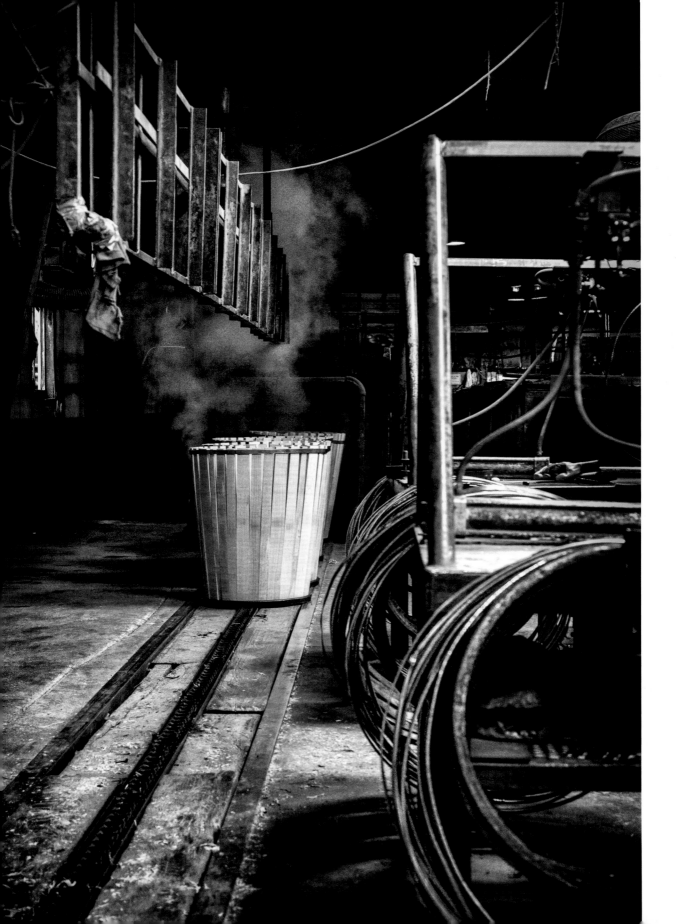

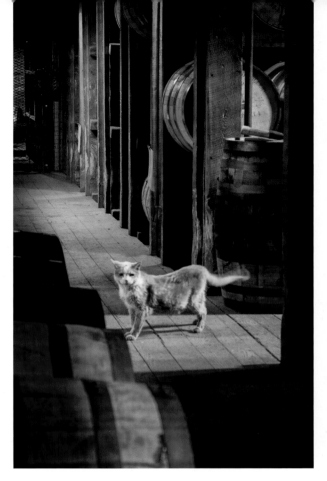

ℰLIJAH THE FELINE

Woodford Reserve Distillery, Versailles, KY. A longtime
resident of the distillery, Elijah (after Elijah Pepper)
the cat surveys the aging barrels in 2013. In 2015, Oscar
(after Oscar Pepper) began his tenure after Elijah died.

𝒲HIRLING QUARTER CUT

Robinson Stave Company and East Bernstadt
Cooperage, East Bernstadt, KY. The log is
continually split with a band saw until it
reaches the correct dimensions for a stave.

FACING

ℬARRELS ON THE STEAM LINE

Robinson Stave Company and East Bernstadt Cooperage, East Bernstadt, KY. Once the staves are
assembled in temporary rings, they are moved through a tunnel that heats the barrels with steam to
moisten them, increasing the flexibility of the staves so that they can be bent without breaking. The
top ring is then tightened, giving the barrel its recognizable shape, with a wider girth in the center.

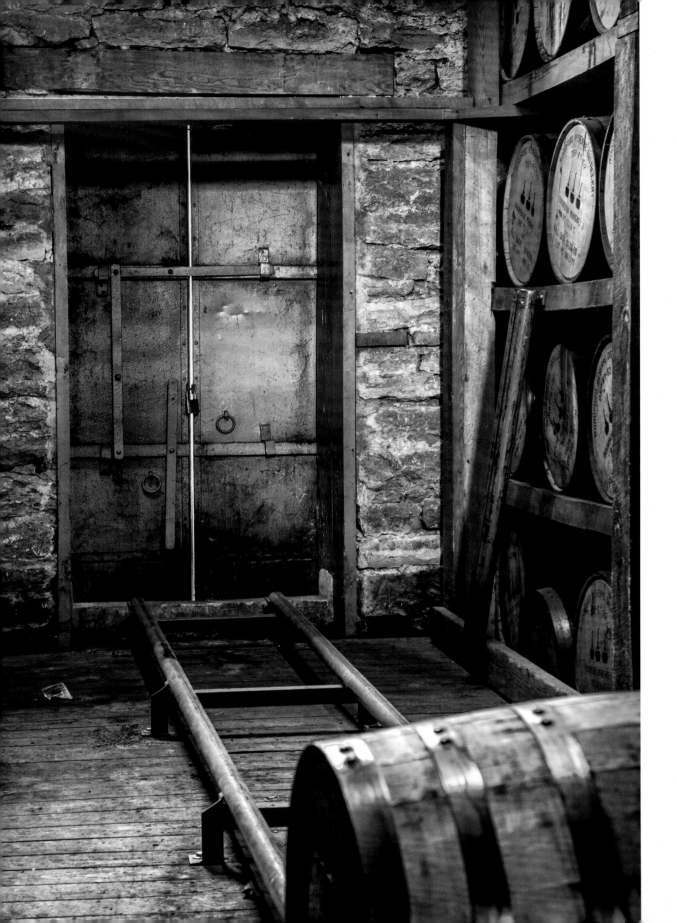

Second Cut

Robinson Stave Company and East Bernstadt Cooperage, East Bernstadt, KY. In the sawmill area the log, which has been debarked and cut in lengths, is split open in the second cut.

Quarter Cuts on Round Conveyor

Robinson Stave Company and East Bernstadt Cooperage, East Bernstadt, KY. The splits are moved through several band-saw cuts on this conveyor.

FACING

Warehouse Door and Barrel Run

Woodford Reserve Distillery, Versailles, KY. Barrel runs inside a warehouse allow the barrels to be moved out the door to the exterior.

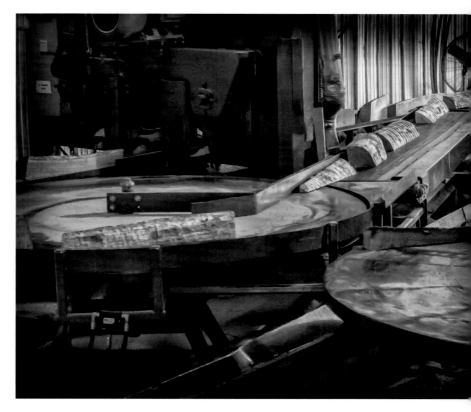

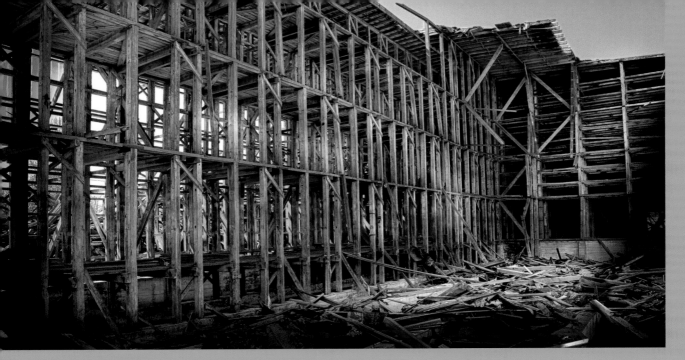

Warehouse Skeleton

Dowling Distillery, Burgin, KY. The skeleton of this warehouse, built post-Prohibition circa the 1930s and in this image in the process of being torn down, shows clearly the construction of a rick warehouse.

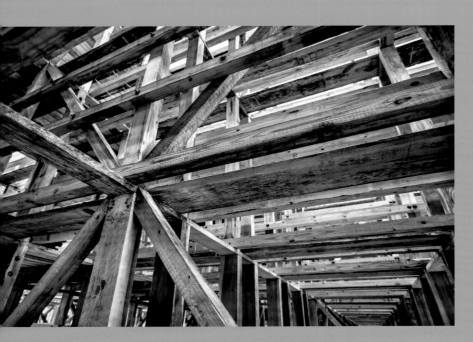

Lumber Star

Buzick Construction, Bardstown, KY. One is able to see how the aisles and ricks are put together during a new warehouse build.

FACING

Open Warehouse Aisle

Buzick Construction, Bardstown, KY. Sunlight still shines through the aisles during this build. Soon the skin, or metal covering, will be placed over the skeleton, and darkness will envelop the barrels as they age.

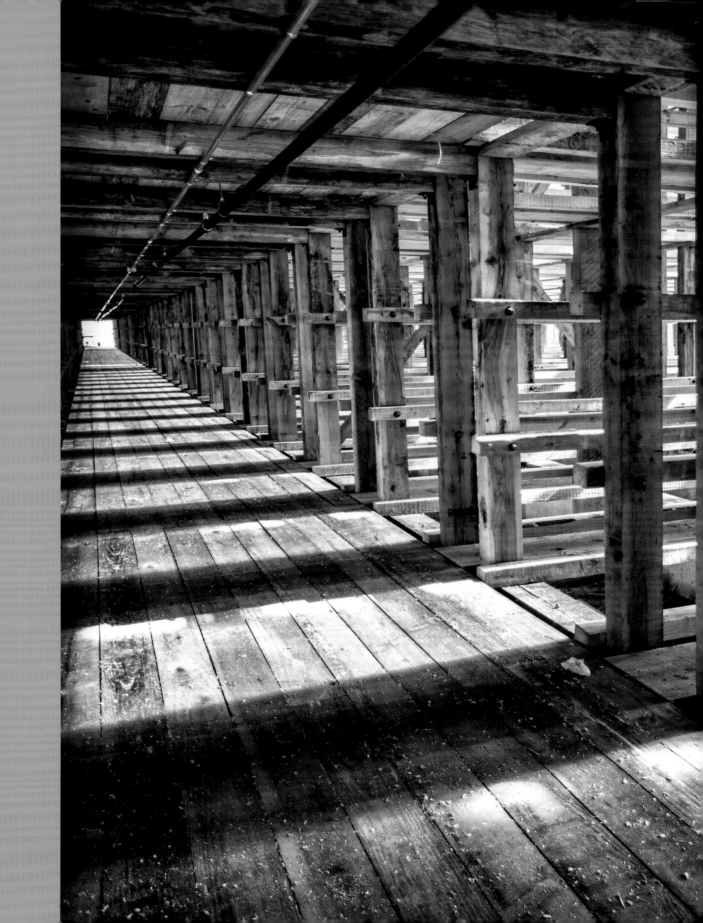

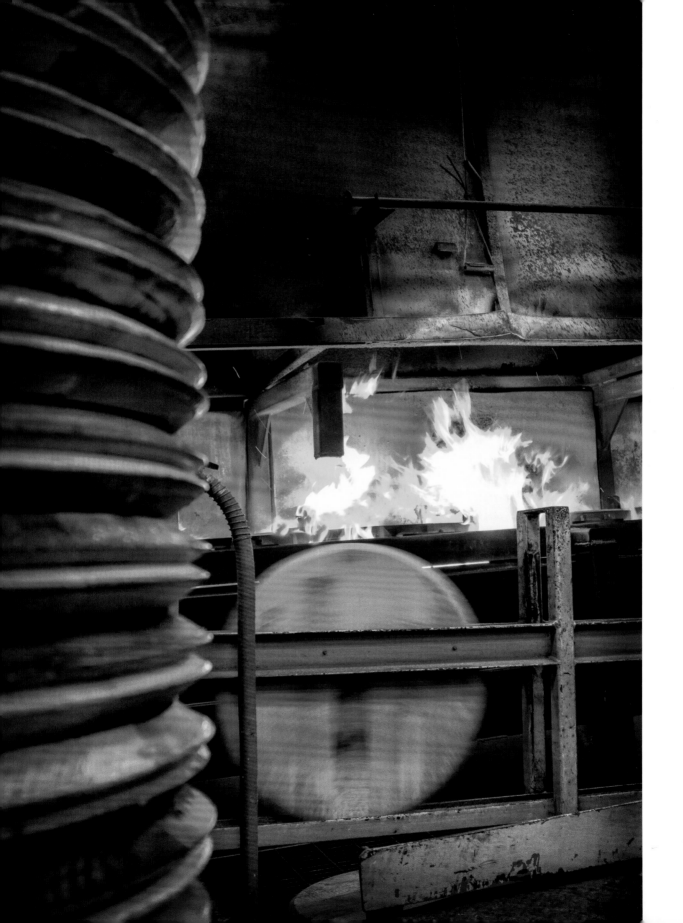

DUAL CHARRING MACHINES

Robinson Stave Company and East Bernstadt Cooperage, East Bernstadt, KY. The lines leading to these two burners supply gas that provides the various char levels. Char levels for bourbon are typically levels 1–4, or fifteen to fifty-five seconds. Charring at temperatures above 284 degrees allows the white oak to break down into wood sugars that add the tastes of brown sugar, toffee, caramel, spice, smoke, and vanilla.

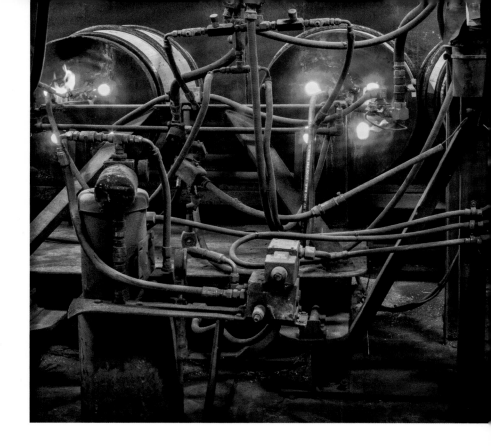

STAVE CONVEYOR WHEELS

Robinson Stave Company and East Bernstadt Cooperage, East Bernstadt, KY. These wheels keep the board steady on the conveyor as it is put through various planers, sanders, and files.

FACING

ROLLING BARRELHEAD

Kentucky Cooperage, Lebanon, KY. Barrelheads are charred as a conveyor moves them through the fire; they are then released to roll toward the end after charring.

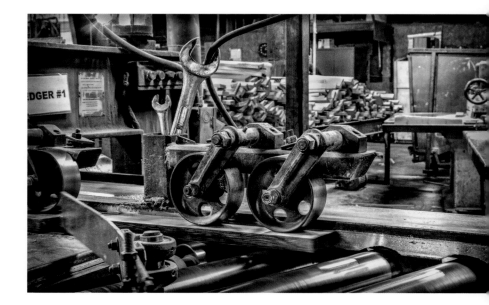

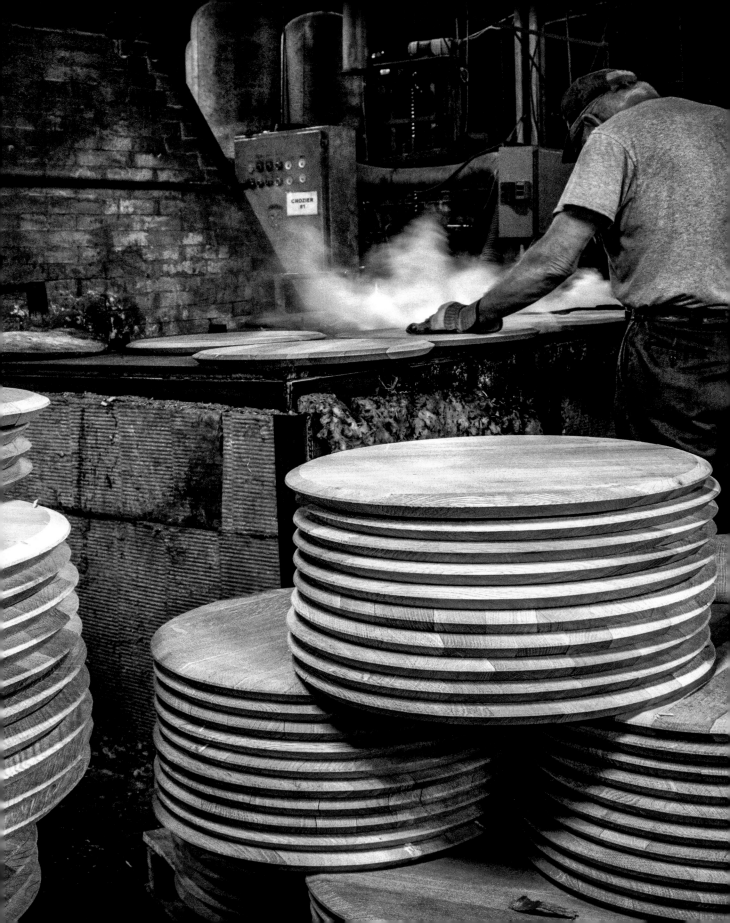

FIRE AND BARRELHEADS

Robinson Stave Company and East Bernstadt Cooperage, East Bernstadt, KY. In a production process reminiscent of historical methods, a worker handles barrelheads, placing them over the gas oven burners and removing them by hand as well.

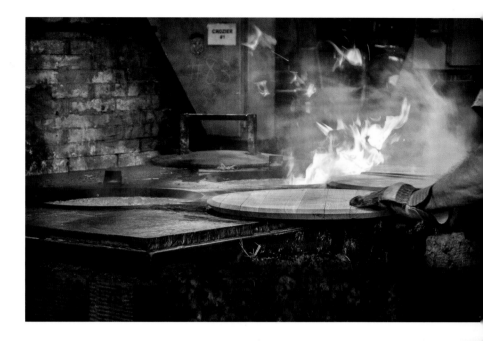

OLD STAVE MACHINE

Robinson Stave Company and East Bernstadt Cooperage, East Bernstadt, KY. This mid-twentieth-century stave machine was the original saw used when the stave mill was first started. The cooperage was started after the sawmill.

FACING

CHARRING THE BARRELHEADS

Robinson Stave Company and East Bernstadt Cooperage, East Bernstadt, KY. Barrelheads are placed over gas-fired openings and charred under the watchful eye of a veteran cooperage worker.

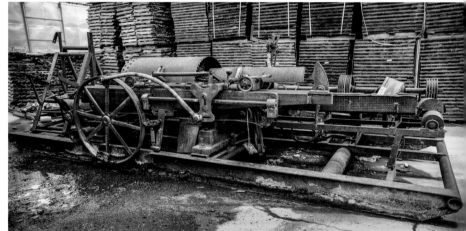

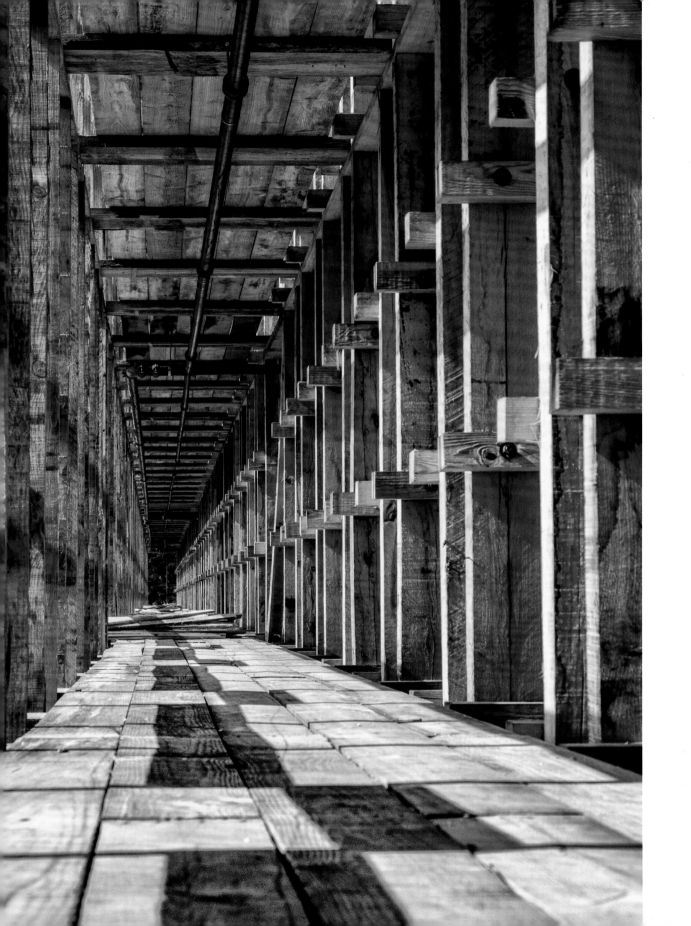

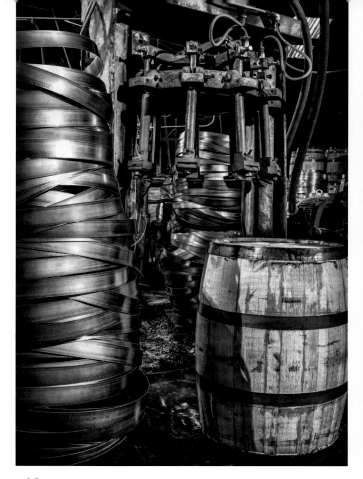

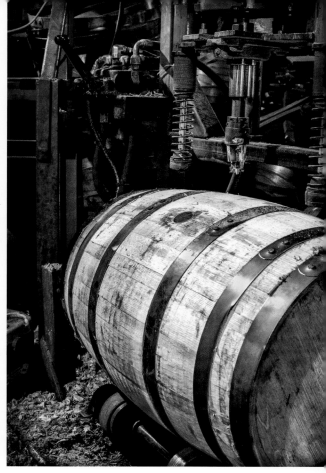

BARREL AND PERMANENT RINGS

Robinson Stave Company and East Bernstadt Cooperage, East Bernstadt, KY. A stack of permanent barrel rings sits beside the machine that will place and secure those rings on barrels, such as the one here.

FACING

CHECKERED WAREHOUSE AISLE

Buzick Construction, Bardstown, KY. The Buzick family founded their company in 1937 and completed the first warehouse by 1941. To this day Buzick Construction continues to be a premier builder of rick houses for barrel aging. This aisle is in a warehouse under construction.

BUNGHOLE DRILL

Robinson Stave Company and East Bernstadt Cooperage, East Bernstadt, KY. Once the barrel has received the char, the permanent rings, and some testing for tightness, the bunghole for filling is drilled.

SNOW-COVERED BARRELS ON A RUN

Old Taylor Distillery, Frankfort, KY. This image was taken when the Old Taylor Distillery was still abandoned. At the time, many distilling elements remained in place, such as these two barrels sitting on a barrel run.

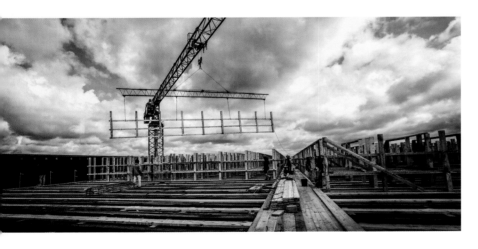

SETTING THE AISLES IN PLACE

Buzick Construction, Bardstown, KY. Buzick Construction specializes in rick house construction. The company builds rick houses using the same methods as early warehouse builders, with upgrades like this lift and other efficiency and safety measures.

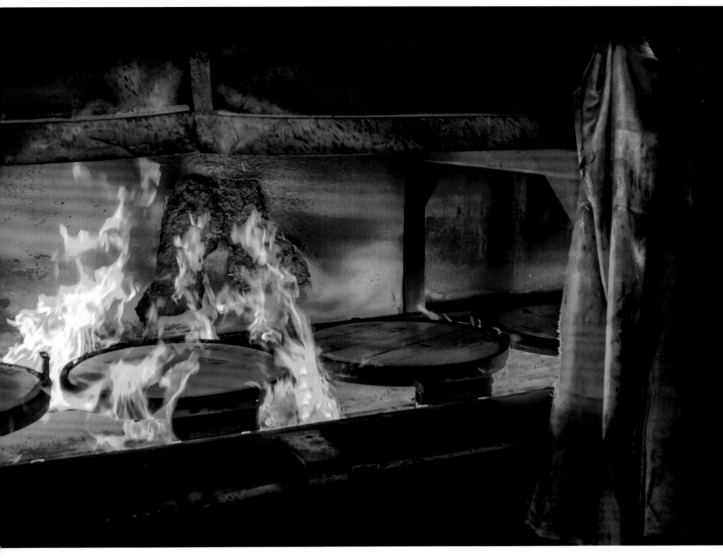

Two Barrelheads in the Fire

Kentucky Cooperage, Lebanon, KY. The white oak scraps used to fuel the fire that chars the barrelheads at Kentucky Cooperage assures that all the wood is used and none wasted.

FOLLOWING

Three Barrelheads in the Fire

Kentucky Cooperage, Lebanon, KY. The conveying of white oak barrelheads through the fire for charring is an intriguing sight for the visitor to the cooperage.

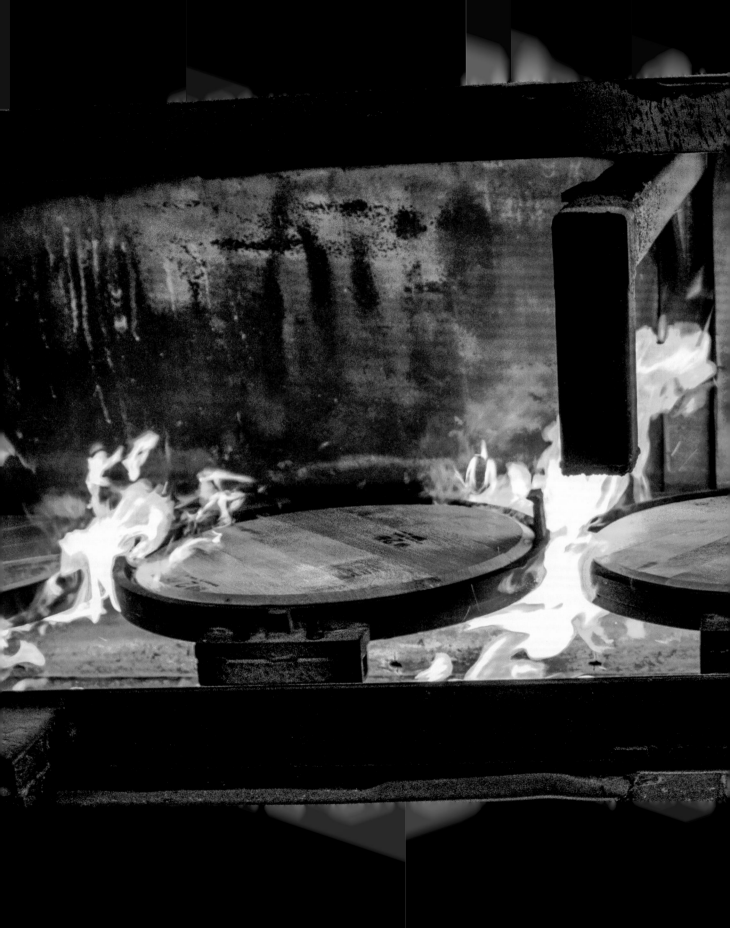

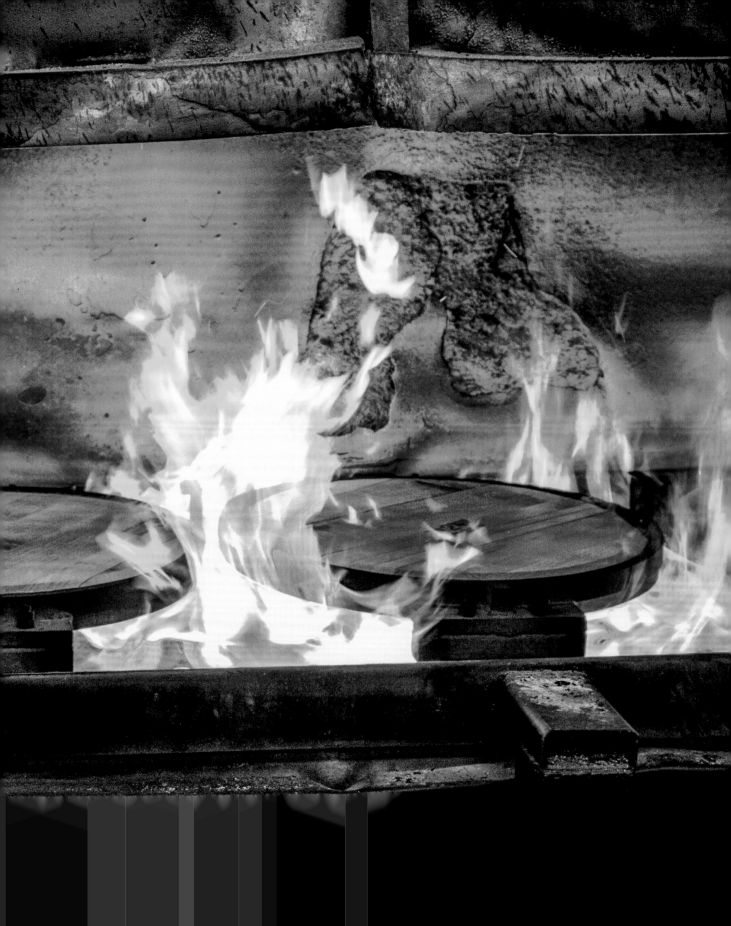

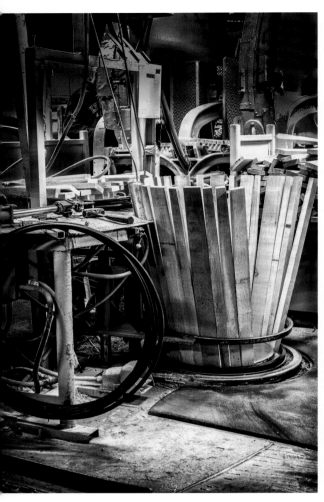

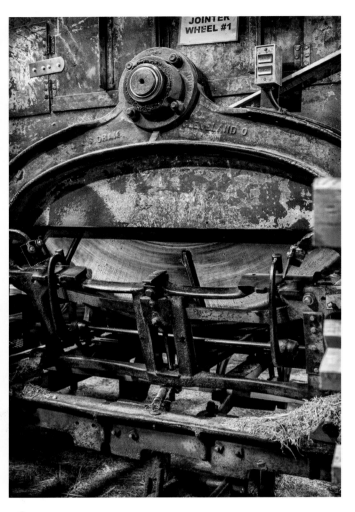

Barrel Assembling Station

Kentucky Cooperage, Lebanon, KY. During
a pause in assembling a barrel, one is able to
view the whole station, with temporary rings
and staves and an almost completed barrel.

Joiner Wheel No. 1

Robinson Stave Company and East Bernstadt Cooperage,
East Bernstadt, KY. Raw staves are contoured and
finished using a variety of machines and blades.

FACING

Barrel in Charring Line

Kentucky Cooperage, Lebanon, KY. The char of a barrel
has a major impact on the flavor of the spirit. The classic
char level, 4, which reflects about fifty-five seconds in the
fire, is also known as "alligator char" because the checkered,
shiny texture of the char resembles alligator skin.

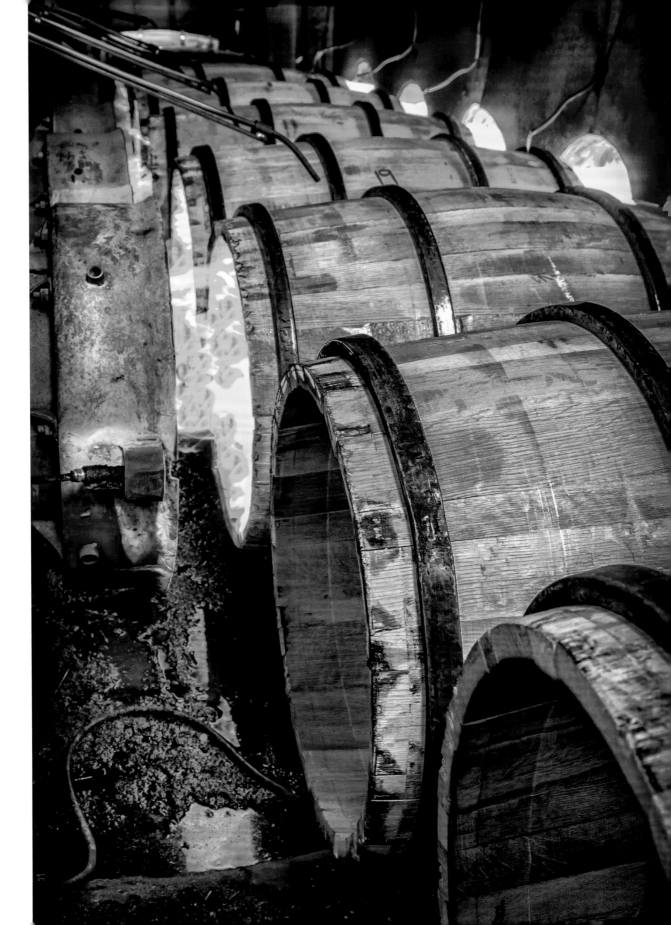

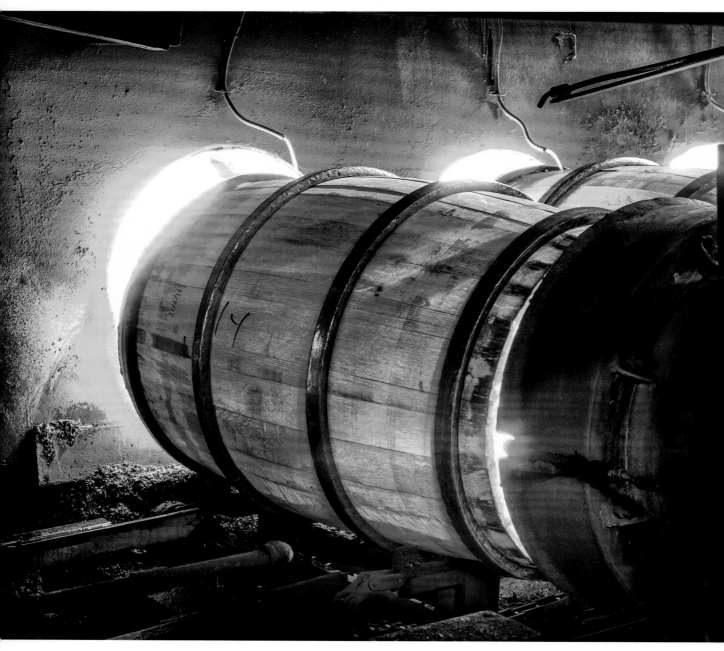

ƒINGLE BARREL CHARRING

Kentucky Cooperage, Lebanon, KY. This close-up of a barrel being released from the firing chambers shows the intensity of the heat, usually 284 degrees or above.

FAIRBANKS BARREL SCALES

Buffalo Trace Distillery, Frankfort, KY. Fairbanks scale products can be seen in most historic distilleries. This barrel scale is no longer used but remains in the tasting room for private barrel selections.

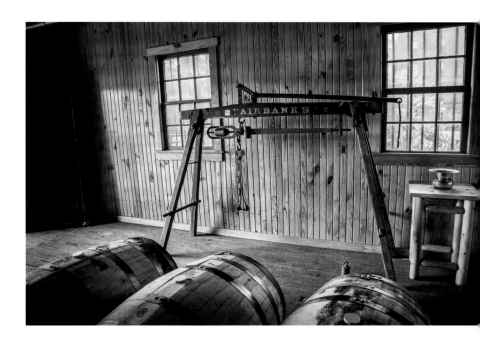

FIRE IN THE BARREL

Kentucky Cooperage, Lebanon, KY. The white oak staves sometimes hold the fire even after moving out of the charring chambers. The barrels are hosed inside after the fire and before moving on in further production, including receiving permanent rings, a barrelhead placed in the bottom of the barrel, and a bunghole.

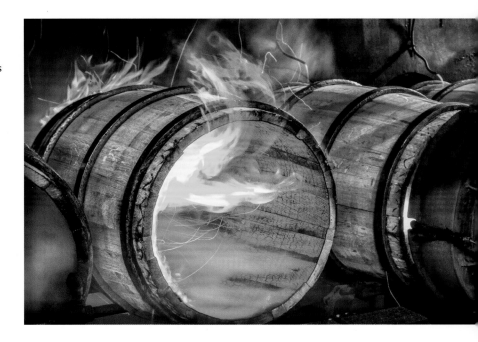

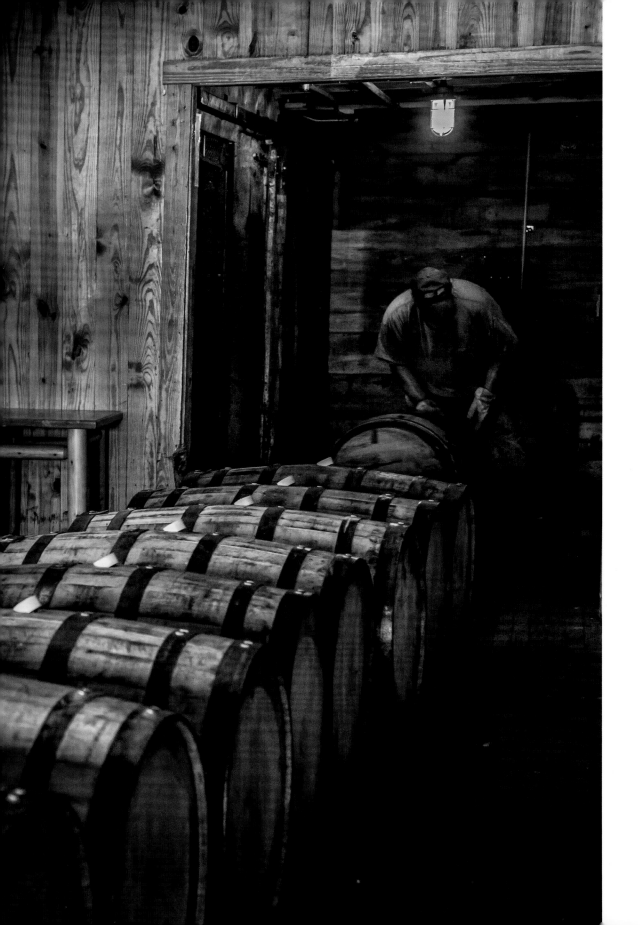

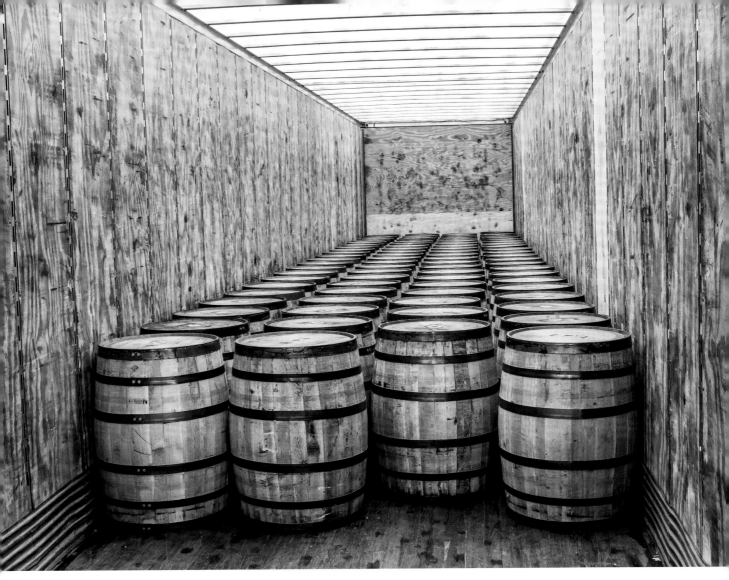

Truckload of Barrels

Kentucky Cooperage, Lebanon, KY. Once the barrels are finished and inspected,
they are loaded three barrels high in trucks to be delivered to distilleries for stamping
and filling and finally to warehouses to begin the long aging process.

FACING

Pushing a Line of Barrels

Buffalo Trace Distillery, Frankfort, KY. Barrels are rolled into the tasting room for a private
barrel selection. The Buffalo Trace tasting room is within a warehouse at the distillery.

CAROL PEACHEE is a fine art photographer who emphasizes cultural heritage preservation. Her work has appeared in *Keeneland Magazine* and has won awards around Kentucky. She is author and photographer of *The Birth of Bourbon: A Photographic Tour of Early Distilleries* and photographer of *Kentucky Bourbon Country: The Essential Travel Guide,* now in its second edition.

ACQUIRING EDITOR
Ashley Runyon

PROJECT MANAGER
Darja Malcolm-Clarke

BOOK & COVER DESIGNER
Jennifer Witzke

COMPOSITOR
Tony Brewer

TYPEFACES
Arno, Cormorant, Voluta Script

PRINTER
Four Colour Imports, Ltd.